SINGAPORE

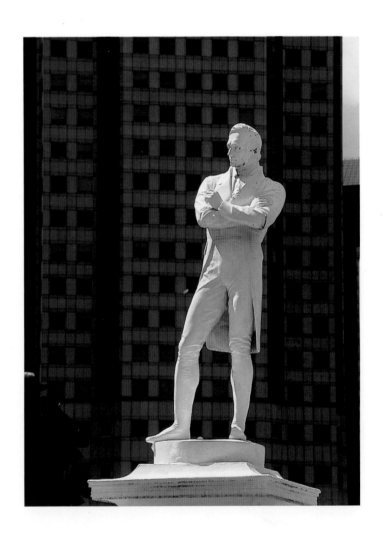

WHITE STAR PUBLISHERS

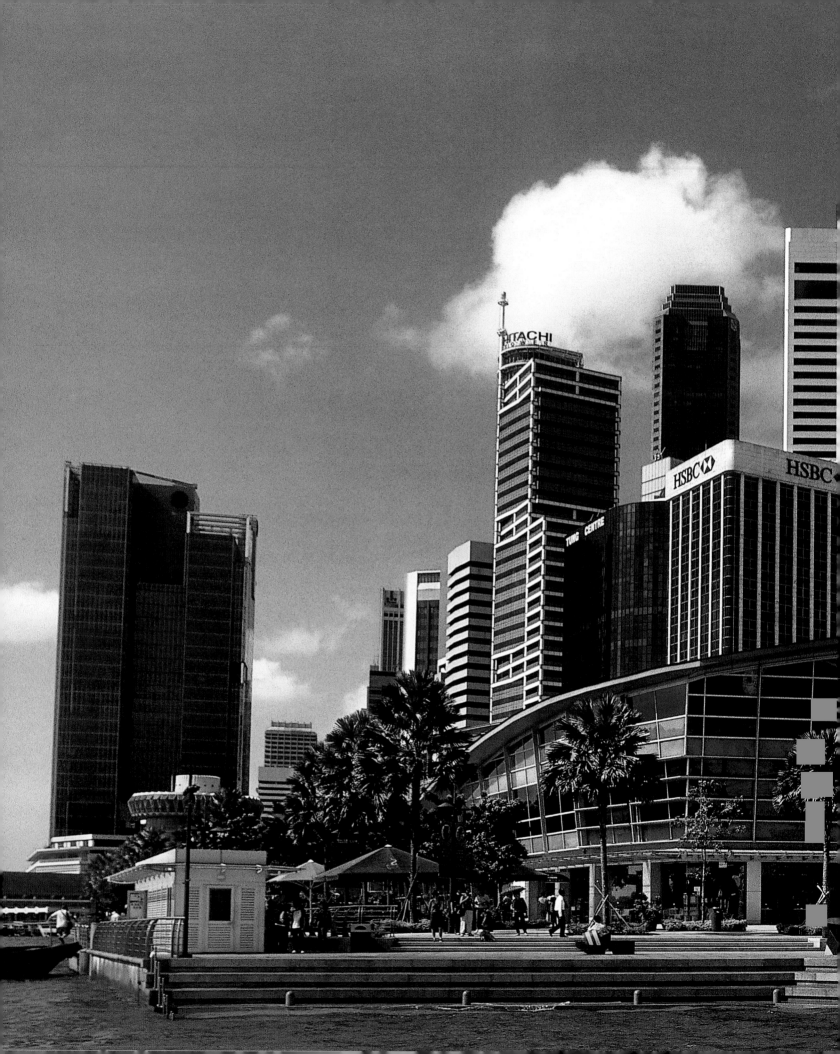

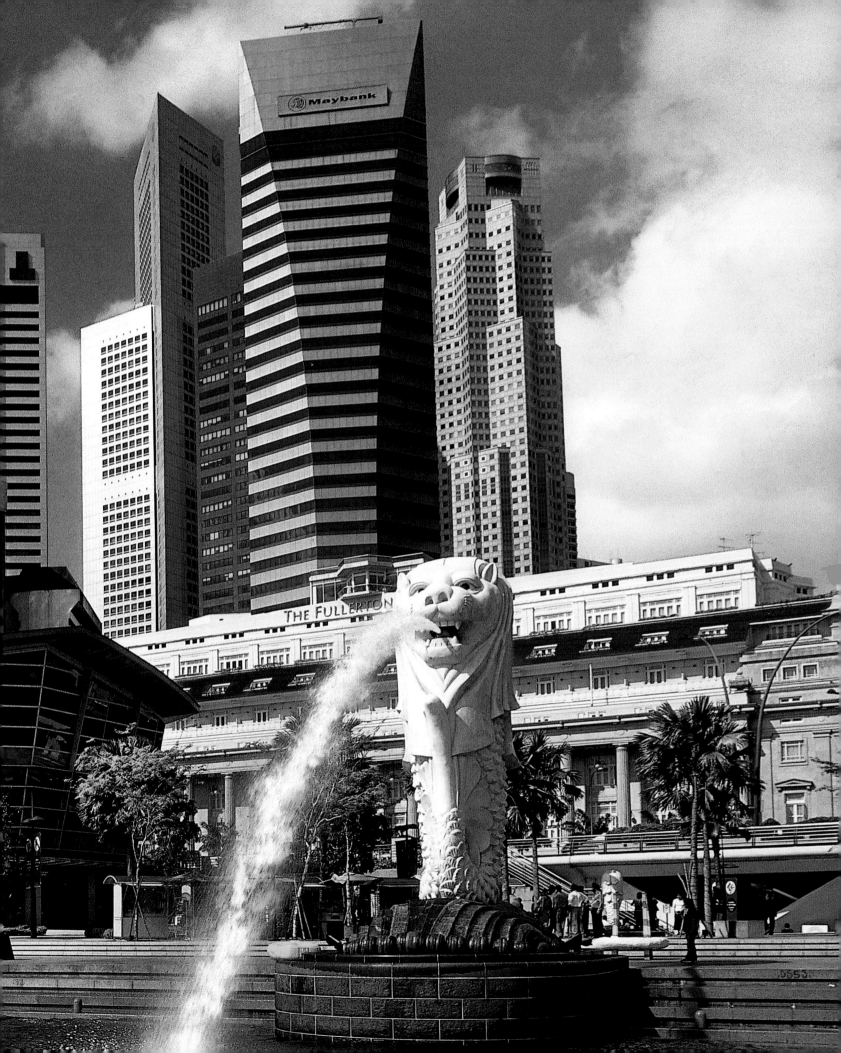

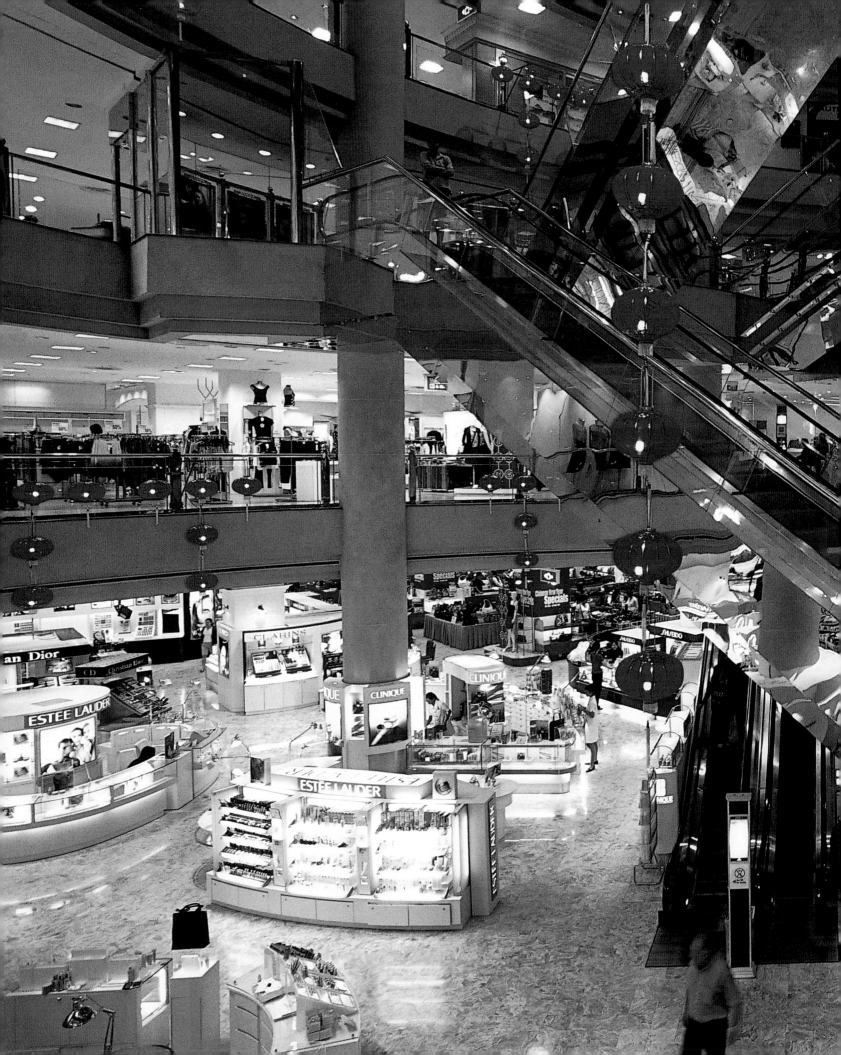

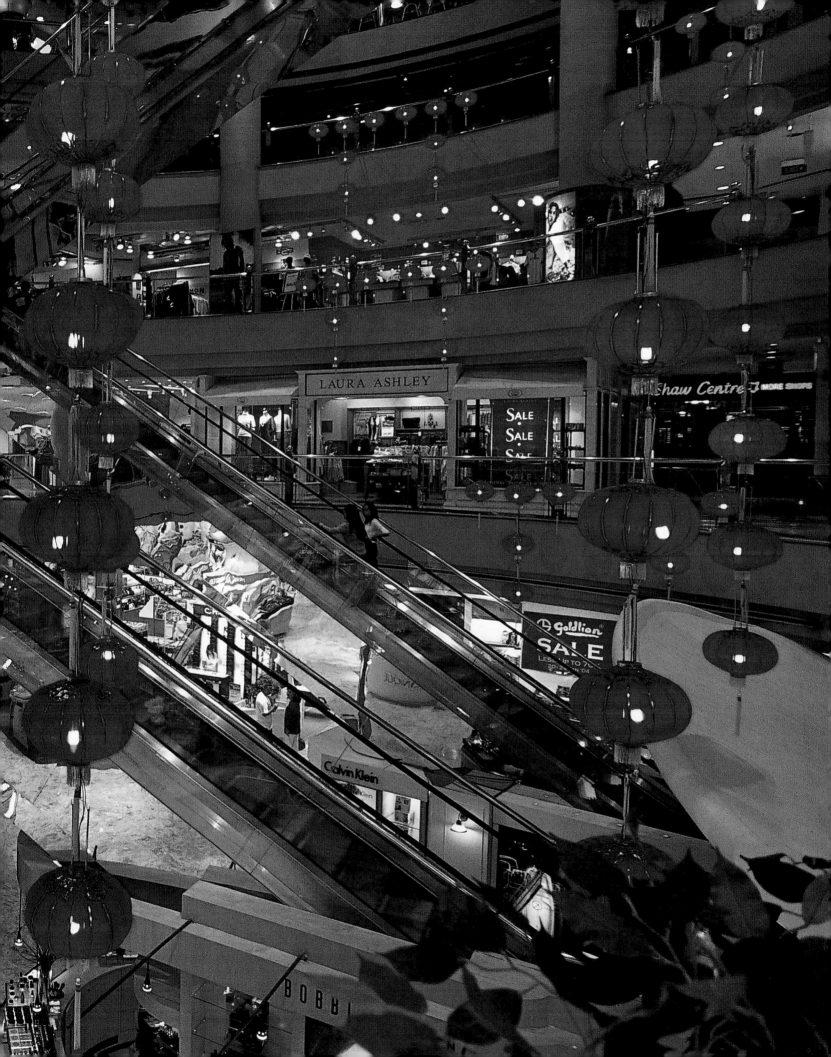

Texts
Marco Moretti

Contents

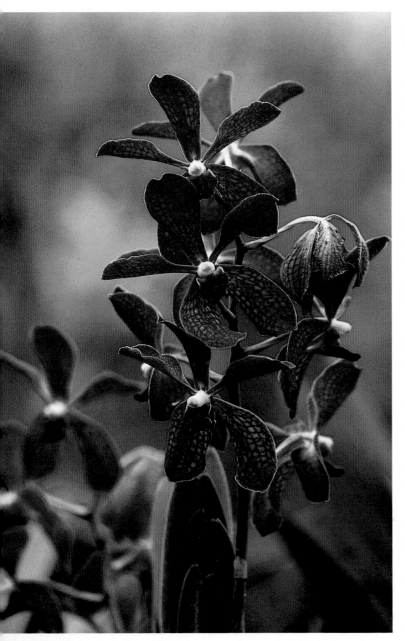

Cover The Central Business District's futuristic steel, concrete and glass skyscrapers feature street-level sculptures by contemporary artists.

Back cover The Central Business District's skyline overshadows the narrow streets that once formed the old Chinatown.

1 On the east side of the Singapore River, a statue of Sir Stamford Raffles marks the spot where the baronet first landed on the island in 1819.

2-3 The Central Business District, located on the Singapore River's south bank, is the city's financial heart, not to mention its most modern face.

4-5 The glittering interior of a shopping center on centrally located Orchard Road demonstrates a contrast often noticeable in Singapore: a totally modern structure, with a central lobby crossed by a clever combination of escalators, unite with traditional red Chinese lanterns.

6 Several hundred varieties of orchids fill the Mandai Orchid Garden, not far from downtown, with fragrances and colors. The garden, though private, is like a giant nursery and public park all in one: the magnificent flowers cultivated on its ten acres of land are sold throughout the world.

7 In keeping with recent dictates on the planning of public areas, the futuristic forms of steel, concrete and glass skyscrapers in the Central Business District now also feature sculptures by contemporary artists that highlight the buildings' varied designs.

8-9 The Singapore skyline becomes even more fascinating at night, when thousands of lights shine through the windows of the skyscrapers to transfigure it into a little Southeast-Asian "Manhattan."

10-11 The Central Business District skyscrapers, giant towers that are the pride of the city's economic and mercantile soul, are also structures of unusual and graceful design, the work of leading architects from Hong Kong and the United States. Those shown here dominate a dock for commuter ferries at the mouth of the Singapore River.

12-13 This magnificent aerial view perfectly shows the contrast – not lacking a surprising harmony – between the Colonial District's venerable Neo-classical-style buildings and Padang with its cricket fields (bottom left) and the Central Business District's skyscrapers across the river.

© 2005 White Star S.p.A.
Via C. Sassone, 22/24
13100 Vercelli, Italy
www.whitestar.it

TRANSLATION
Amy Christine Ezrin

ISBN 88-544-0065-3

REPRINTS:
2 3 4 5 6 10 09 08 07 06

Printed in Singapore
Color separation: Chiaroscuro, Turin

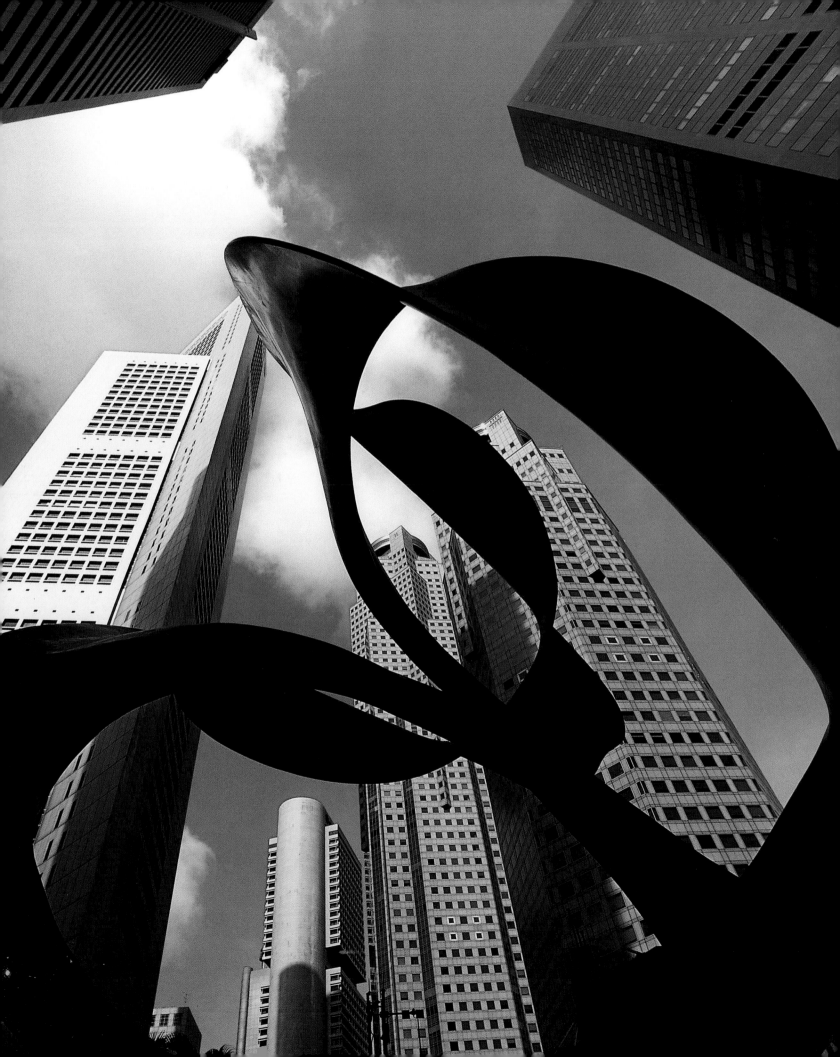

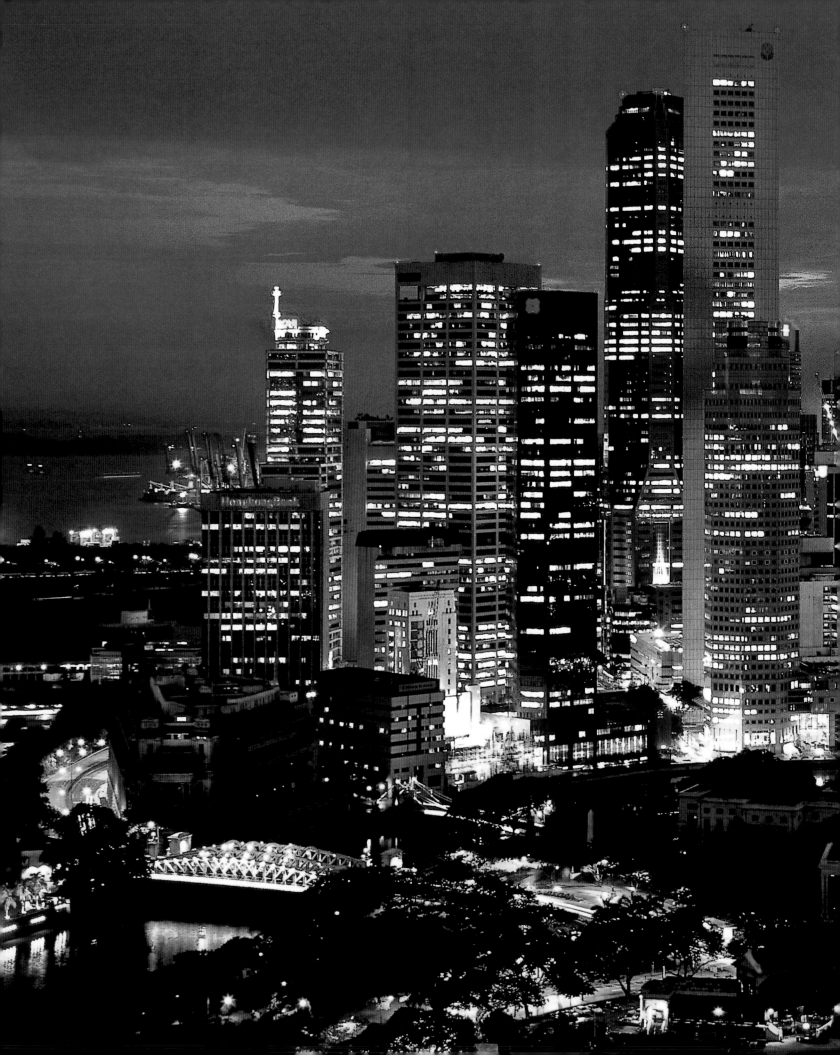

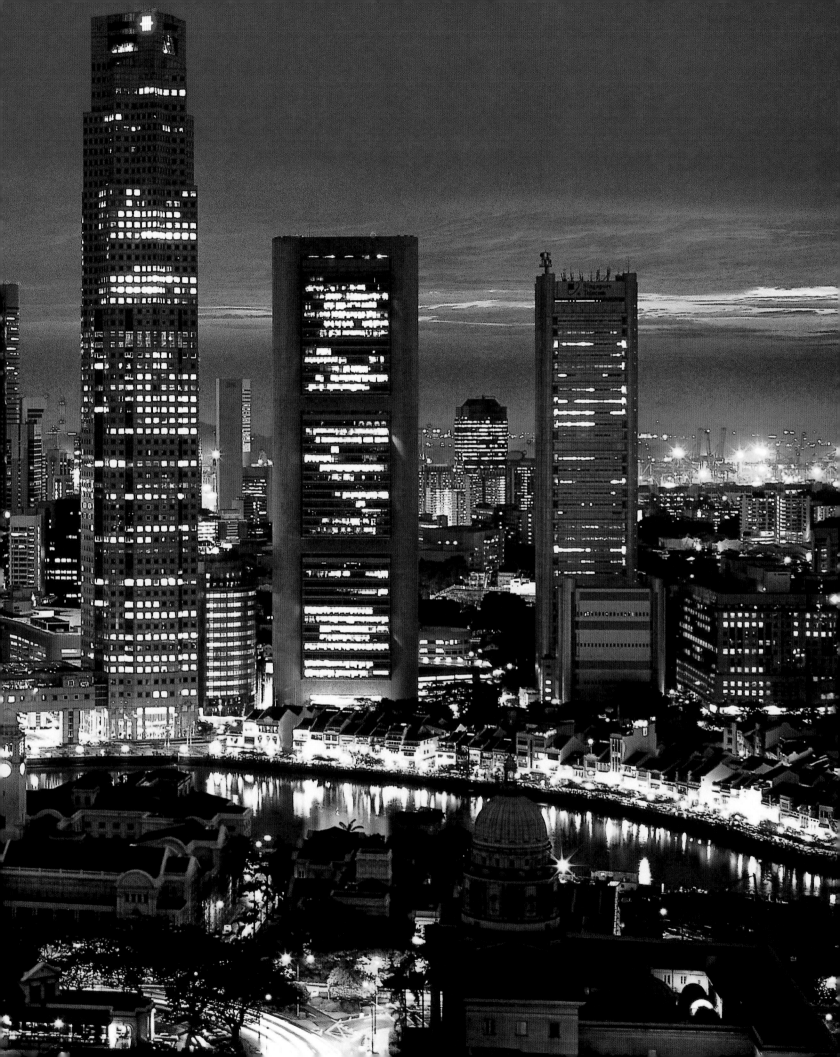

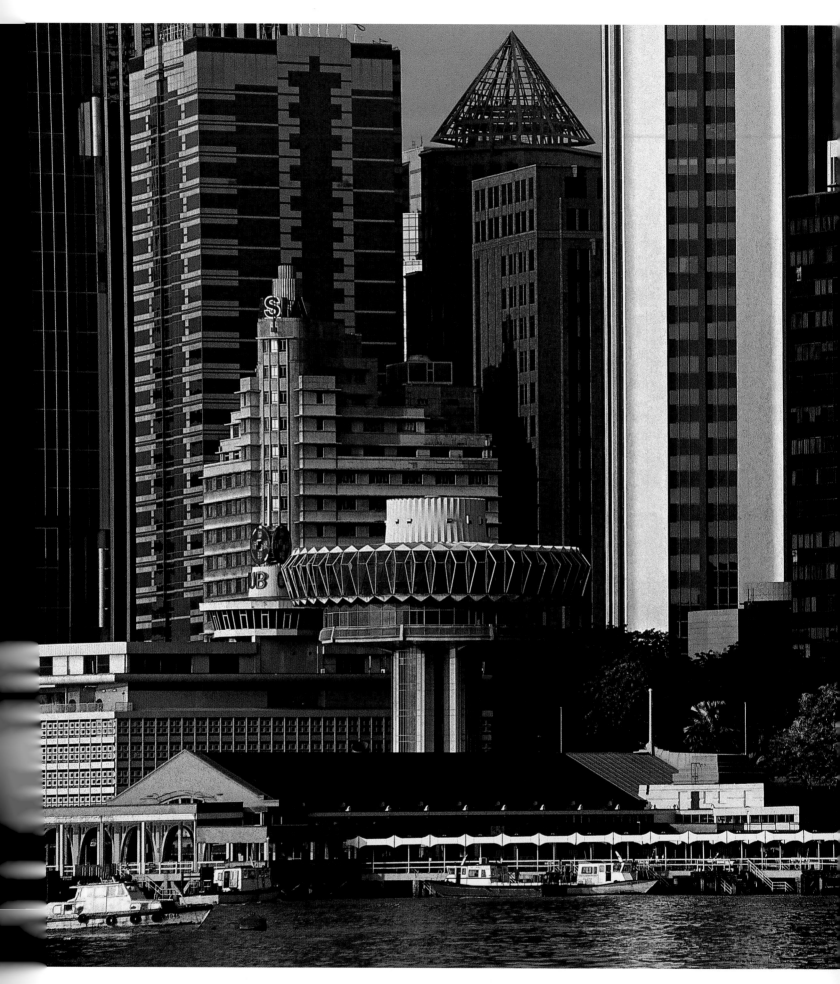

Introduction

Just arriving at Changi International Airport is enough to confirm that Singapore is the city of the future. The hub is one big shopping mall, where merchandise of all kinds mingles with spas where travelers can get a massage between one flight and the next, free Internet points, bookstores, and restaurants accommodating any budget. In the taxis headed toward downtown, small plasma-screen televisions entertain passengers. The automobile glides along avenues and overpasses amid the flowing traffic – unexpectedly fast-moving for a city-state with over 15,000 inhabitants per square mile – through residential neighborhoods made up of tall buildings that pop up out of the lush tropical vegetation, until clusters of futuristic skyscrapers proclaim downtown's proximity.

The city does not suffer from the congestion of the other Asian metropolises because traffic is regulated by high-technology systems combined with a zero-tolerance attitude toward those who violate the rules of the road. The traffic lights are triggered by sensors in the pavement that register the number of automobiles backed-up in traffic jams. Broken-down cars or accidents are removed within minutes by tow-trucks alerted by video cameras monitoring the main roads 24 hours a day. A subway system, buses in preferential lanes, and taxis reign supreme downtown, where private cars can only enter upon producing exorbitantly expensive permits, with cost varying according to the number of passengers carried: the fewer there are, the more it costs. Infrared video cameras survey the entrances to the limited-traffic zones, while electronic devices check vehicle speeds. Nothing escapes this alliance of efficiency, technology, and discipline, the definition of the Singapore of the third millennium.

Visitors can sense this alliance as soon as they find themselves among the steel, crystal and cement skyscrapers along the very central Orchard Road, lined by luxurious shopping malls with giant screens flashing advertisements and videos at the street, with wide, squeaky-clean sidewalks where fashion boutiques alternate with Parisian-style bistros, shops selling Chinese porcelain, restaurants of various nationalities, banks, Buddha bars, high-tech superstores, cafés serving Italian espresso, display windows featuring Burmese silks, immense book shops, leather shops, sushi bars, jewelry stores, and beauty-supply shops. Air-conditioning everywhere fights the tropical heat, and all around the orderly crowd does not push and shove, smoke, or eat on the street, an unadvisable activity that, if done on public transportation or in shopping centers, can be punished by severe fines.

In Singapore, order and cleanliness are among the means employed to achieve excellence; in fact the Urban Redevelopment Authority invite citizens to aim toward creating "a tropical city of excellence." This quality is recognizable not only in the total efficiency of the traffic and public facilities, but also in hotels and in consumer protection. Shops displaying the lion image (Singapore's symbol,) issued

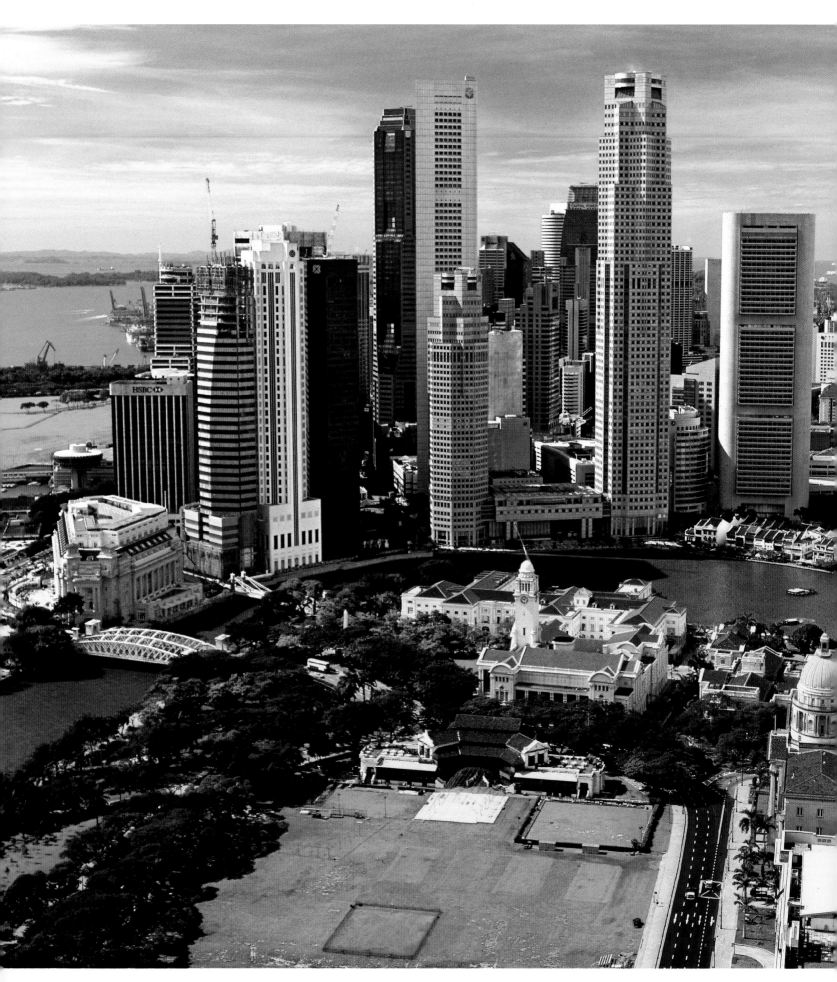

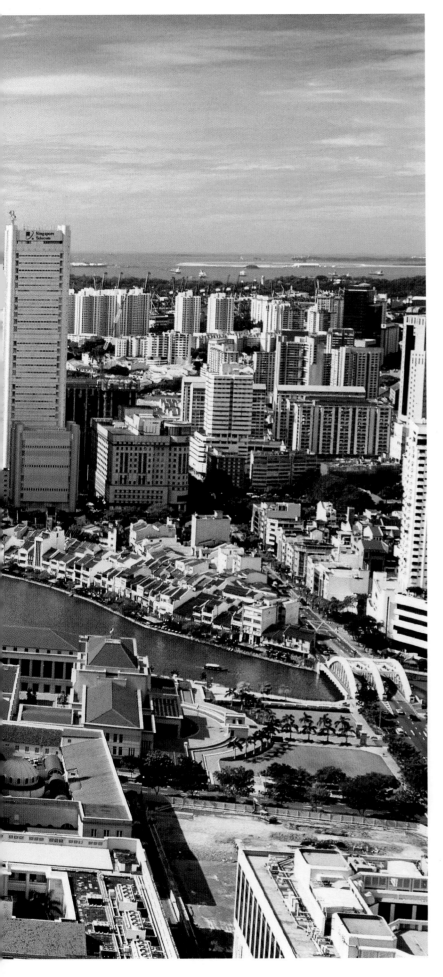

by the tourism board guarantee fair prices and the quality of all their merchandise. Singapore Airlines, for the last twenty years considered to be the world's best airline, proudly displays the lion symbol.

All of this achievement has occurred in the last two decades. To understand Singapore, it is necessary to review its unique history, much more recent than that of the other Asian countries. It began in 1819, when Sir Thomas Stamford Raffles (1781-1826), an official of the East India Company, bought the 267 square miles of swamp and rain forest that make up the island from the Malaysian Sultan of Johore. Raffles saw in that strip of jungle – situated in a strategic position south of the Malacca Peninsula between the main Indonesia islands – the ideal base upon which to establish a free port where British traders traveling to and from India, Australia, and China could converge. It was a brilliant hunch. Today, Singapore, besides being an acclaimed shopping paradise, is the most important port in the world for container shipping and brokerage businesses. One hundred and twenty-five international banks have transformed Singapore into the third-largest financial hub of Asia. Halfway through the 1990s, it had surpassed the largest European countries in terms of per-capita income. With an average life span of 81 years, the city-state occupies one of the highest spots on the world scale, just after Japan. Wealth also means better quality food, an element that has influenced the physical condition of the country's inhabitants: in twenty years, the average height of Singapore's citizens has risen from 5' 2" to 5' 7" and their average weight from 97 lbs to 130 lbs. However, excessive weight is prohibited: the government stresses the health dangers it poses and extends the military service of overweight young men.

Returning to the port, it looks like a giant video game controlled by robots on super shiny loading yards like the lobbies of grand hotels. To build it, Sir Thomas Raffles employed Malaysian workers from nearby Penang, followed by thousands of "coolies," the Chinese porters that came from the southern regions of the yellow giant. Then, English officials, traders, and businessmen arrived, along with Indian workers and bureaucrats, above all from the southern states of Tamil Nadu and Kerala, and Arab merchants. Hired by Raffles, the Irish architect George Coleman designed a city where every ethnic group had its own neighborhood. The English colonists lived in the Colonial District north of Singapore River, the Chinese in Chinatown, the Indians in Little India, and the Arabs and Muslim Malaysians around Arab Street, divisions that still hold true in part today.

North of the river, Coleman built several Neo-Classical-style buildings, of which his masterpiece was the Armenian church of St. Gregory on Hill Street. Nearby, on a street named after the Irish architect, stands the Anglican cathedral of St. Andrew. The area also has numerous monumental buildings constructed in the colonial era: the High Court, the City Hall, Victoria Theater (originally used as the town hall), and the adjacent Victoria Memorial, all Neo-Classical structures in which Neo-Palladian colonnades mix with Italian-style palaces, as in the High Court building that the Italian architect Cavaliere Nolli designed in 1939. Among these buildings is the Padang, the level grassy park where generations of Britons have played cricket, another relic of the colonial city, though its Cricket Club is still a meeting place for Singapore's upper class. In front of Victoria Theater stands a statue of Sir Thomas Raffles: a copy of the monument has been installed at North Boat Quay,

13

on Raffles Landing, the place where he first docked on the island.

Raffles returned to Great Britain, where he died in 1826. In the British quarter of Singapore, a big hotel was named after him that for over a century was a meeting place for writers and explorers in Southeast Asia and represented one of the British Empire's most evocative vestiges. In 1897, at the Raffles Hotel Joseph Conrad wrote much of his famous novel *Lord Jim*. In later years, Rudyard Kipling, Herman Hesse, Somerset Maugham, André Malraux, and Noel Coward all stayed there and drew inspiration from the ambience. In the mid-1900s, the American novelist James Michener wrote that "to have been young and had a room at the Raffles means having got the best out of life." The hotel was completely restored in 1991, and the rooms decorated with colonial furniture, prized textiles, and teak floors that open onto veranda corridors overlooking an internal garden packed with tropical plants.

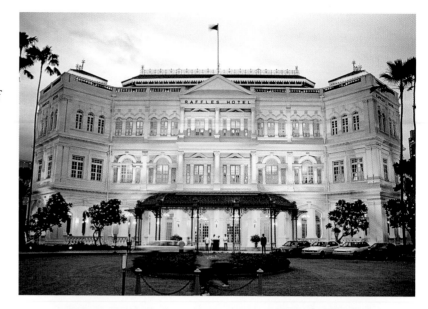

Singapore is in many ways a myth that withstands time, amplified by its exoticness as a garden city. In 1883, the most prolific Victorian-era travel writer, Isabella Lucy Bird, described Singapore as "a world of wonders that appear at every step. Mangroves immersed in the water and tufts of coconut palms and groves of banana, mango, durian, and lime trees with orchids. Lush, profuse vegetation that envelops and almost suffocates, full of every brilliant shade of green." Even today, though affluence and demographic pressure (4,354,000 inhabitants on just 267 square miles, counting those reclaimed from the sea) have multiplied the amount of asphalt and concrete, Singapore deserves to be called a garden city. It boasts the Botanic Gardens on Cluny Road with thousands of species from both humid and dry climates. Elsewhere, the well-maintained trees along the avenues and in the parks mingle with the scent of frangipani, an infinite variety of palm trees, cascades of brightly colored bougainvilleas, and bushes of red, yellow, and variegated hibiscus. The lively vegetation, the result of Singapore's geographical location just north of the equator and two distinct monsoon seasons (December to March from the northeast and June to September from the southwest) that hit the island with abundant rains are the cause of an undeniably humid tropical climate.

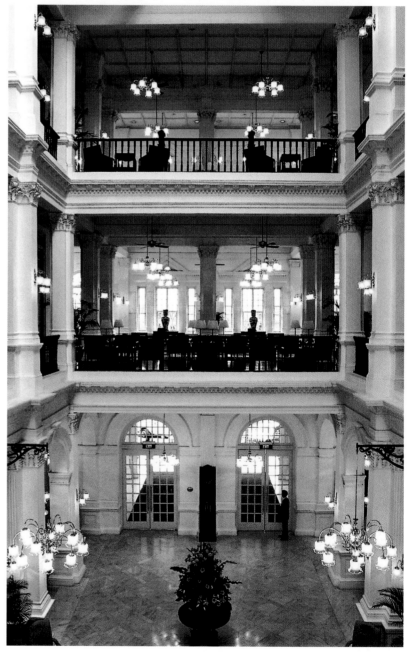

This climate is in part the result of environmental choices. Singapore is one of only two cities (Rio de Janeiro is the other) that have incorporated and preserved within their urban area a patch of rain forest: the 405 acres of Bukit Timah Hill, located on the island's highest point have been transformed into a national park with paths that lead visitors to exotic birds, butterflies, squirrels, flying lemurs, and rare plants like the carnivorous pitcher plant. Meanwhile, the Oriental gardening tradition triumphs in the Chinese and Japanese Gardens, a replica of a Sung-era Chinese garden with bridges, pagodas, a tea house, and a stone boat reflective of the Zen precision of Japanese gardens with its stone lamps, hills, and landscaped rock gardens.

Singapore's economic boom began at the start of the 1900s, the result of initiativess and technologies that had revolutionized the world in the second half of the 1800s. The opening of the Suez Canal in 1869 increased traffic coming through its port, and the creation in 1862 of a telegraph line between Sydney and London – crossing the British possessions of Singapore, Bombay, Aden, Suez, and Malta – made the city

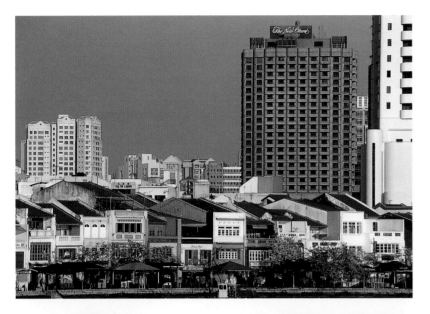

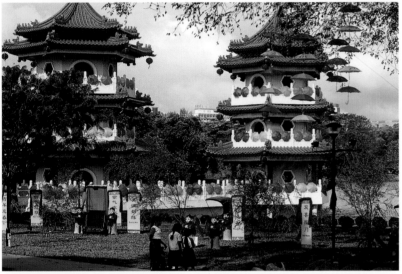

a communications hub, and it became ever more prosperous. From China, starving in the aftermath of a series of wars, ever greater numbers of immigrants arrived, until the followers of Confucius finally became the majority among the population. Business deals of all kinds proliferated, and alongside the legal commerce, brothels, gambling houses, and opium dens multiplied.

The Chinese today represent 76 percent of the inhabitants versus 14 percent of Malaysians, 8 percent Indians, and about 2 percent between Westerners and Peranakan. This last group is a minority born of the multiethnic mingling of colonial Singapore: its members are the offspring of mixed marriages between Chinese, Malaysians, and Europeans. This blend of elements from the three cultures has also influenced cuisine, decoration, clothing, and architecture. Manifestations of the Peranakan culture can be encountered on East Coast Road, where the exterior of the houses are decorated with floral-design majolica panels, and Katong Antiques House represents a middle ground between a museum and an antique shop with batiks, clothes, furniture, sculptures, and porcelain.

It is a melting pot without tensions, even from a religious point of view: the syncretism between Buddhism, Taoism, and Confucianism at the base of the Chinese faith lives alongside the moderate Islam of the Malaysians, various Christian denominations from the West, and Hindu and Sikh minorities from India. Four official languages are in use: Chinese, English, Malay, and Tamil. The streets are invaded indiscriminately by paper dragons and fireworks for the Chinese new year, thousands of lights for the Hindu Deepavali, and mass prayer sessions at the end of the Muslim Ramadan. Regardless of the holidays, languages, and religions, the Chinese majority dominates the scene and determines the dominant culture. A local saying claims that the Chinese are like the gin in a Singapore sling (the famous cocktail invented at the end of the 19th century by Ngiam Tong Boon, a bartender at the Raffles Hotel): they are the city-state's main ingredient. The Malaysians are like the cherry brandy, the Indians like the lime juice, the Westerners like the bitters, and the Peranakan like the Cointreau, all liquors and aromas that enhance the flavor of the gin in the long drink. Jokes aside, Singapore's most recent history and its extraordinary economic success result from the encounter and combination of the Confucian ethnic group (based on pragmatism, moral and social order, studiousness, obedience to authority, and respect for elders and the cult of the ancestors) and investments from the Chinese Diaspora with the British mercantile spirit.

After the Japanese invasion of Singapore during World War II, its liberation in 1945 by a British-Indian army, and the post-war economic crisis, the People's Action Party came to the fore. Headed by the third-generation Chinese politician Lee Kuan Yew, the party led the country to independence, first as part of the Malaysian Federation and then, after 1965, as a totally autonomous entity. Father and creator of modern Singapore, Lee Kuan Yew subdued the socialist tones of his party and opened the country up to foreign investment, oriented around a sort of "authoritarian democracy" called Great Harmony, based on the nationalist and patriarchal values of Confucianism and a free market accompanied by efficient social cushions. Lee Kuan Yew shaped a government

14 top The expansion of the Raffles Hotel, whose princely façade in Late-Victorian-Italianate-Revival style dates back to 1899, mirrors the development of Singapore. Now among the world's most legendary hotels, the Raffles started off in 1887 as a simple bungalow with ten rooms.

14 bottom The three celebrated floors of the Raffles, which look onto the central lobby, have witnessed the passage of world-famous kings, princes, actors, artists, and writers. The hotel has been a National Monument since 1987.

15 top Singapore's Boat Quay presents the umpteenth image of architectural contrast, between the little pastel-washed houses along the riverbank and the tall monochromatic hotels behind them.

15 bottom The sophisticated charm of a 10th-century Chinese garden lives again in Singapore's splendid Chinese Gardens, where, among the lush and

well-kept greenery, visitors can encounter pagodas, gazebos, ponds, and "hunchbacked" bridges. In addition, the park holds events and contemporary art exhibits in some cases based (as shown here) on the spectacularity of color.

16-17 This young man wears make-up and traditional Chinese clothes to take part in one of the many lunar calendar holidays regularly celebrated in Singapore, where Confucian doctrine is the basis of the dominant culture.

18 A fakir, his tongue and chest pierced by pins, participates in the Thaipusam procession in Little India, one of numerous festivals organized by Singapore's Hindu community.

18-19 Following a custom widespread throughout southern India, many Hindu temples in Singapore have a central gopuram, a big votive tower decorated with colorful sculptures of divinities venerated by the Tamils.

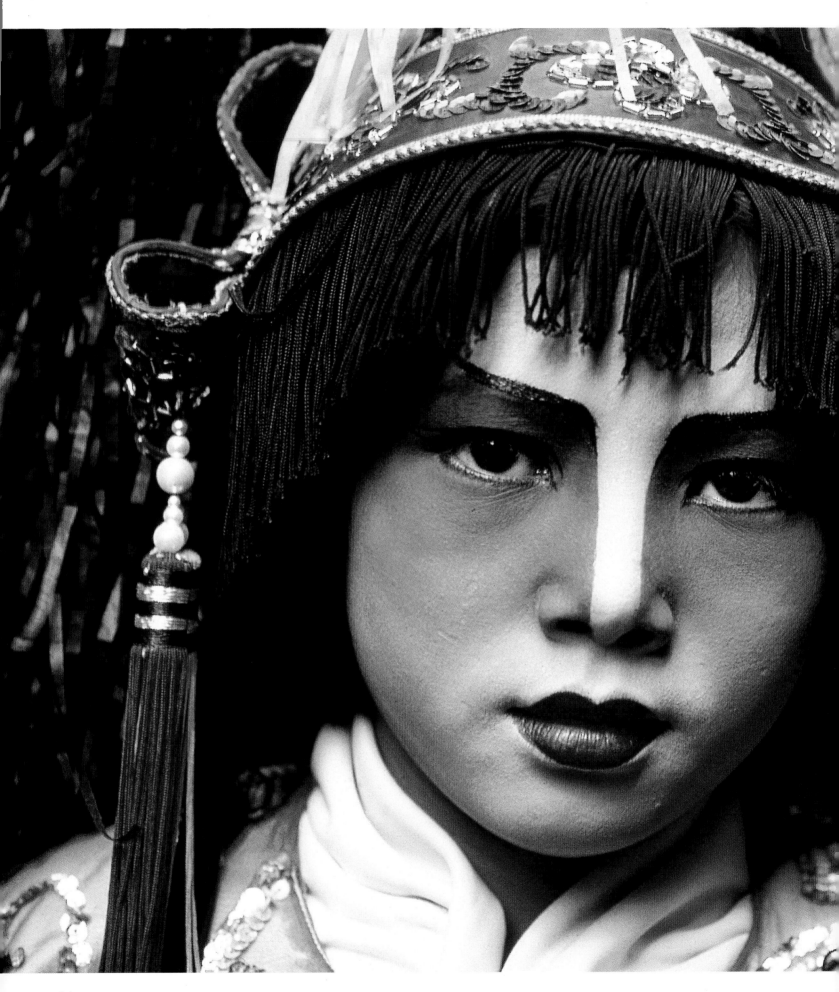

as efficient at providing services to its citizens as in planning their lives. Unemployment does not exist. The state guarantees health care, education, housing (90 percent of the population today live in houses they own), and pensions. However, the city's unconventional halo is dimmed by the death penalty (enforced for drug possession) and by the destruction of the streets where women and transvestites used to practice prostitution. Incentives are provided for study, free enterprise, and risk-taking ventures. At the same time, strict rules are imposed regarding traffic, hygiene, and many aspects of public life. Crime has disappeared: Singapore is one of the safest cities in the world; women can walk around in the middle of the night without any fear. In the 1980s, the growing economy fed the construction boom that led to the destruction of a good part of old Chinatown in order to make way – in the Central Business District and Orchard Road areas – for skyscrapers, banks, offices, hotels, and shopping centers. Manufacturing and construction corporations, service industries, and communication companies have been added to the activities of the port and financial sectors. In the first half of the 1990s, the economy of Singapore exploded, and within a few years its currency doubled in value against the dollar and European currencies, affluence was on the rise, and the small city-state became one of the richest and best-organized countries in the world, a condition that not even the grave Southeast-Asian financial crisis of the late 1990s could touch. What remains of Chinatown revolves around South Bridge Road. There are Confucian temples, pagodas with curved roofs in which worshipers burn incense and replica bank notes in honor of their ancestors, like Thian Hock Keng, meaning temple of heavenly happiness, on Telok Ayer Street, built in 1821 and dedicated to Ma Chu Poh, the heavenly sea goddess who protects sailors and fishermen. A number of masterpieces of Chinese culture, from the Neolithic period to the Ming dynasty, are on display at the Asia Civilization Museum. In Chinatown, old restored Chinese houses featuring façades repainted in bright colors can be seen, in stark contrast with the futuristic austerity of the skyscrapers. Sago Lane is noteworthy with its little, pastel-colored, late-19th-century houses inhabited by professionals.

Modernity has not erased the ancient Chinese teachings. At the Imperial Herbal Restaurant, a doctor takes his clients' pulses as he listens to their problems in order to suggest rejuvenating menus: icy root drinks to absorb fats, invigorating ginseng soups, and shrimps sautéed with energizing nuts and grass gelatin to lower internal temperatures. In Sago Street, some pharmacists, specializing in Chinese phytotherapy, sell oils to cure any ailment through massage: cinnamon oil relieves rheumatic pain, eucalyptus oil heals burns and insect bites, and nutmeg flower oil eradicates any abdominal pain. On the same street – among ever-present bird cages – are found ceramic and porcelain shops. A few steps in any direction bring visitors to swarming food markets, myriad street vendors, and alleys overflowing with the workshops of engravers, calligraphers, typographers, shoemakers, and master craftsmen fabricating masks and dragons from paper for the holidays of the lunar calendar. Then, there are almond-eyed dealers who import antique furniture from China to South Bridge Road, the same avenue in which the Sri Mariamman Temple is found, the main Hindu sanctuary with its brightly colored statues of gods and Brahmin priests performing rituals with spices, coconut oil, and fire.

The Indian community, however, does not live there but rather orbits around Serangoon Road, in a neighborhood nicknamed Little India, where the scent of curry wafts around the jewelry stores, saris, silks, sacred dirges, bronze pieces, cheap guest houses, Hollywood films, and vegetarian restaurants serving, spicy vegetables on banana leaves, in perfect Tamil style. Though the extreme cleanliness, high technology, and air conditioning sometimes create an antiseptic atmosphere around Orchard Road, Little India by contrast offers all the color, olfactory stimulation, and commotion of the Orient. Strolling down Serangoon Road, among the spice and perfume sellers, the visitor can reach the Perumal Hindu Temple dominated by a multicolored Tamil-style *gopuram* (votive tower), where an automatic Coca-cola machine can be glimpsed among the *puja* (Hindu prayers), incense smoke, and images of Vishnu. Nearby is the Central Sikh Temple, a design masterpiece built in 1986 featuring a dome 43 feet in diameter, in addition to being a place of

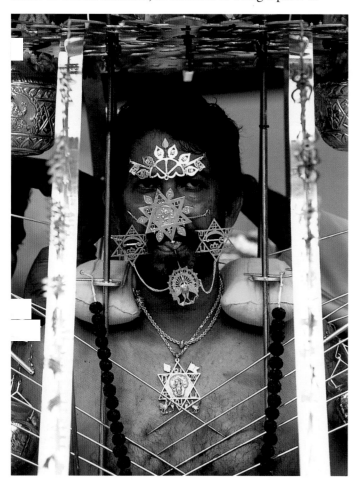

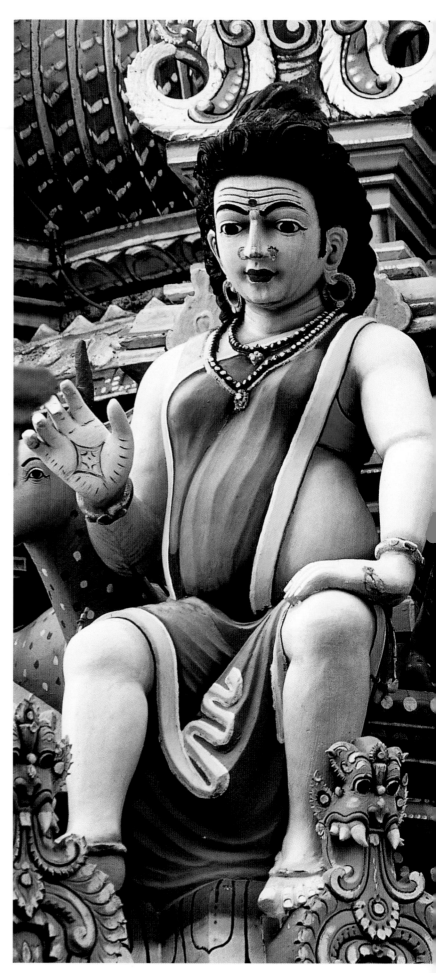

worship for the 15,000 Indians of the Sikh religion who live in Singapore. Then, there is a memorial dedicated to Mahatma Gandhi in Race Course Lane and a Burmese Buddhist temple in Tai Gin Road.

A few blocks south of Little India is the Muslim quarter – bordered by Arab Street, Beach Road, and North Bridge Road – with mosques, veiled women, *kilim* and Persian-carpet shops, Malaysian coffee, textile markets, and basket weavers with handicrafts in rattan, bamboo, and wicker. The scene here is dominated by the domes of the monumental Sultan Mosque, the largest in Singapore, completed in 1928.

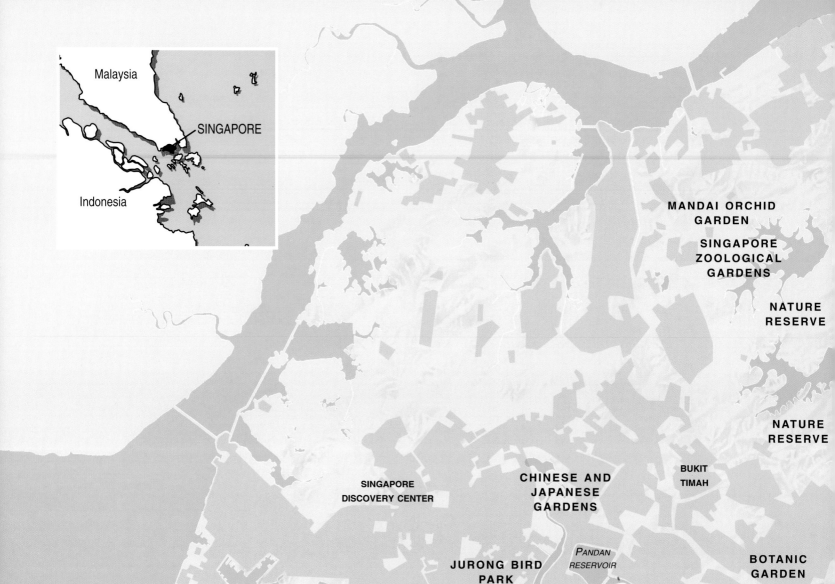

Malaysia

SINGAPORE

Indonesia

MANDAI ORCHID
GARDEN

SINGAPORE
ZOOLOGICAL
GARDENS

NATURE
RESERVE

NATURE
RESERVE

SINGAPORE
DISCOVERY CENTER

CHINESE AND
JAPANESE
GARDENS

BUKIT
TIMAH

*PANDAN
RESERVOIR*

BOTANIC
GARDEN

JURONG BIRD
PARK

*STRAITS OF
JURONG*

22-23 *"Where history and culture
merges": thus goes the motto of the
Asia Civilization Museum of
Singapore, an important institution
founded to exhibit the city's ethnic
heritage from Southeast Asia and
China, with particular emphasis on
the Peranakan cultural mix, which
blends local, Chinese, and Western
influences. The museum also offers
pan-Asian exhibitions of ancient and
contemporary art.*

24-25 *A characteristic feature of the
Chinese New Year, an enormous
dragon, a true masterpiece of the art
of working with paper so beloved by
East Asia's various peoples, is carried
in a parade by a group of skilled
technicians in the area of the Chinese
Garden. Given the exquisitely
"Heavenly Empire" setting, no better
place could be found to celebrate this
traditional festival of the Chinese
calendar.*

N

CHANGI INTERNATIONAL AIRPORT

LITTLE INDIA

COLONIAL DISTRICT/ PADANG

ARAB STREET

MALAY VILLAGE

BOAT QUAI

BUSINESS DISTRICT

MARINA BAY

CHINATOWN

SINGAPORE RIVER

SENTOSA ISLAND

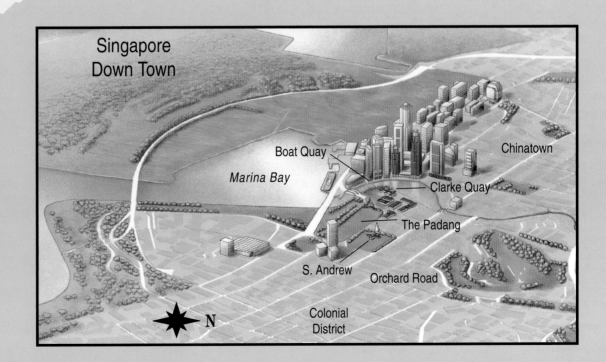

Singapore Down Town

Marina Bay

Boat Quay

Chinatown

Clarke Quay

The Padang

S. Andrew

Orchard Road

Colonial District

N

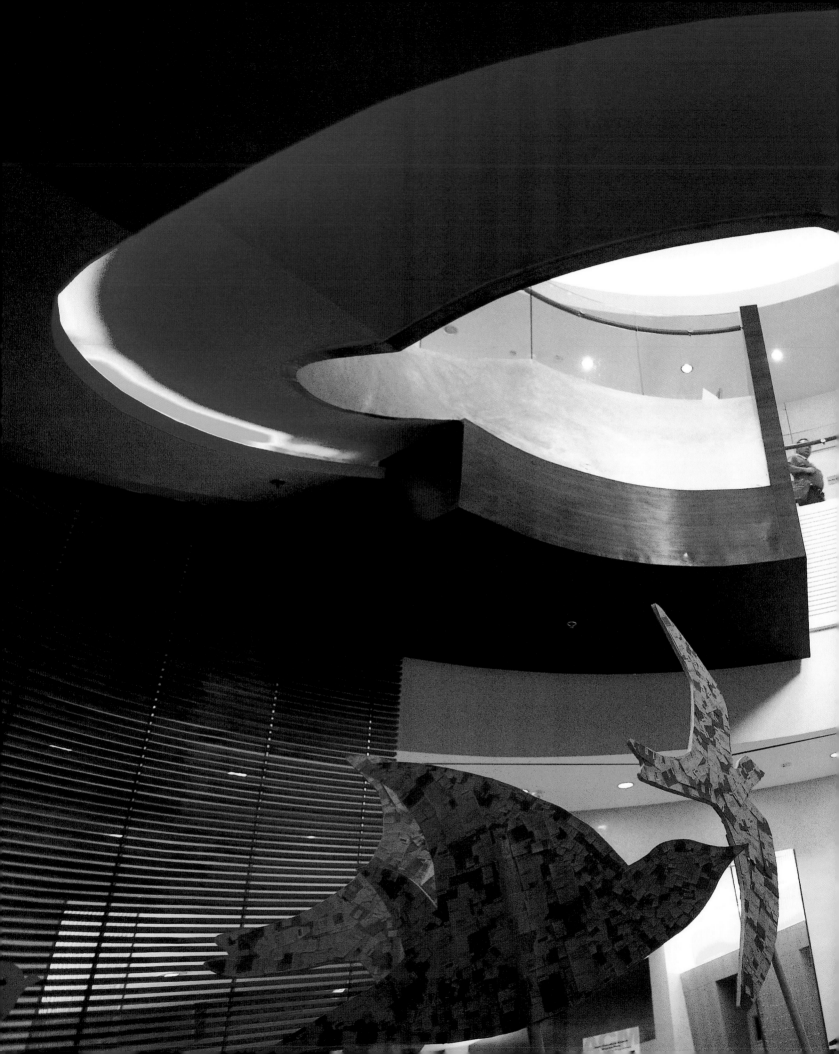

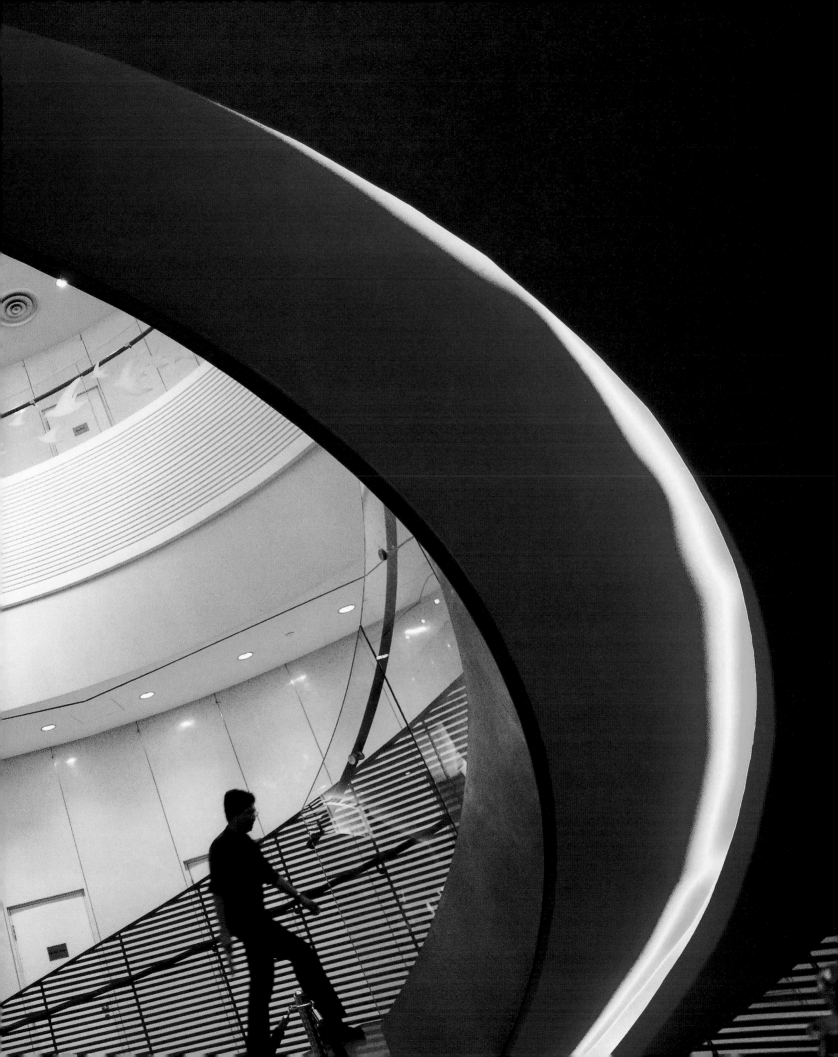

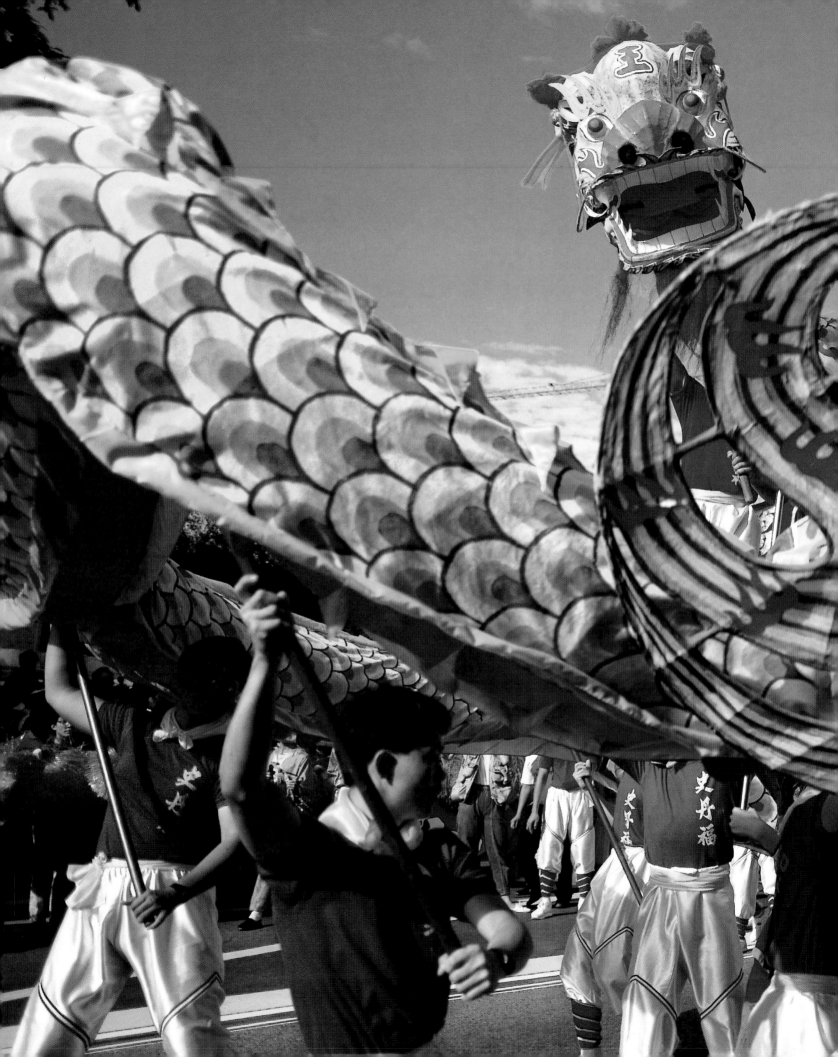

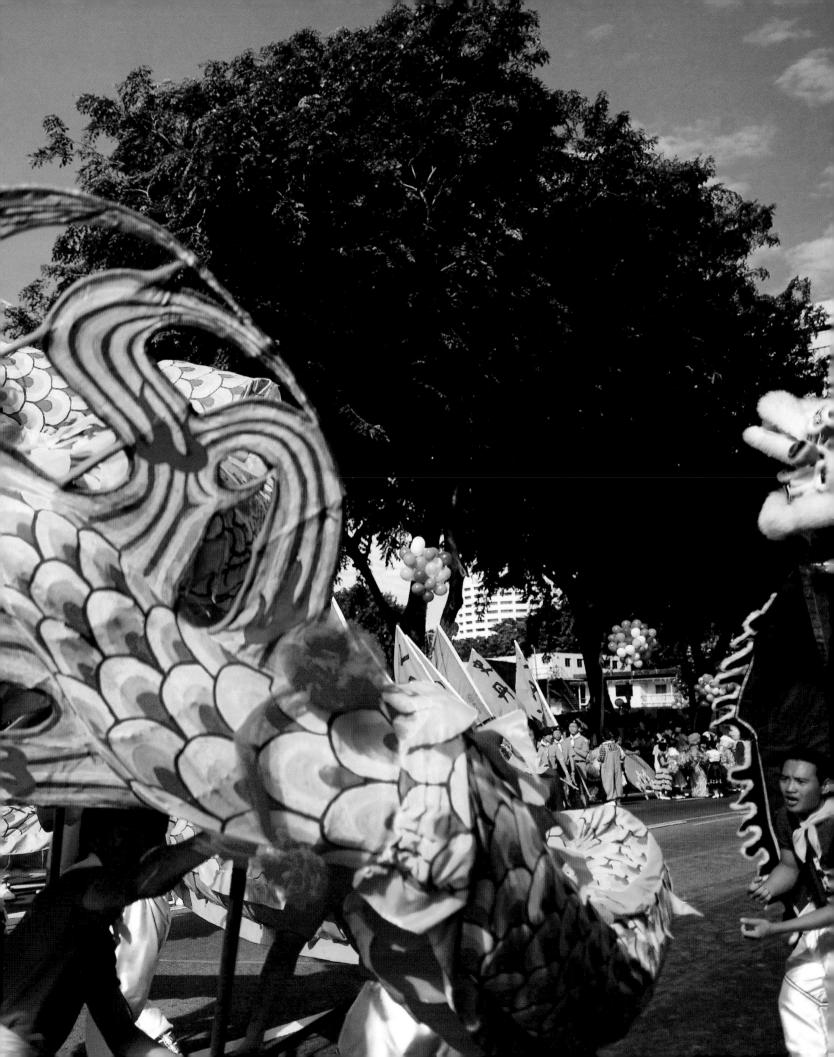

Business District

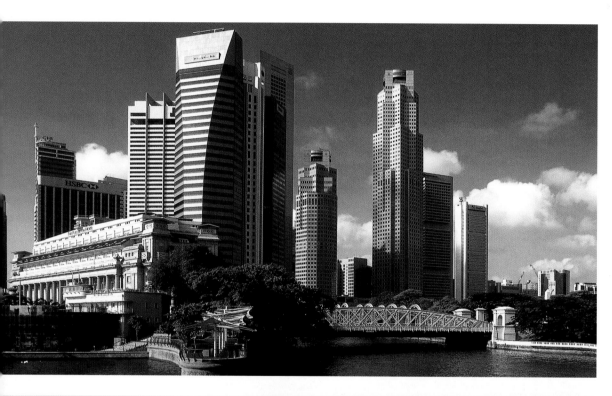

26 left In the Business District's futuristic development, which started to take shape in the 1980s, some of Singapore's early 20th-century bridges were preserved: top, the 1910 Anderson Bridge, bottom, Elgin Bridge, completed in 1929. Their pleasing lines soften the area's otherwise predominant verticality.

26 right Acting as a model of excellence for all of Asia, Singapore takes its inspiration from the urban trends around, embellishing itself with sculptures and hyper-functional street.

27 The skyscrapers that have changed Singapore's profile are concentrated mostly in the Business District. Enclosed by Marina Bay, Chinatown, Orchard Road, and the Colonial District, the quarter has luxury hotels as well as the offices of the maritime companies and the 125 banks from around the world that operate in the city.

28-29 The Central Business District's skyline developed at the expense of the little streets that used to form old Chinatown, once lined by wooden and brick houses.

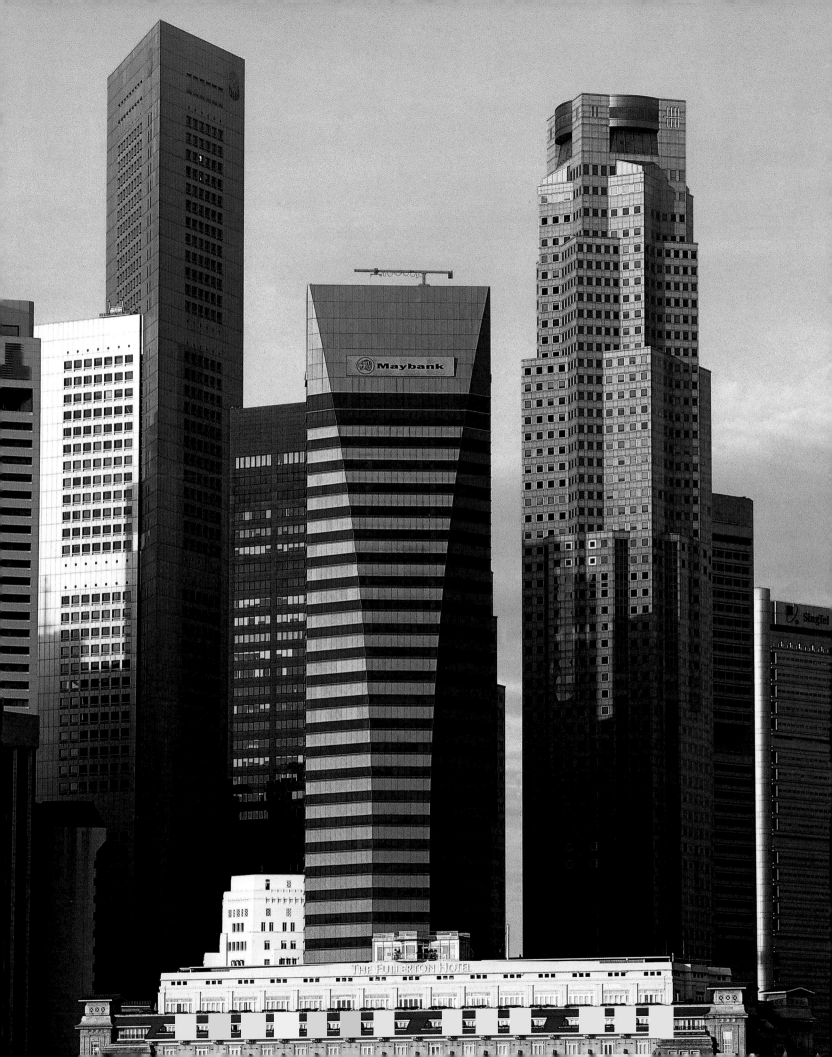

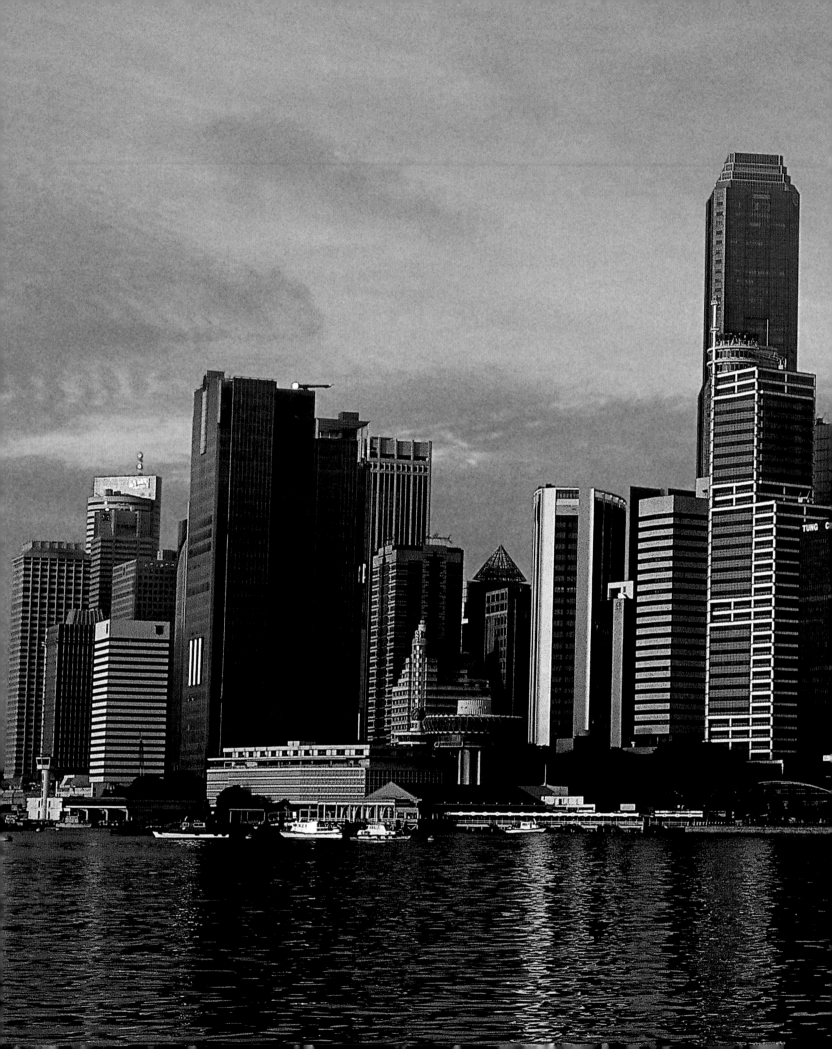

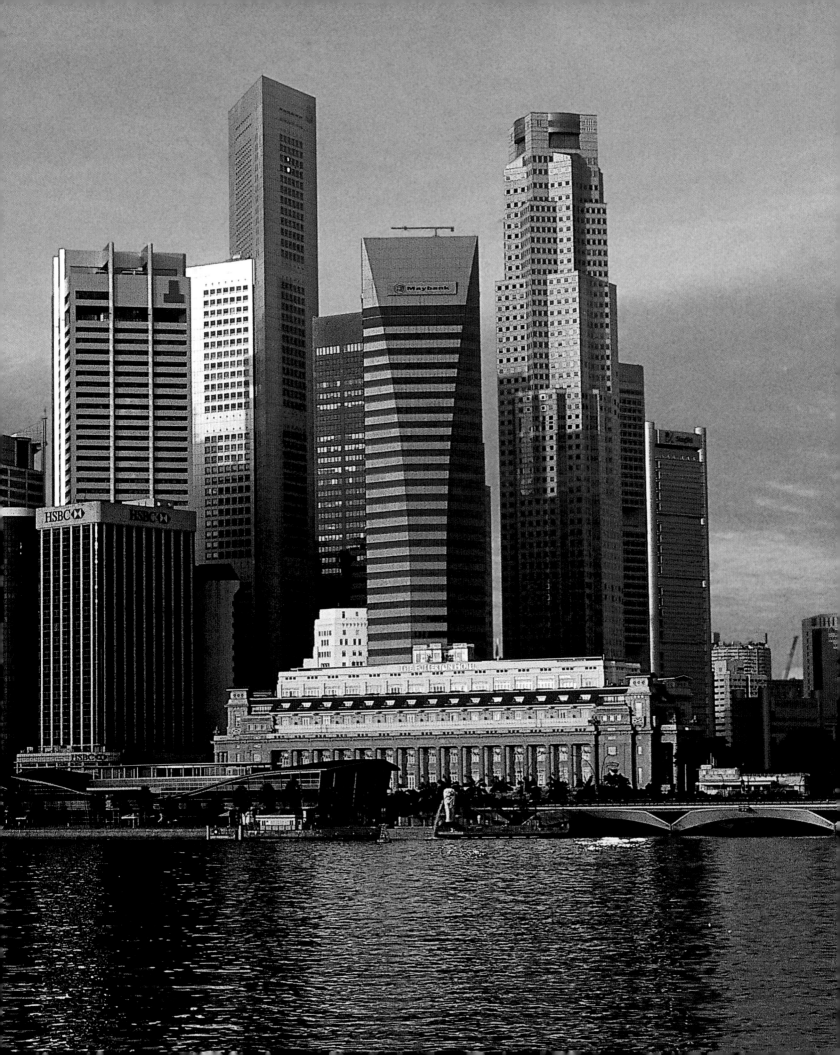

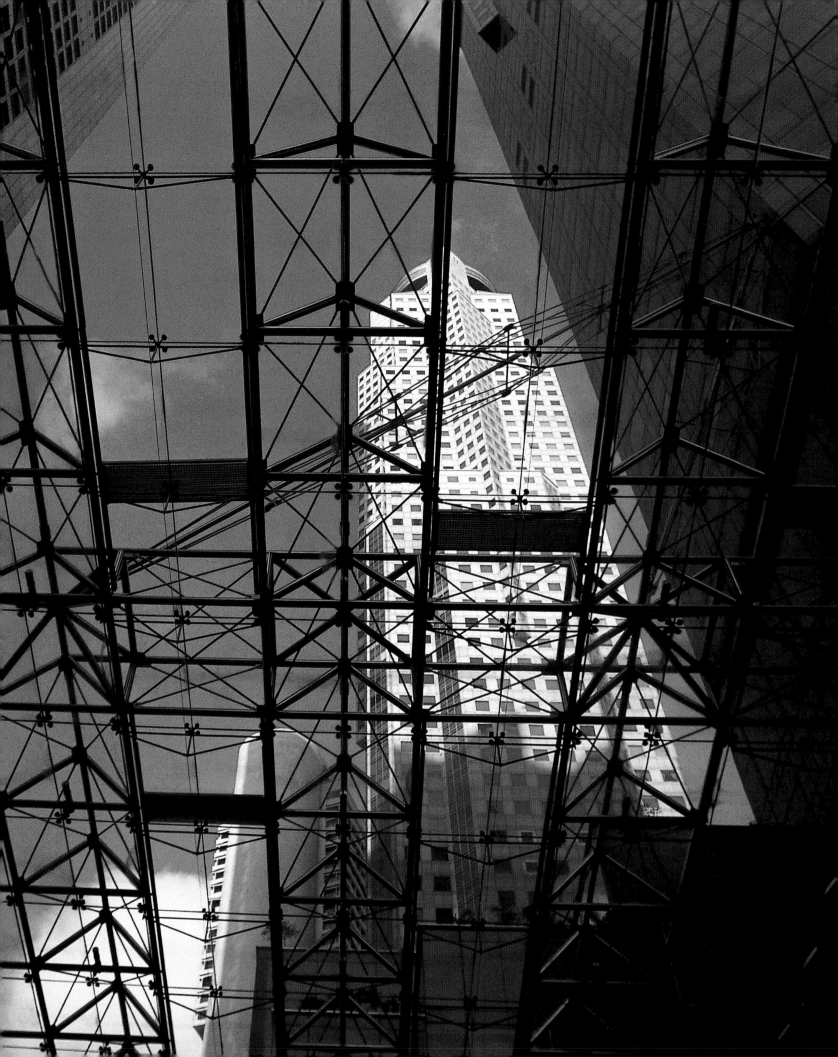

30 The massive composite structure of one of the towers of the UOB Plaza ONE complex rises through 66 floors to 919 feet on Raffles Place. At the beginning of the 21st century, Singapore had more than 3,000 high-rise buildings, to which several hundred have been added.

31 Though it is the result of incessant competition to create innovative skyscrapers in terms of shape and structure, the Business Center cannot boast "giants" of worldwide stature because Singapore's planning code prohibits buildings from surpassing 920 feet (even if a 4,922-foot-tall tower is in the works!).

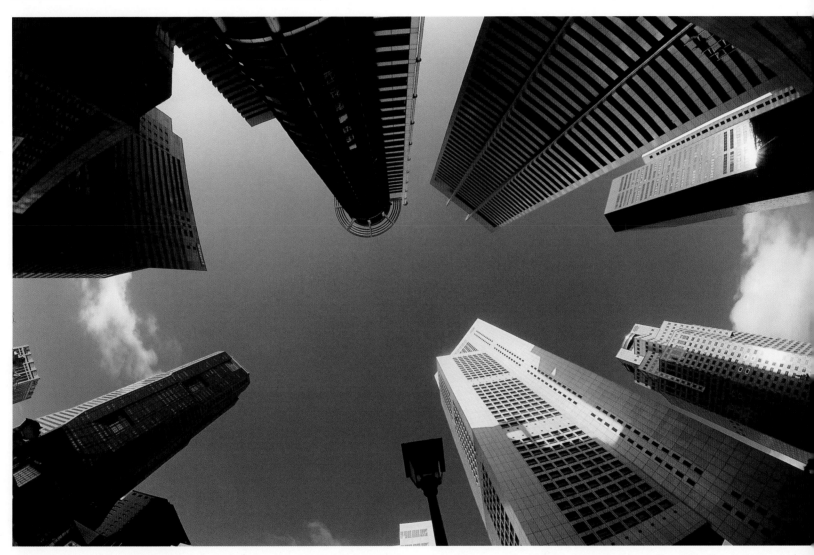

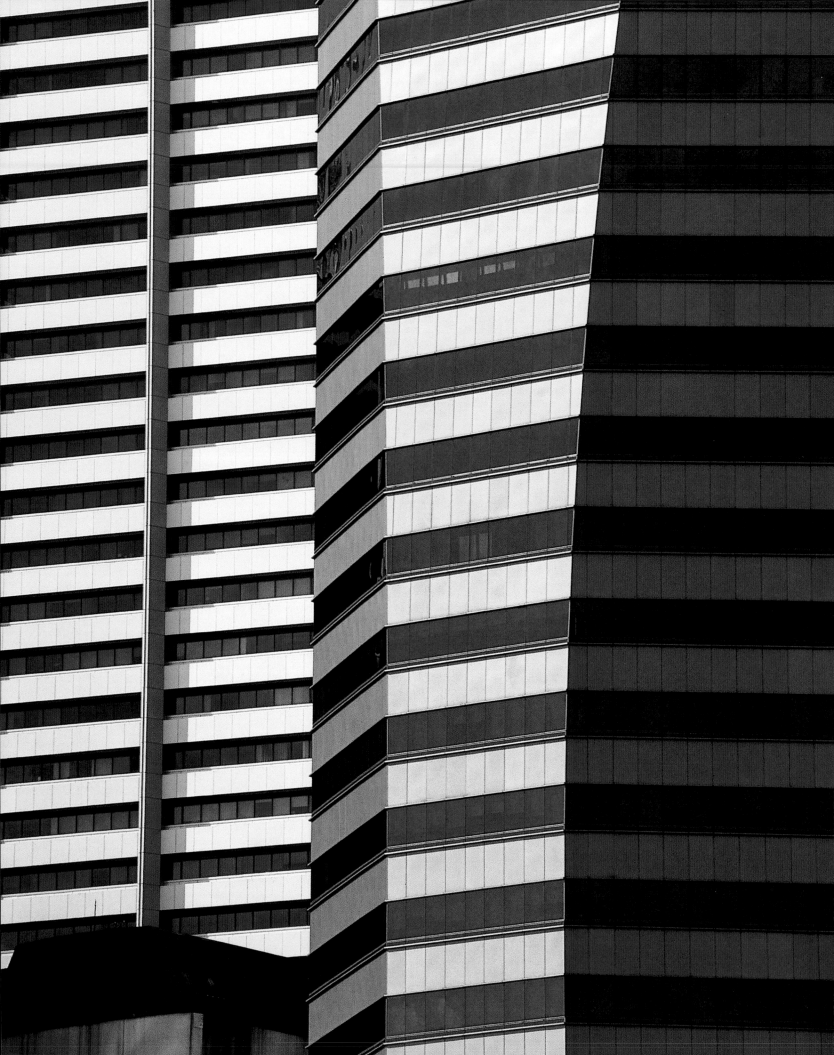

32 Some of Singapore's best examples of modern architecture are found in the Central Business District. Dizzying towers of steel, crystal, and concrete symbolize not only the economic success of the city-state but also its ambition.

33 One of the most fascinating aspects of the Central Business District is the contrast between what remains of the buildings of old Singapore (in this case, Cavenagh Bridge and a colonial Malaysian-style building) and the façades of the skyscrapers.

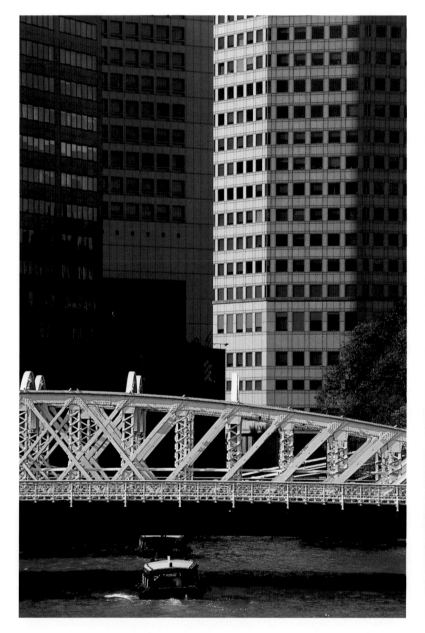

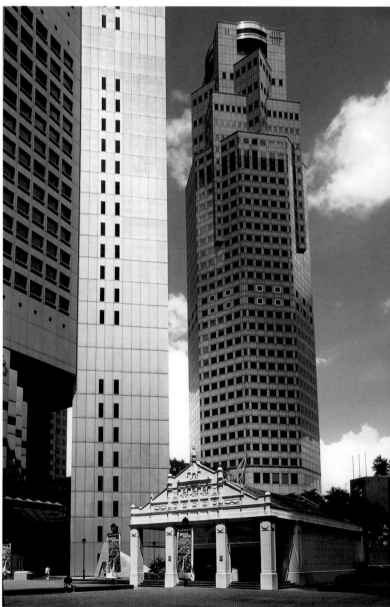

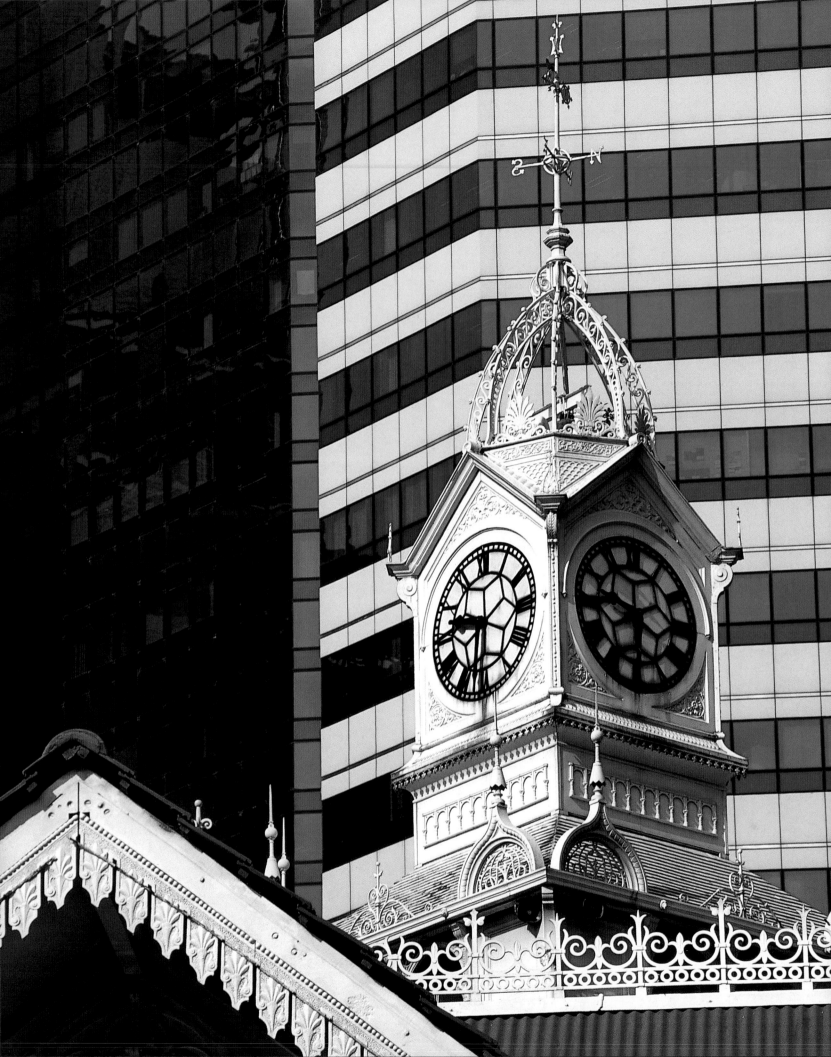

34 and 35 A small white clock-tower of nostalgic design challenges a wall of glass and concrete in the Financial District. The clock-tower marks the location of the Lau Pa Sat Market, one of several that, whether they sell foodstuffs or consumer goods, can still be found in the shadow of early 20th-century structures, despite Singapore's rapid modernization.

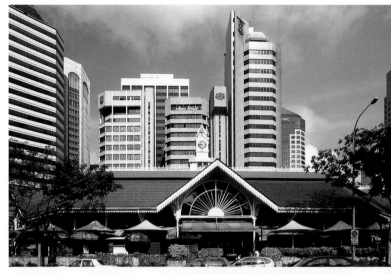

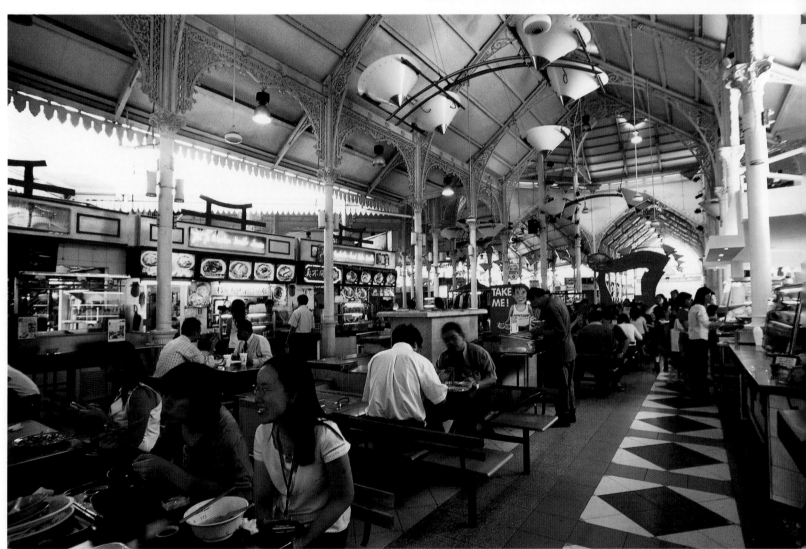

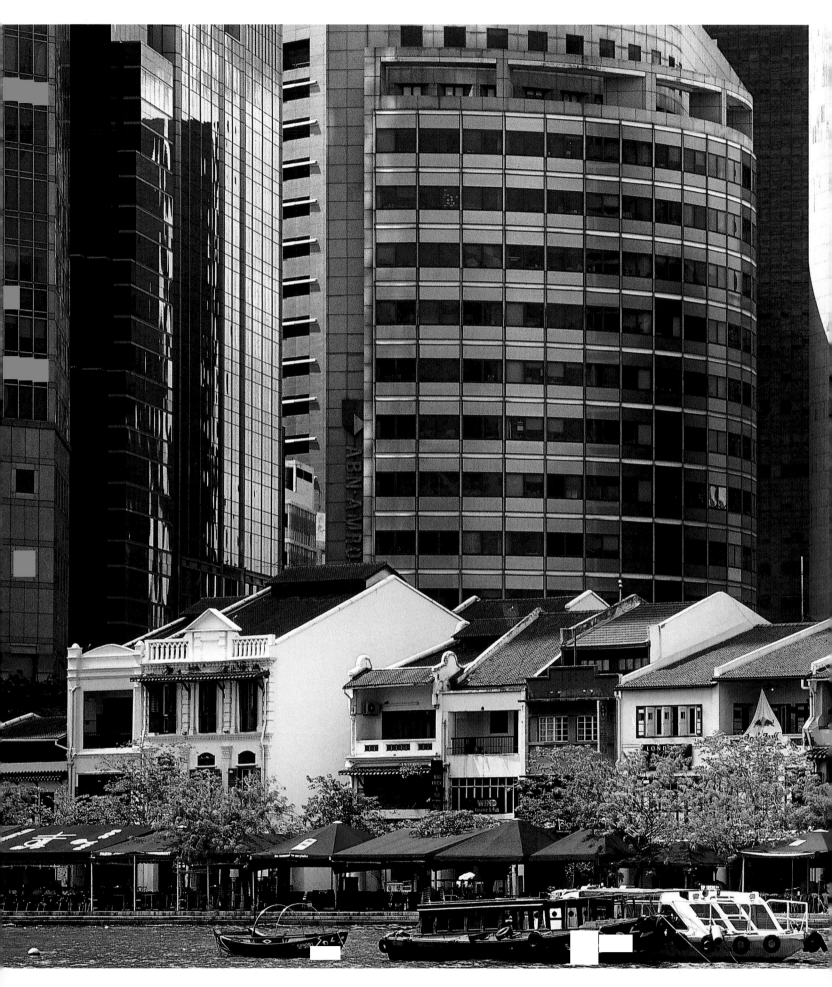

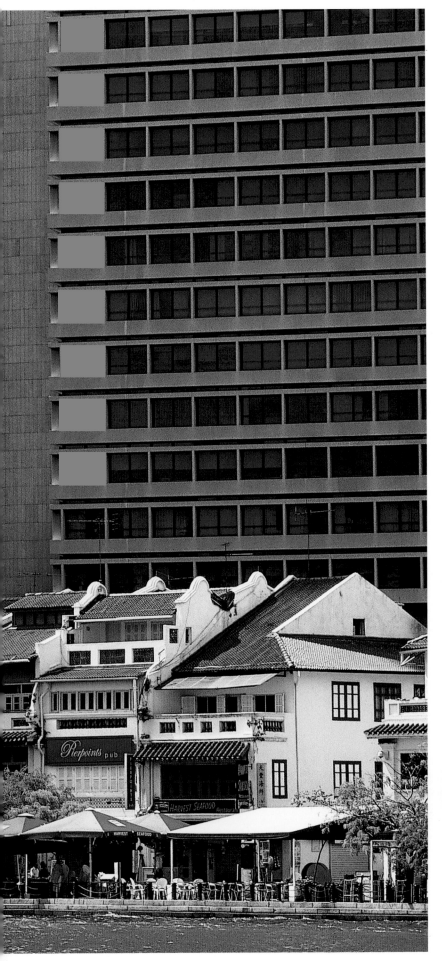

36-37 and 37 Boat Quay, one of the liveliest areas on the banks of the Singapore River, teeming with restaurants and nightlife establishments, well exemplifies the different aspects of Singapore's architecture, or rather, the overlapping of two cities. Colorful little colonial-era houses stand out against modern buildings, creating a vivid contrast between the new and old Singapore.

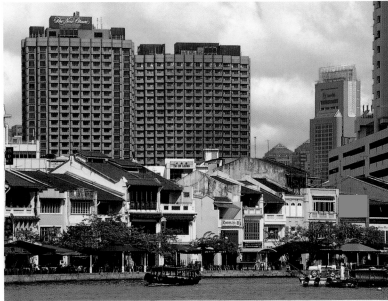

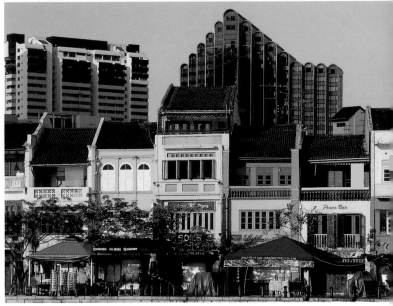

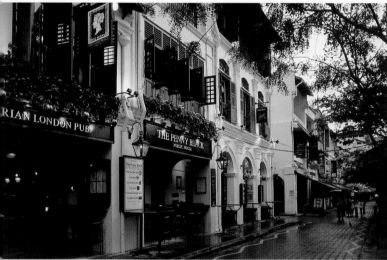

38 The Boat Quay area is crowded with bars and restaurants, open until the early hours. Many have a pronounced Western look, above all British; some feature a Chinese-British mix in appearance, furnishings, and décor.

38-39 The intense green that shines out from this pub's façade immediately brings Ireland to mind; in fact, it is pub in the most traditional Irish style, one among many Boat Quay establishments that perpetuate the Singapore's old cosmopolitan attitude.

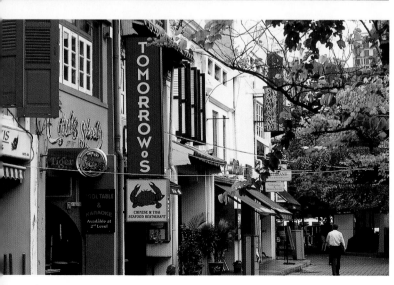

39

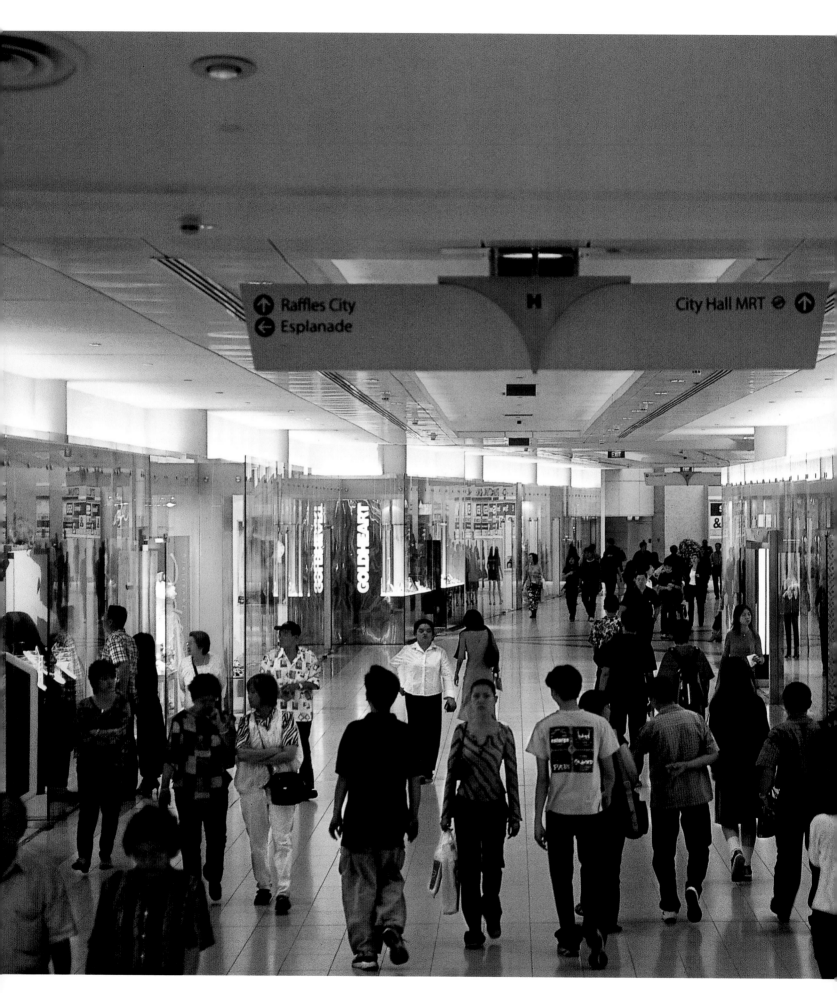

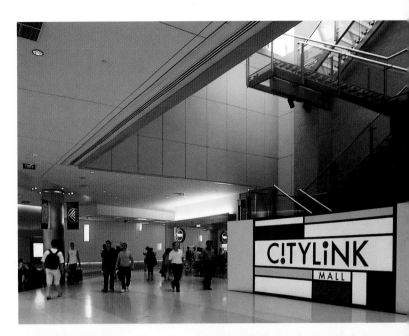

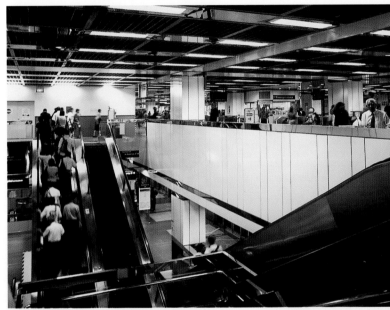

40-41 *Below the Central Business District, a network of galleries and shopping centers has developed. These universes of marble and crystal, often connected by walkways linking them to the skyscrapers above, take advantage of the most advanced architectural methods.*

41 top *City Link Mall represents "all the rage" in terms of underground shopping centers: avant-garde logos, tailor-made artificial illumination, and, of course, "trend-setting" people in the Asian capital of excellence.*

41 center and bottom *A crowd in constantly controlled transit populates the subway stations of the MRT (Mass Rapid Transport). Begun in 1987, the underground transportation system was completed within a few years by using cutting-edge technologies.*

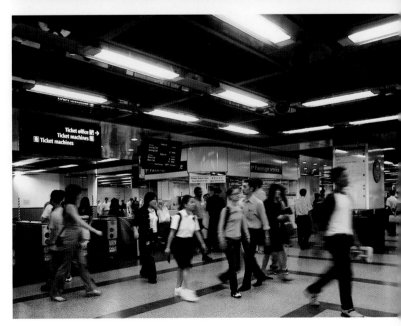

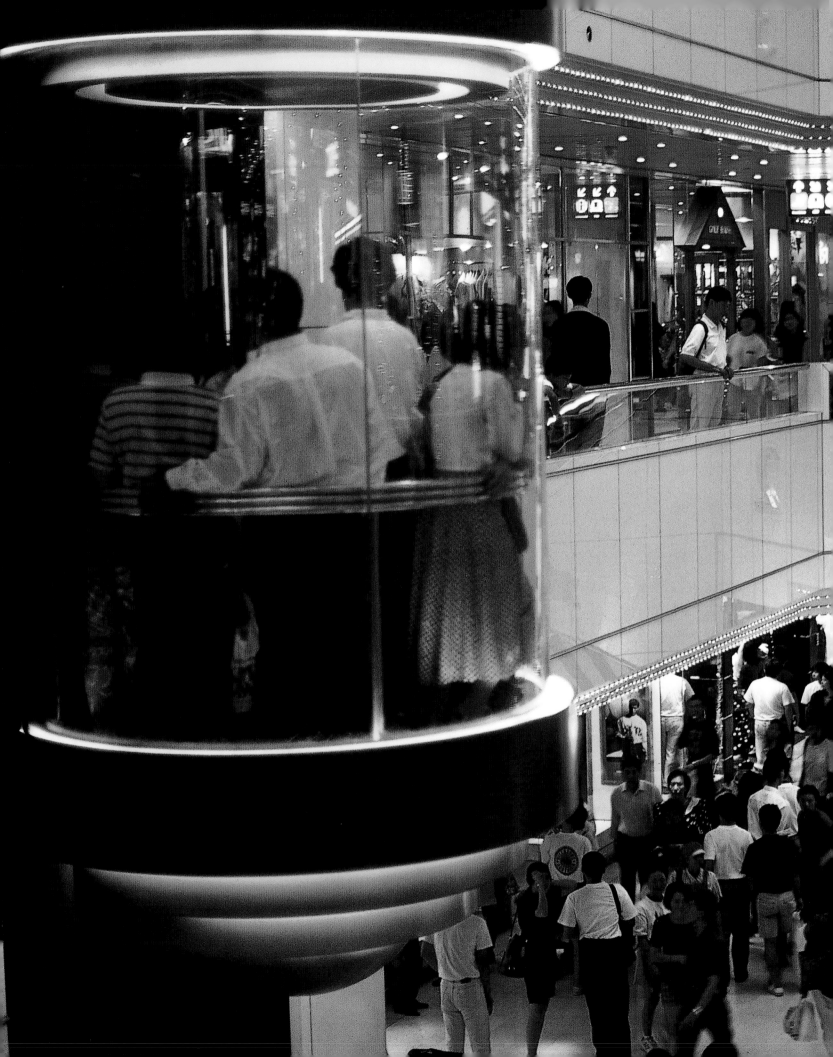

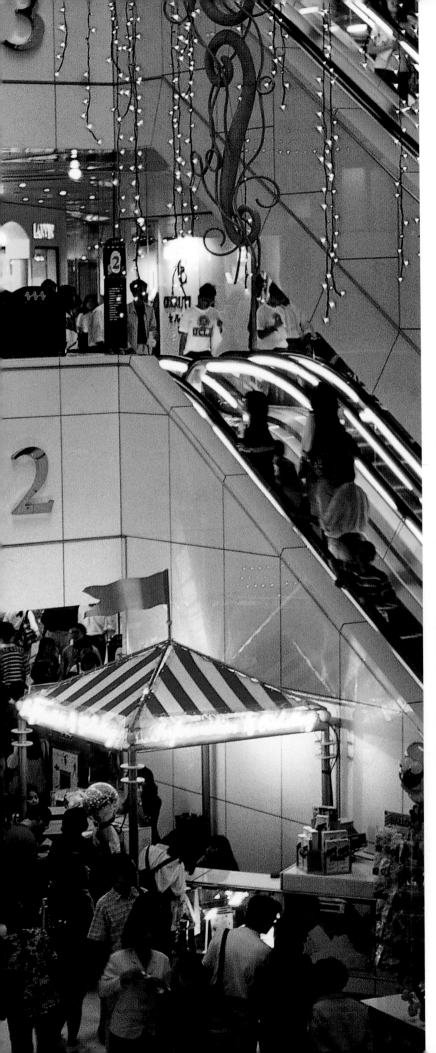

42-43 The empire of sales: Singapore's shopping centers offer end-of-series sales almost year-round, but above all between June and July, when the "Great Singapore Sale" pleases thousands of customers with its low prices.

43 Like classical agoras once did, Orchard Road's shopping malls welcome crowds of people, whether interested or not in buying. Singapore's economic fortune is supported by a happy equilibrium between commerce and culture.

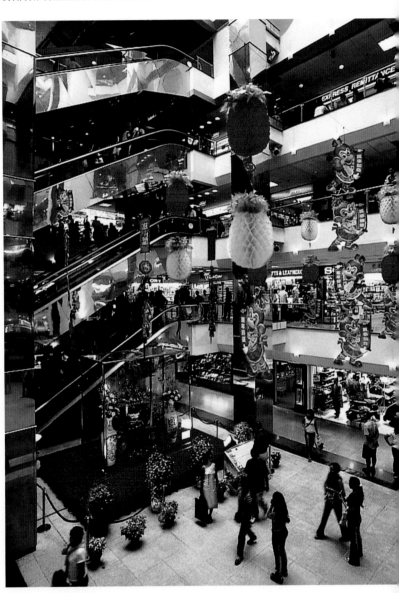

44-45 The warmer, more reassuring golden glow of the Palladian style Fullerton Building, with Cavenagh Bridge on the right, contrasts with the cold neon light illuminating sections of the Financial District's skyscrapers. The Fullerton Building, inaugurated in 1928, was the General Post Office's administrative headquarters until 1996, when it was converted into an ultra-sophisticated hotel, one of the new symbols of Singapore in evolution.

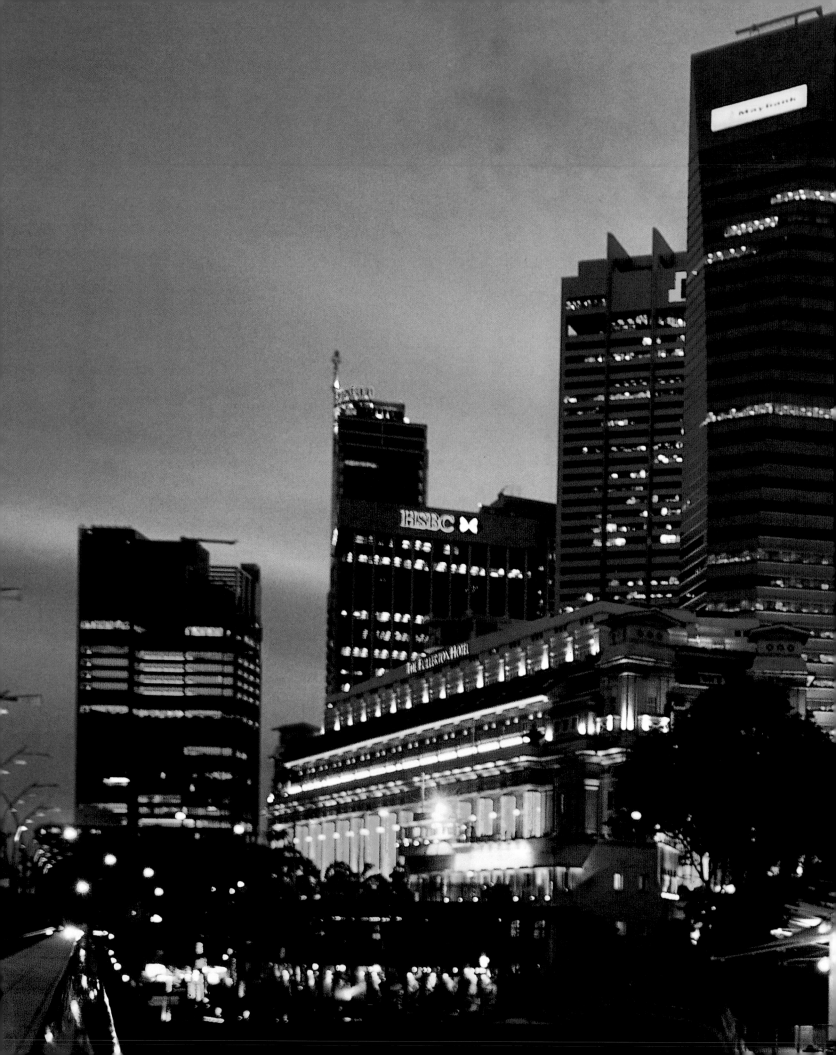

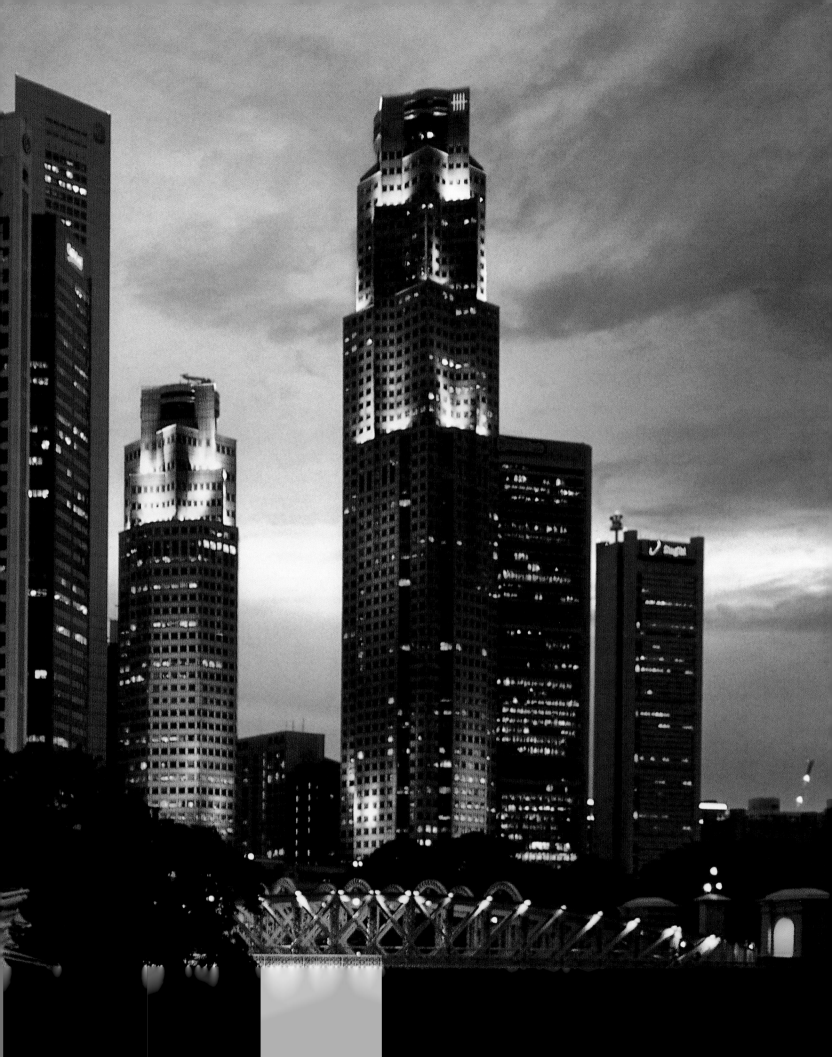

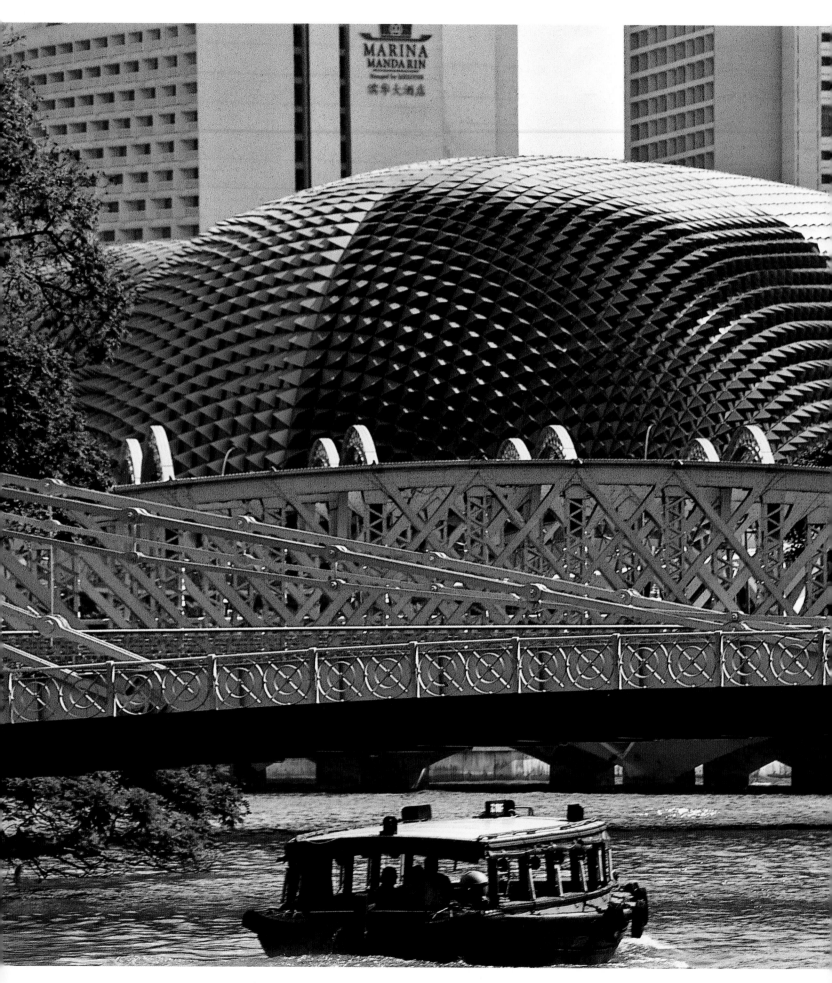

Esplanade and Orchard Road

46-47 *The Esplanade-Theaters on the Bay complex, inaugurated in October 2002, is a multimedia structure with two giant domes towering over a theater and concert halls.*

47 *Facing onto Marina Bay, the futuristic Esplanade-Theaters on the Bay immediately became a cultural emblem for the new Singapore.*

48-49 *Covering 10 acres, the complex encompasses five auditoriums and many inside and outside spaces for musicians and performances, in addition to offices, shops, and apartments.*

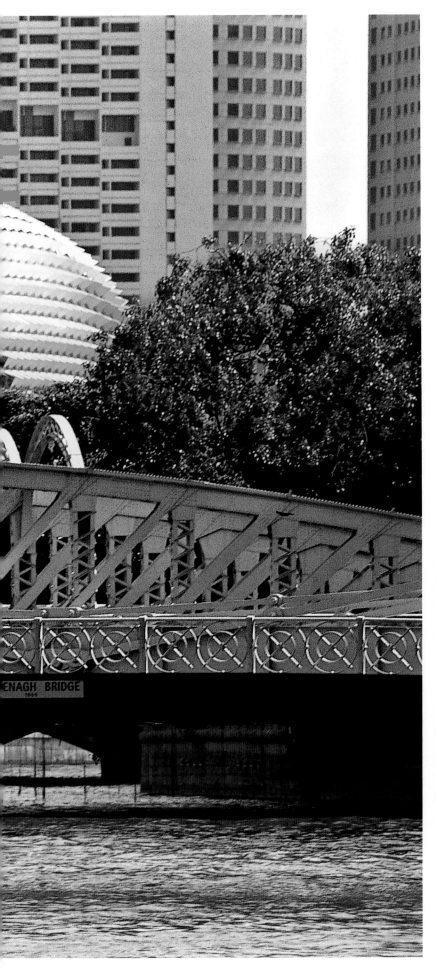

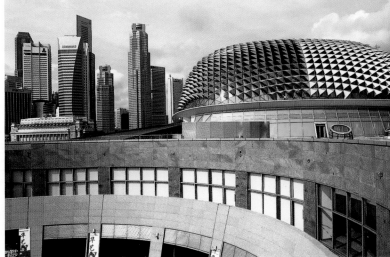

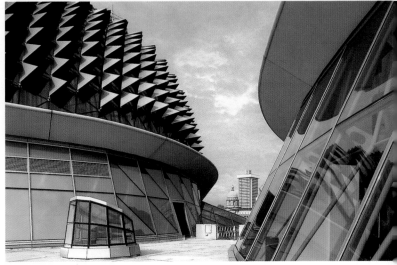

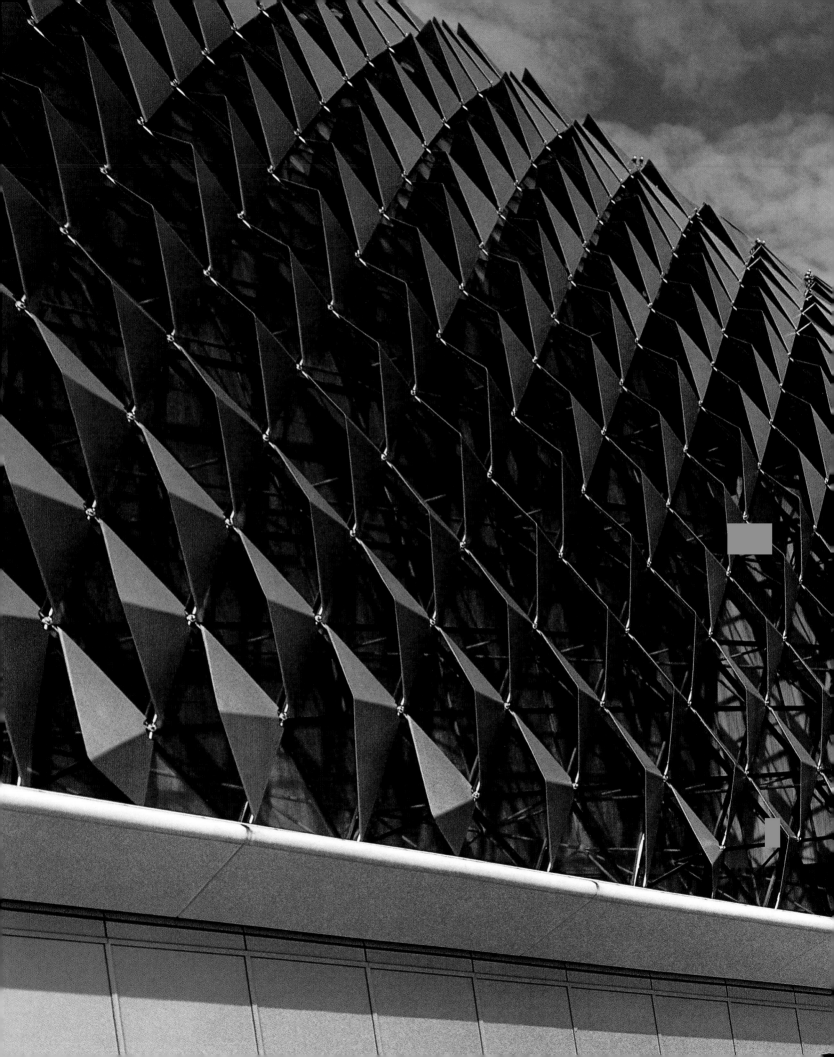

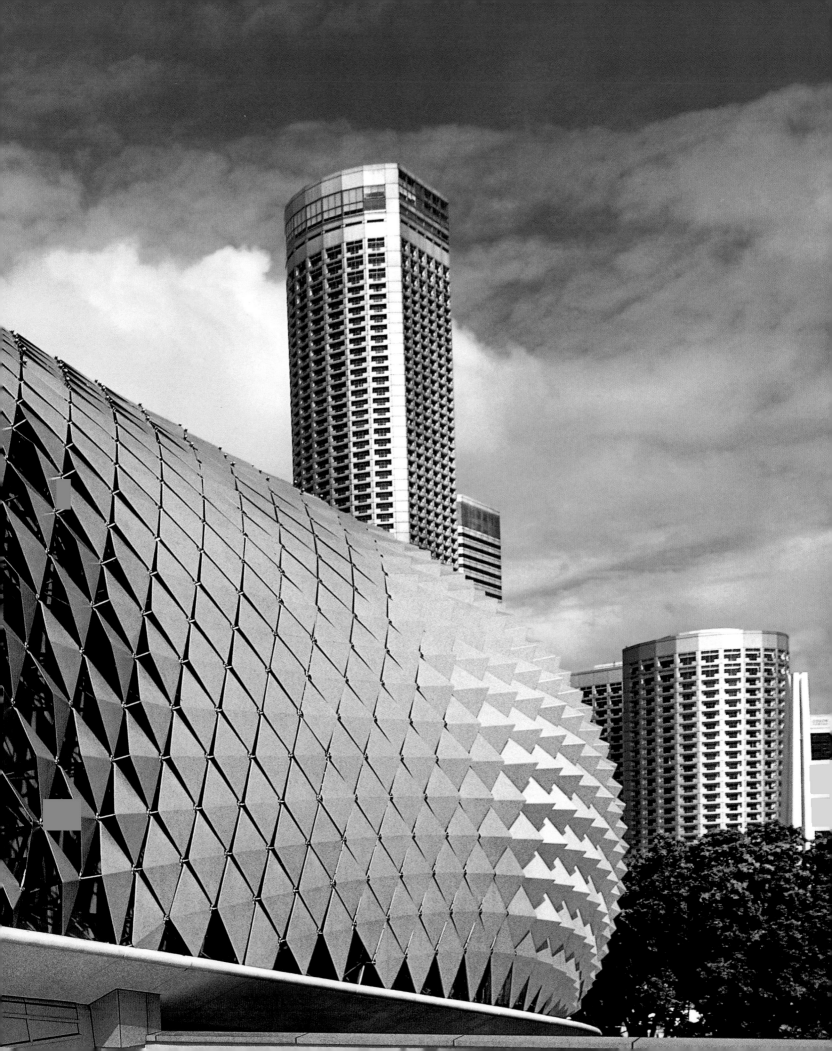

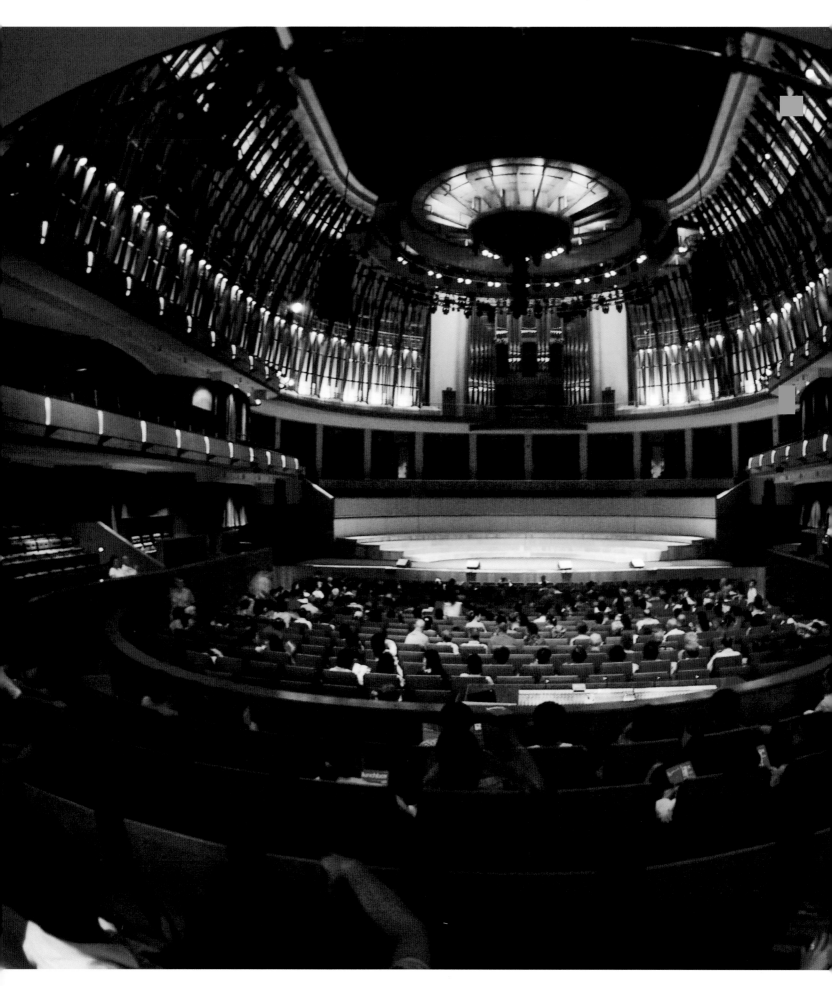

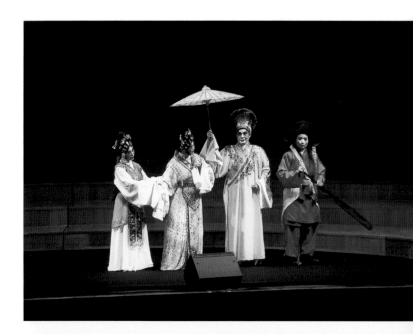

50-51 The Concert Hall of the Esplanade-Theaters on the Bay is the pride of the complex: 1,600 seats on four levels, a sound system that can vary the acoustics according to the music on the program, and 4,740-pipe organ.

51 Chinese opera features frequently among the programmed events in the Esplanade-Theaters on the Bay theater and auditoriums.
The complex hosts all kinds of shows: from plays to dance to concerts to performances to visual arts exhibits. The calendar is also packed with festivals, musical reviews, literary meetings, exhibitions, and professional conventions.

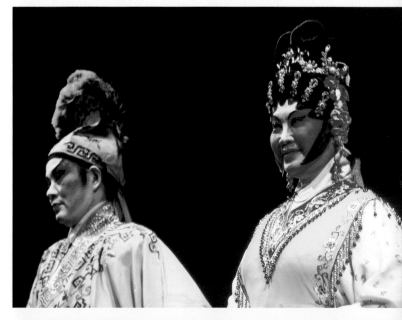

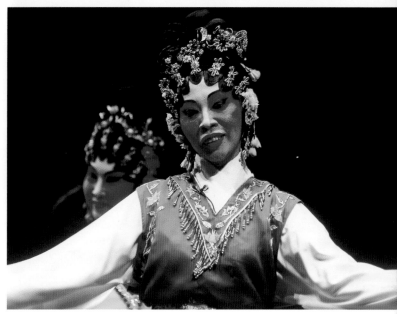

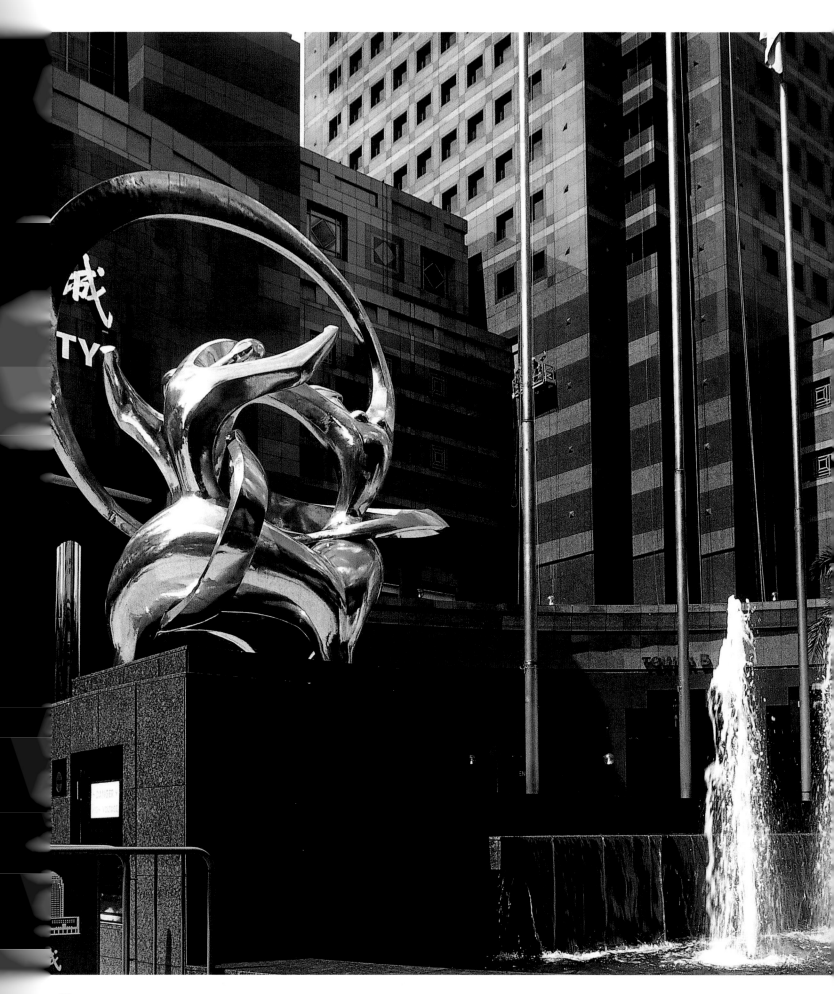

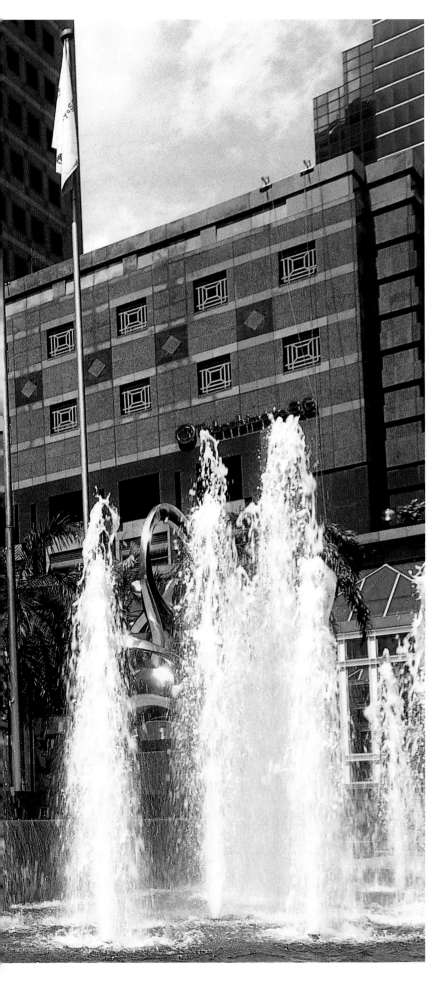

52-53 and 53 Singapore's metropolitan setting is enlivened by sculptures and fountains between the skyscrapers rising along Orchard Road, hub of the Singapore of the third millennium. Anything can be found here: "pagoda" hotels, shopping malls, fashion boutiques, bistros...

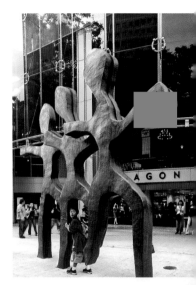

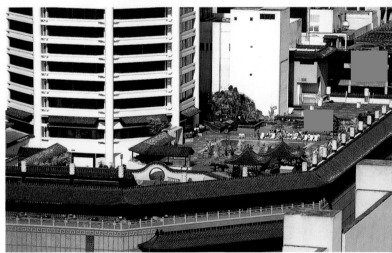

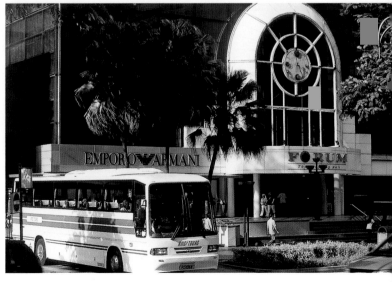

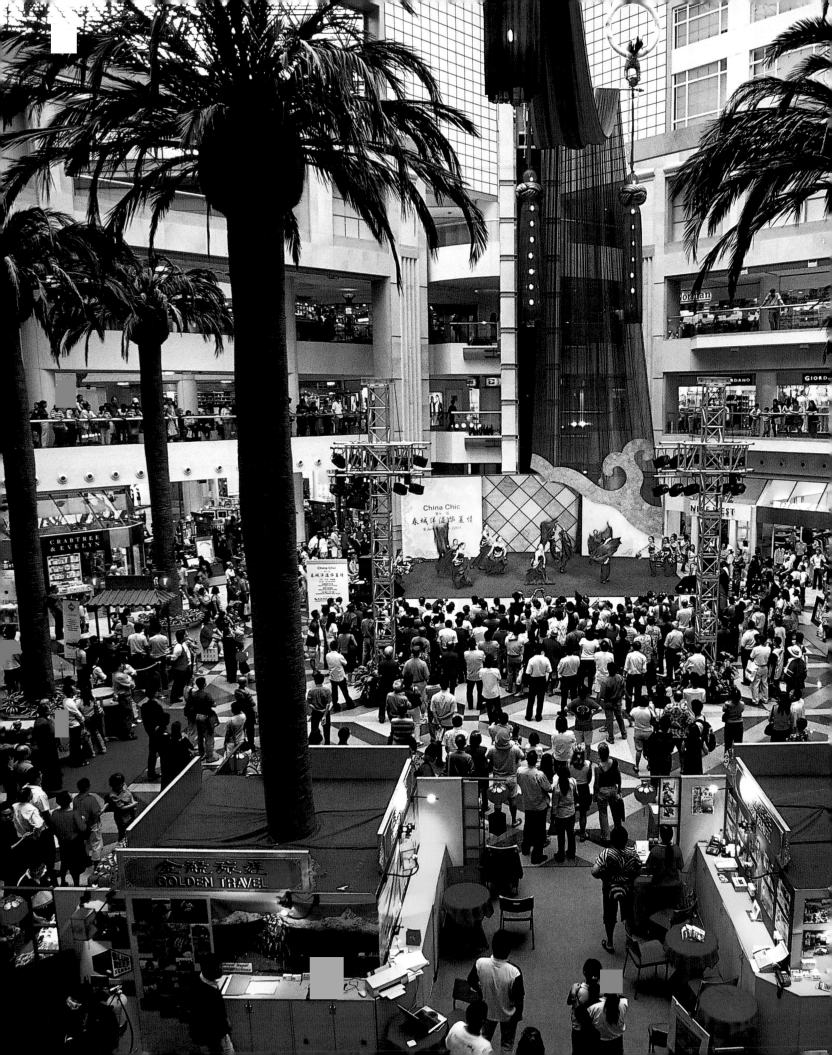

54-55 and 55 top The Raffles Shopping Center is one of the biggest and best-stocked of Singapore's shopping malls. Inside a crystal tower, a vast central lobby full of palm trees greets the escalators carrying customers to the hundreds of shops on several floors. This architectural solution has won the Raffles City Tower several prizes, among them that of the New York Association of Consulting Engineers.

55 bottom As shown here Singapore has always tried to balance the impact of concrete with parks, gardens, and greenery. It is the only city in the world, besides Rio de Janeiro, to have maintained patches of rain forest within its borders. For these reasons, by the end of the 19th century Singapore had already been defined as a 'garden city.'

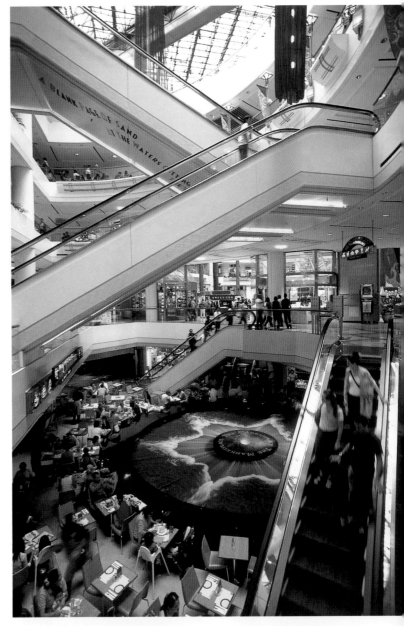

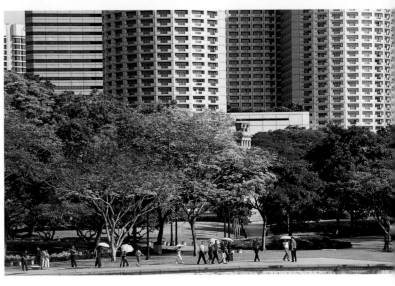

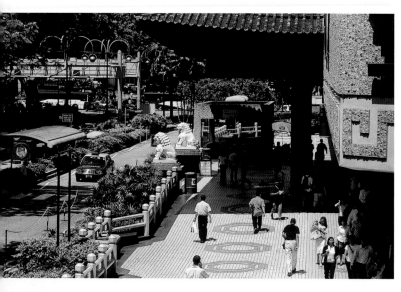

56 top left, center right and 56-57 Orchard Road's wide sidewalks, designed after the truly impressive dimensions of those along the Parisian boulevards, are mostly lined by skyscrapers with ever more grand and spectacular luxury hotels and shopping centers, though here and there the delightful colors of little colonial-era houses still pop up.

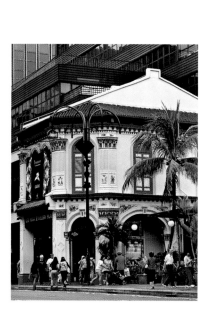

56 center left and bottom Orchard Road is Singapore's main social hub of Singapore, not to mention its fashion street: the boutiques of Asia and Europe's the most famous designers are found there.

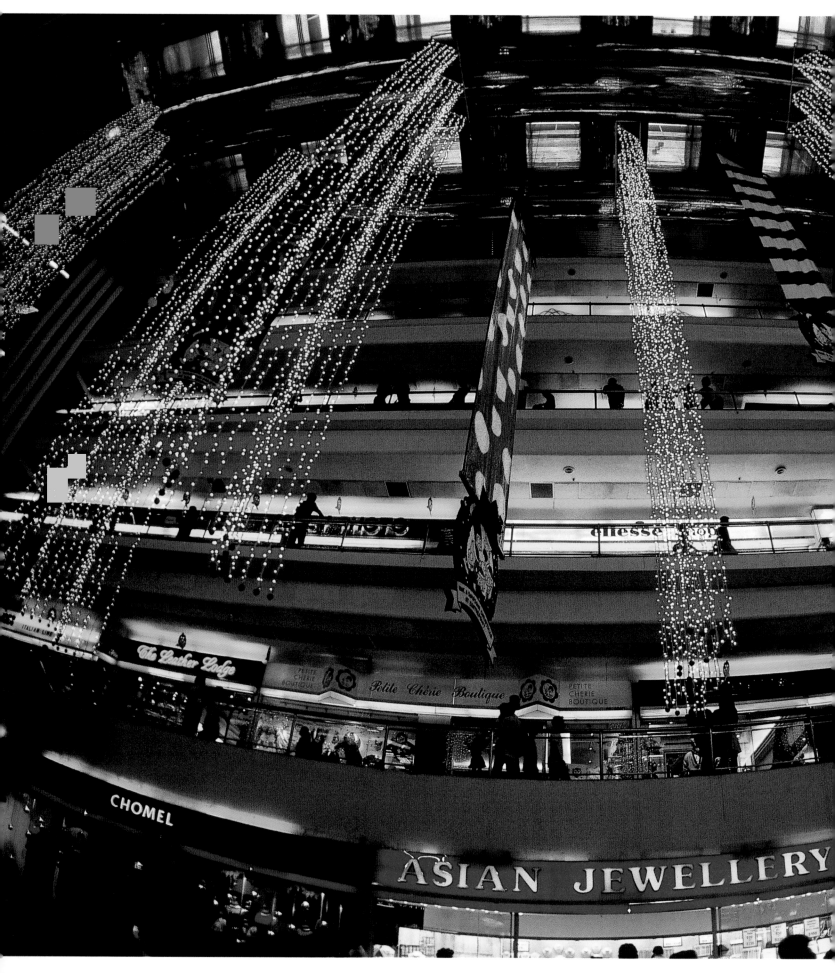

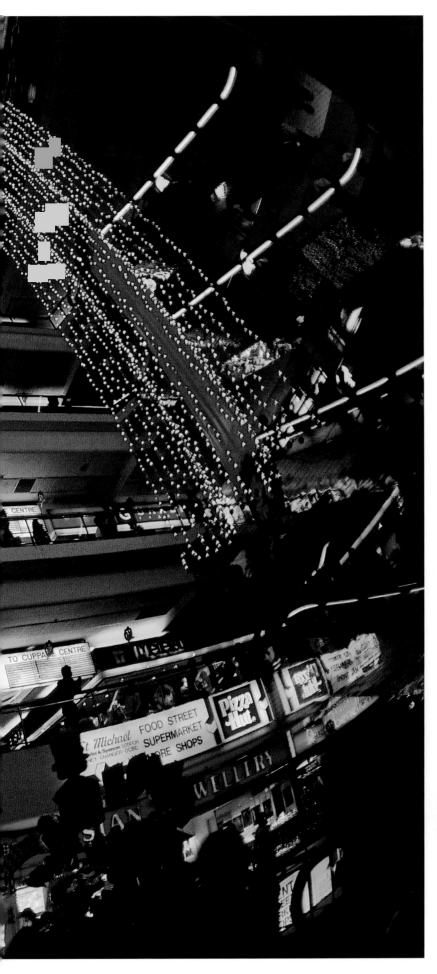

58-59 Brilliant nighttime lighting makes Orchard Road's immense shopping malls, which stay open until late at night after the equatorial sun has long since set, even more spectacular. Very safe and well monitored, Singapore boasts the complete accessibility of its shopping centers and malls even at times in which, in other large cities around the world, it would not be advisable to go shopping.

59 The big shopping malls of Singapore can be defined as having a "global" style more than a "Western" one, similar to those that can be found in many other modern metropolises, even if, at times, displays with red lanterns and colorful floral decorations remind shoppers that three-fourths of the city's population is of Chinese origin.

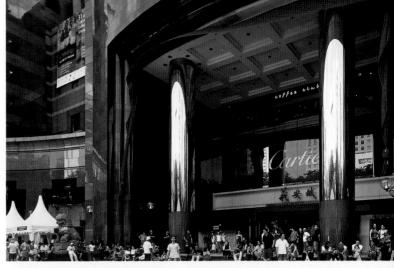

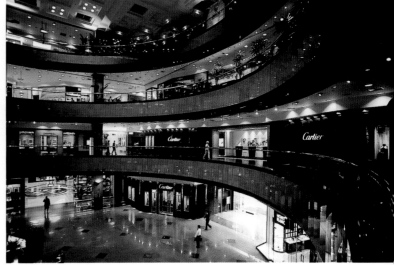

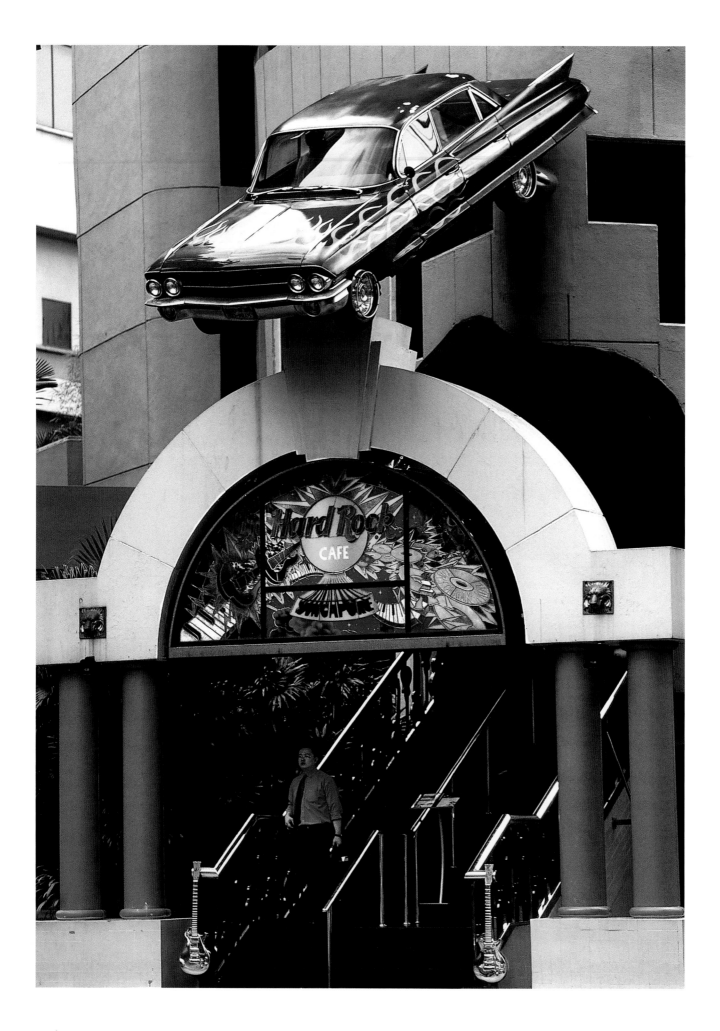

60 and 61 An old-fashioned
Chevrolet marks the entrance
to a bar-restaurant of a famous
chain found throughout the world,
which inside features "vintage"
electric guitars and memorabilia
from the history of rock and roll.
The move from cosmopolitanism to
non-nationalism seems to be by now
completed (here, anyone can feel "at
home"), even though, in this case, the
call of Western culture co-exists with
a restaurant with a highly Chinese
design, the umpteenth example of
syncretism between East and West
in the city-state.

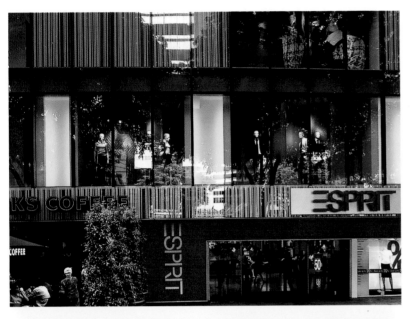

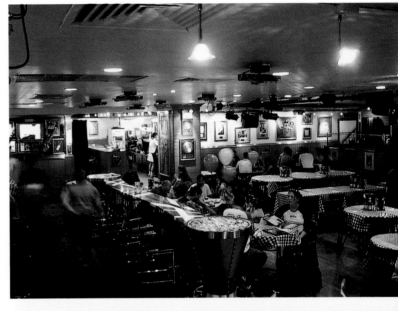

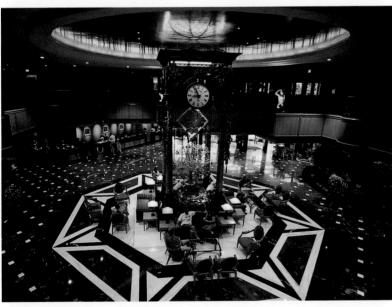

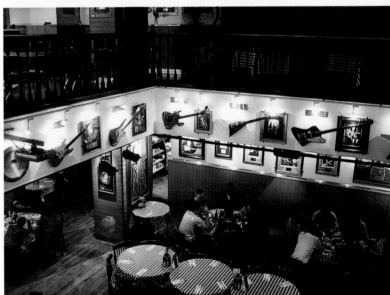

61 top left Orchard Road features
an attractive union between high-
fashion stores and cafés. Unlike in the
rest of East Asia, in Singapore, coffee
continues to attract more and more
devotees, replacing tea, the
traditional Chinese drink.

61 bottom left The constant contrast
between colonial style and flashy
modernity characterizes the lobby of a
big hotel on Orchard Road. All the
large worldwide chains have long ago
opened at least one hotel in
Singapore.

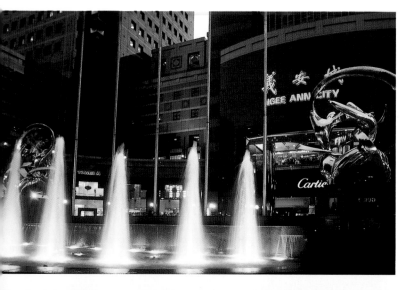

62 and 62-63 *After dark, the sidewalks of Orchard Road are still crowded with tourists and locals who – after surviving another sizzling day thanks to the ever-present air conditioning – come out to enjoy a bit of cool air and admire the play of the lights illuminating the fountains, boutiques, palm trees, hotels, and shopping centers along the busiest road in the city-state.*

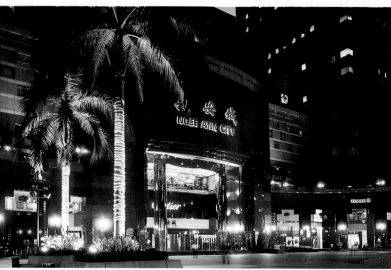

64-65 *The towers of steel, concrete, and crystal, which have popped up like mushrooms over the last 20 years between the Central Business District and Orchard Road, create a modernistic postcard-perfect picture giving Singapore the look of a city of the future.*

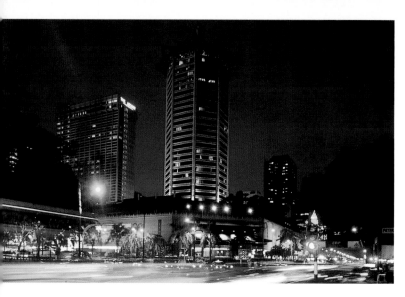

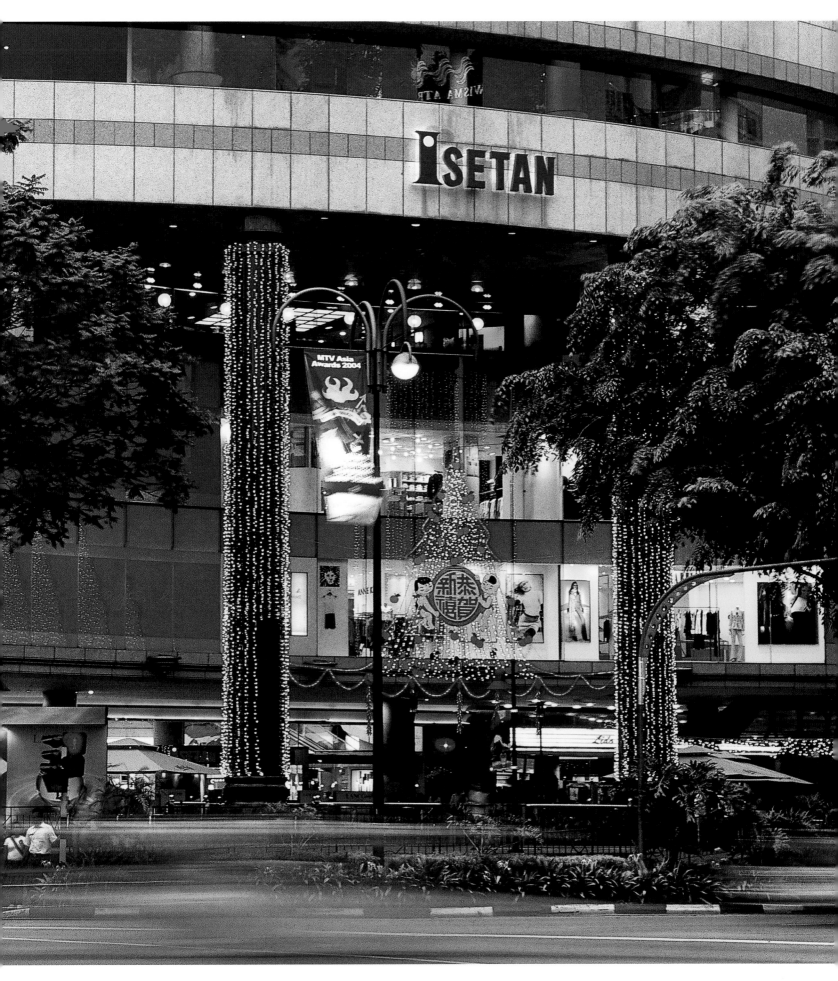

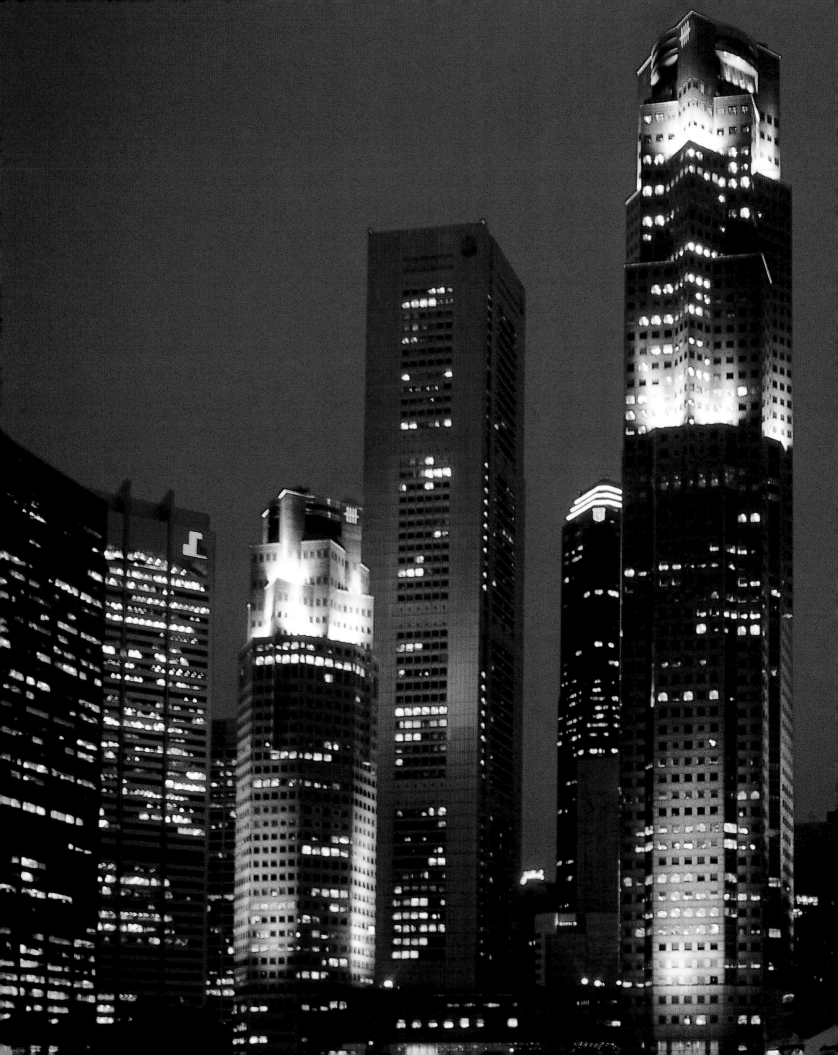

Chinatown

66 *The marriage between modernity and tradition at the foundation of the history and success of Singapore is even apparent in Chinatown, which gradually renders its old, bustling alleys for the benefit of planned urban development, with its new skyscrapers and curved-roof kiosks.*

66-67 *Eu Tong Sen Street, the main road of "new Chinatown," is decorated for New Year 2004, dedicated to the monkey. Many Chinatowns, both small and large, can be found spread throughout half the world, but that of Singapore is considered the most beautiful and livable.*

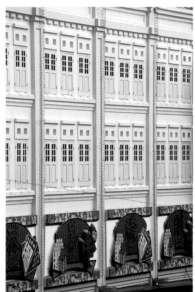

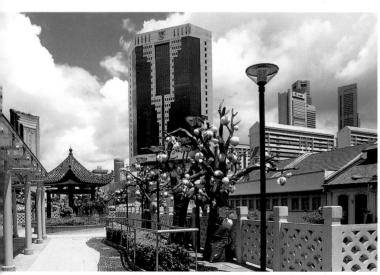

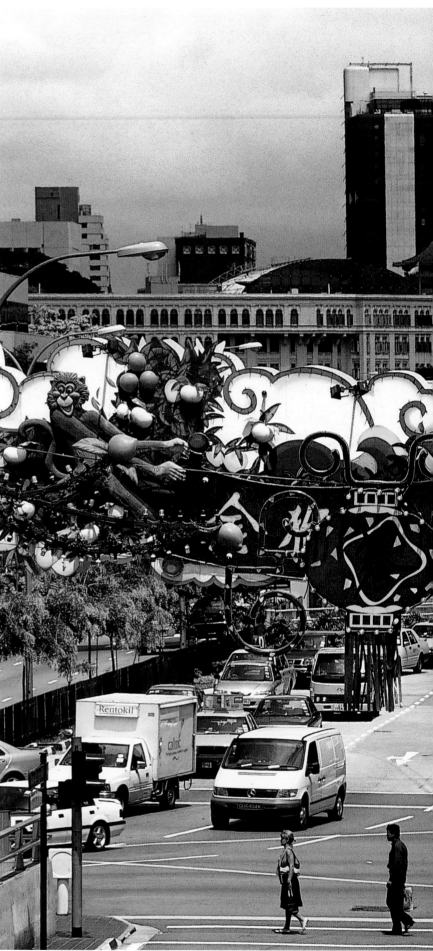

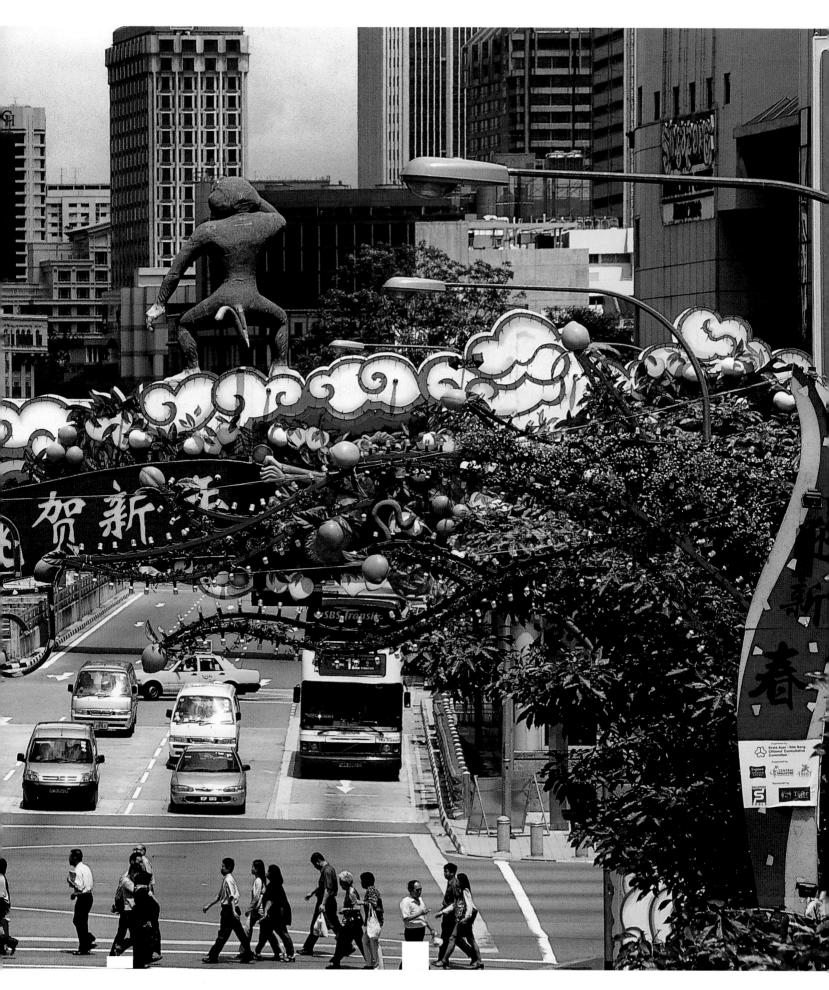

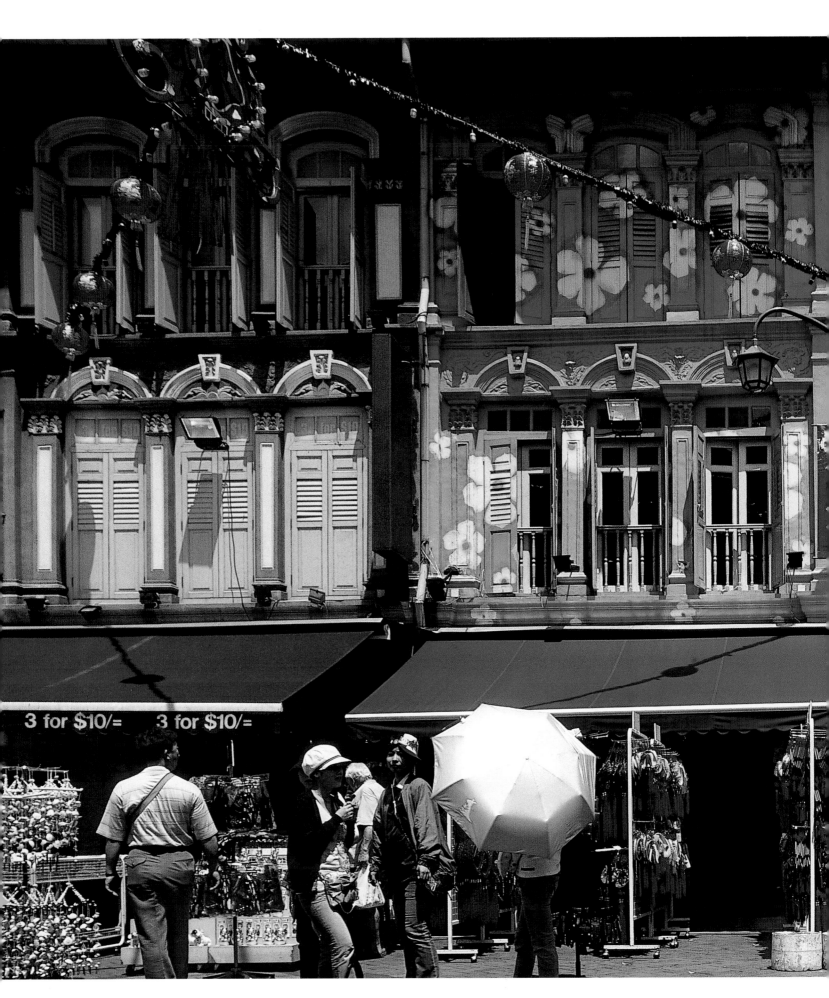

3 for $10/= 3 for $10/=

68

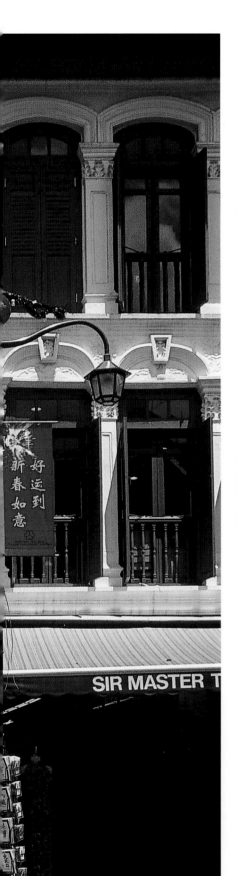

68-69 No less than the city's parks and green areas, the streets of Chinatown, restored and made functional, offer the people of Singapore relatively quiet spots, removed from the traffic of city life.

69 Chinatown lives above all on business with tourists, who know they can find products here like calligraphy ink, the most refined teas, and pieces in lacquer, wood, and of course, Chinese porcelain.

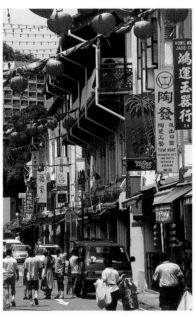

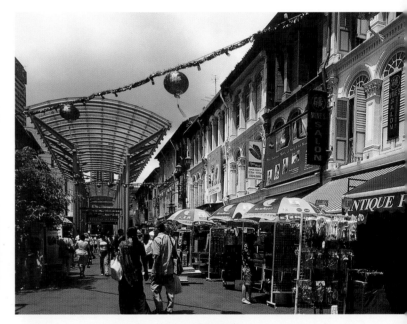

70-71 The few colonial houses remaining in Singapore's Chinatown have been restored and painted in bright colors. Some of the best examples can be seen on Sago Lane, flanked by small, late-19th-century, one-family homes lived in by professionals.

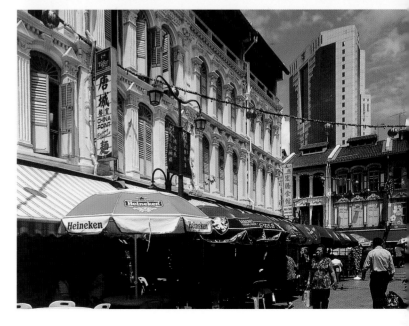

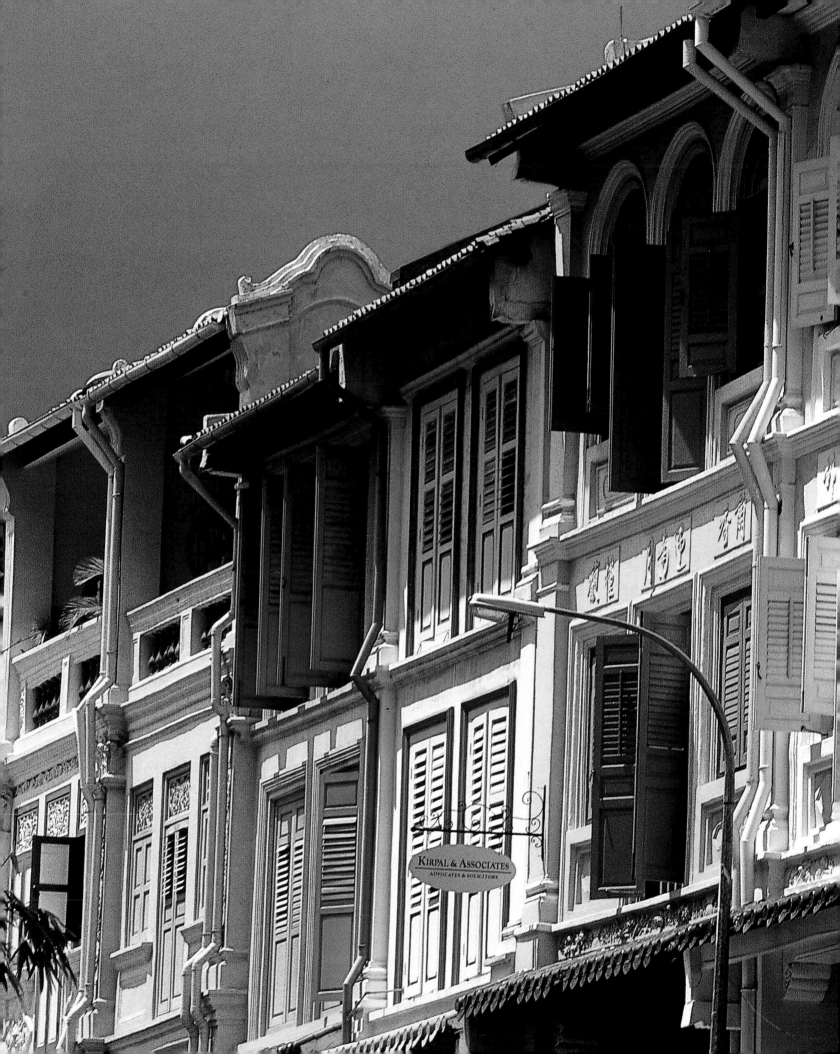

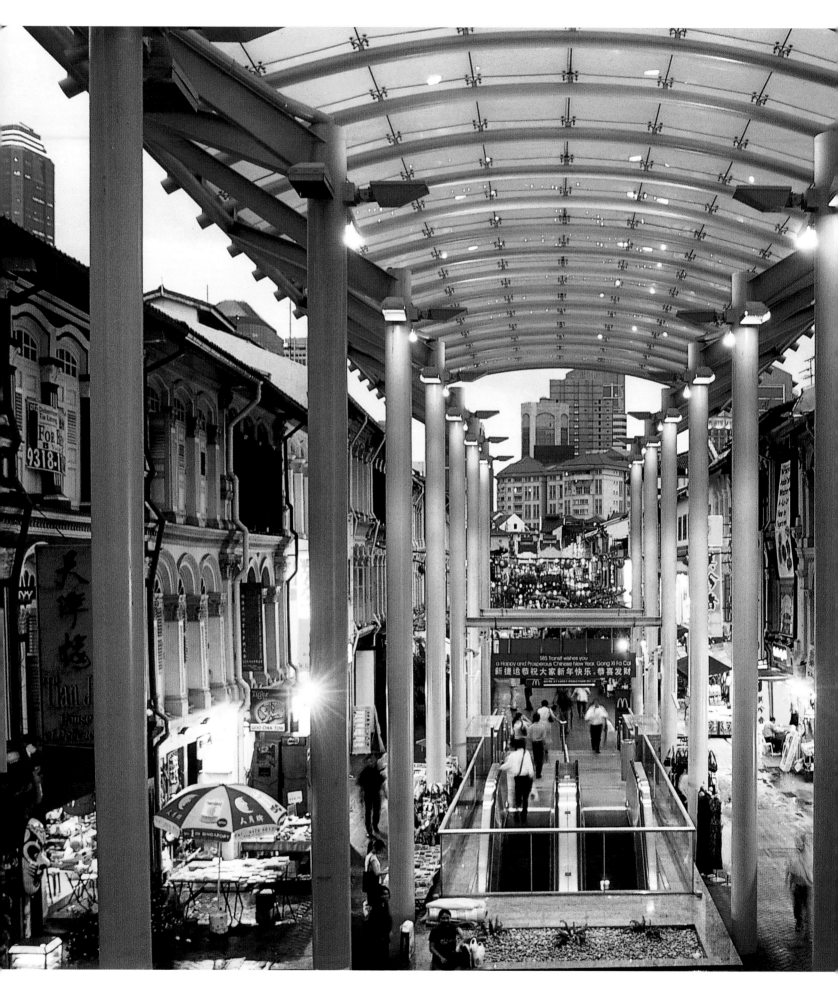

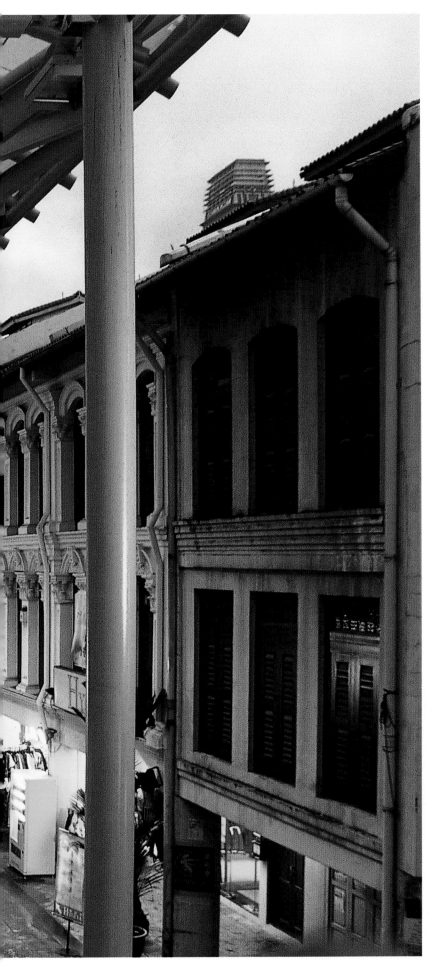

72-73 and 73 bottom In Chinatown, new and old buildings blend into new structures, like in the shopping center shown in these photographs: streets with old, colonial-era houses have been covered by metallic roofing to protect from the rain and equipped with escalators linked to the subway.

73 top On main roads, the traffic always flows well because the traffic lights are triggered by sensors in the pavement that count the number of cars waiting in lines. Broken-down vehicles are quickly removed by tow-trucks alerted by video cameras surveying the streets 24 hours a day.

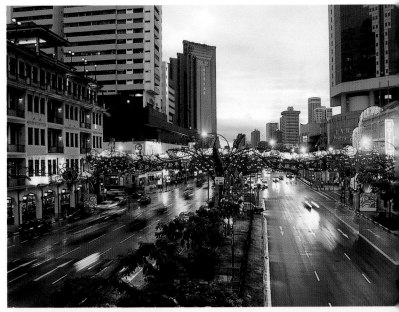

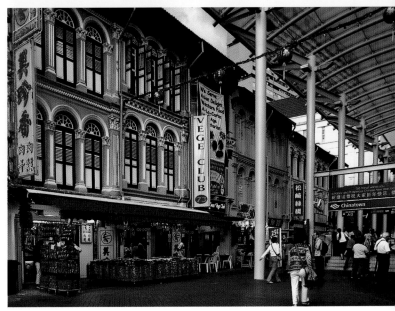

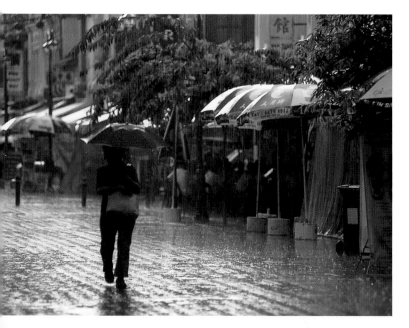

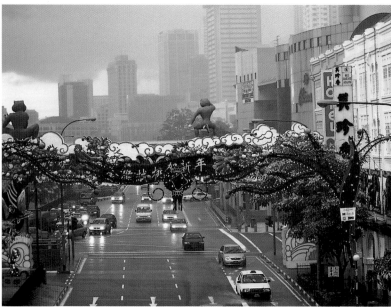

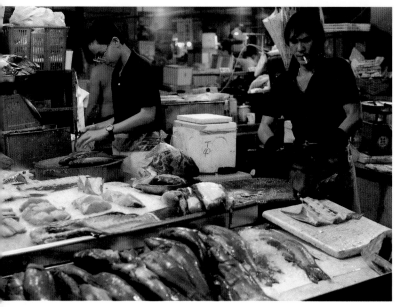

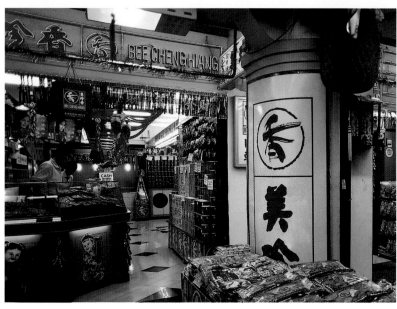

74 top The streets of Chinatown under the pouring rain. Singapore, located just north of the equator, has a very rainy tropical climate because it is hit by two different monsoon seasons, December to March from the northeast, and June to September from the southwest.

74 bottom and 75 At first sight, Singapore might seem a city of the future without any cultural roots. However, a visit to Chinatown and its food markets, stalls and shops, and picturesque people is likely to change that judgment. There, alongside fish, meat and vegetables, the visitor will find herbs, salves, and therapeutic oils – the products of ancient Chinese knowledge.

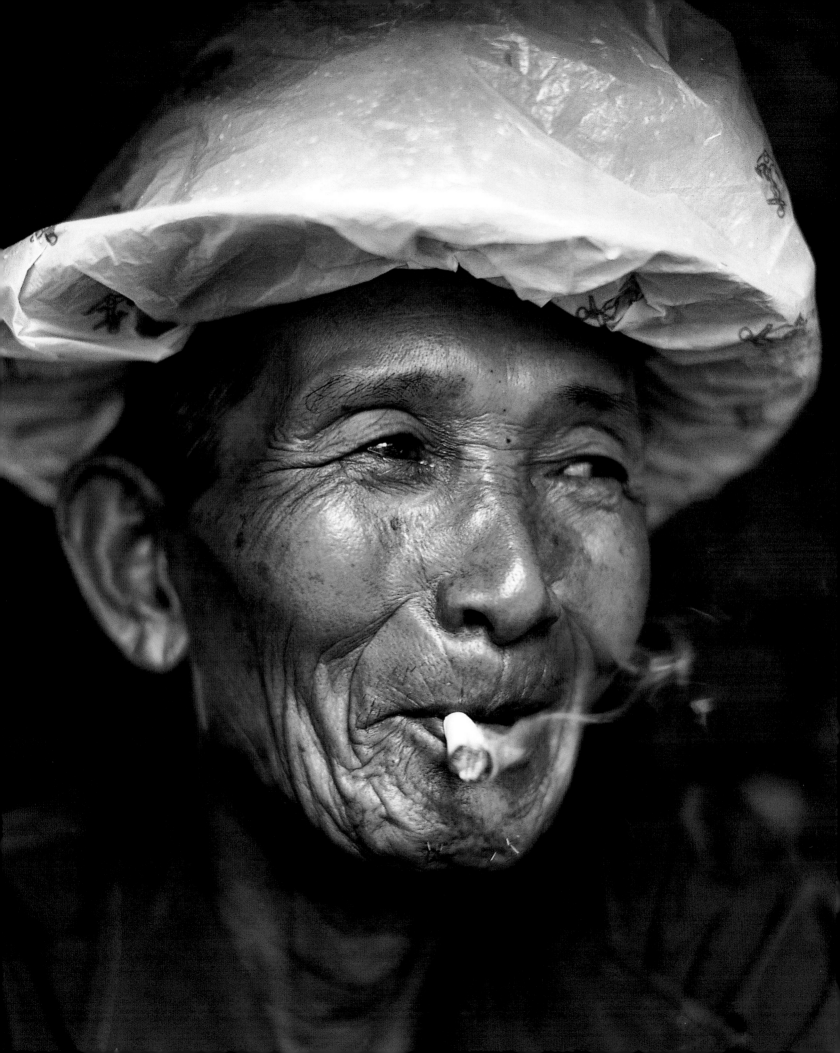

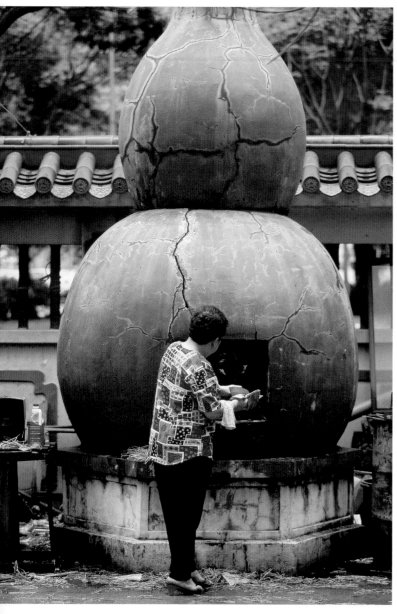

76 top In the courtyard of Wak Hai Cheng Bio, the "Temple of Calm Seas," a worshiper inserts fake bank notes into a big terracotta oven in honor of his ancestors, as dictated by Confucian doctrine.

76 bottom Spectacular spirals of incense hang from the ceiling of Wak Hai Cheng Bio, to be burned during ceremonies.

76-77 Prayer in Confucian temples follows a predetermined path, with stops at different altars. According to the ritual phase, worshipers light sticks of incense, as shown here, scraps of colored or golden paper, and candles.

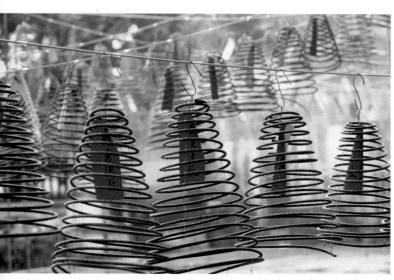

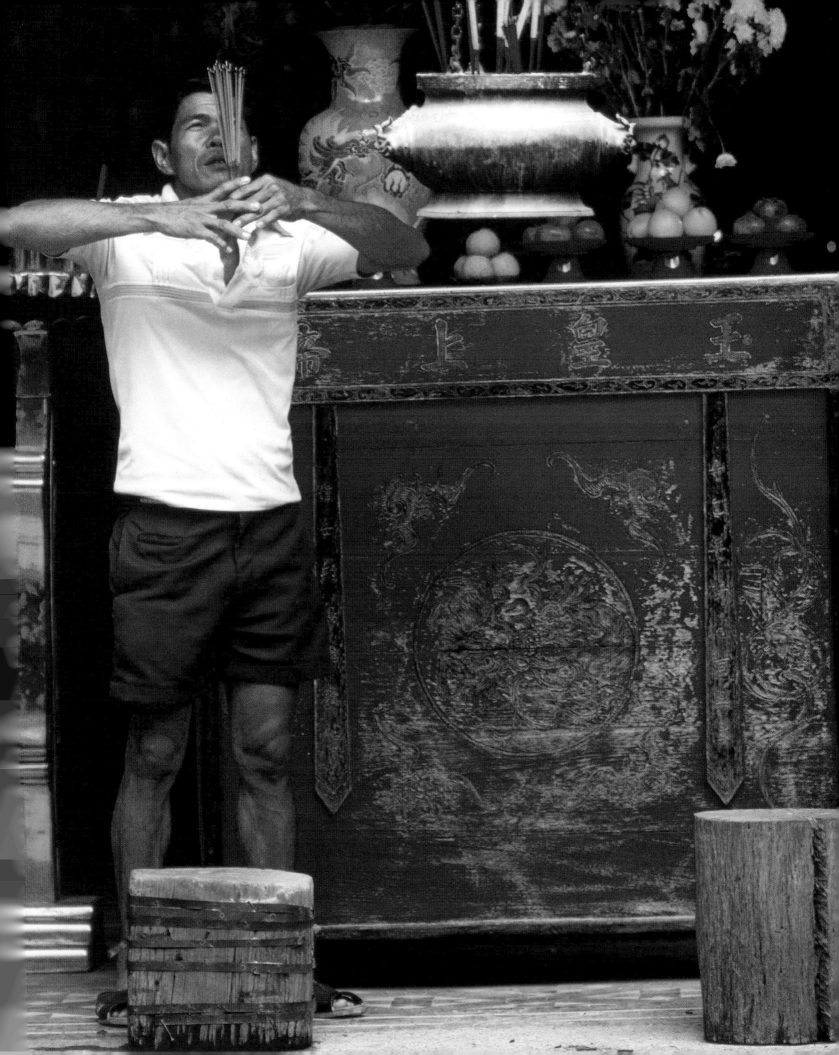

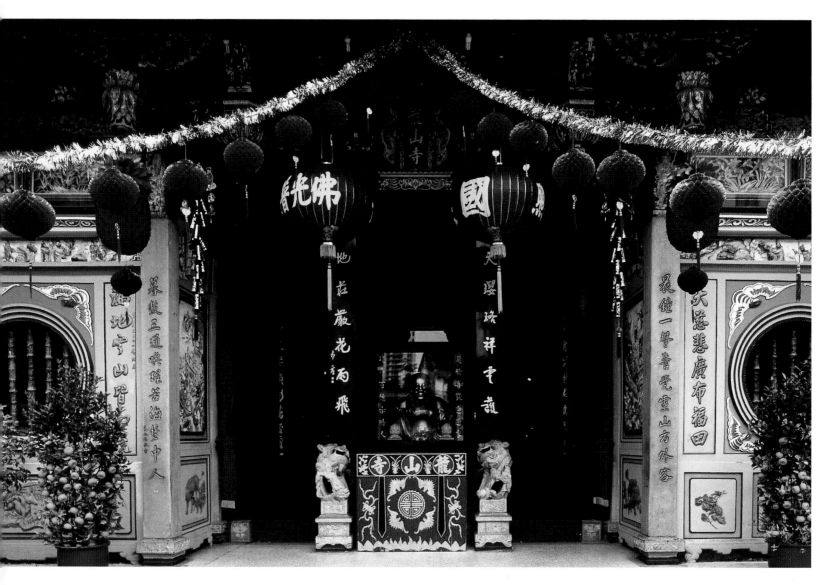

78 In a shrine placed at the entrance to Leong San See Temple, dating back to 1917, a statue of Fo, the Chinese Buddha, features the typical "heavy" traits that reflect health and prosperity.

79 Among festoons and big paper lanterns, Chinese citizens of Singapore offer incense to the deceased during celebrations of the festival of the dead, which falls in the seventh month of the lunar calendar.

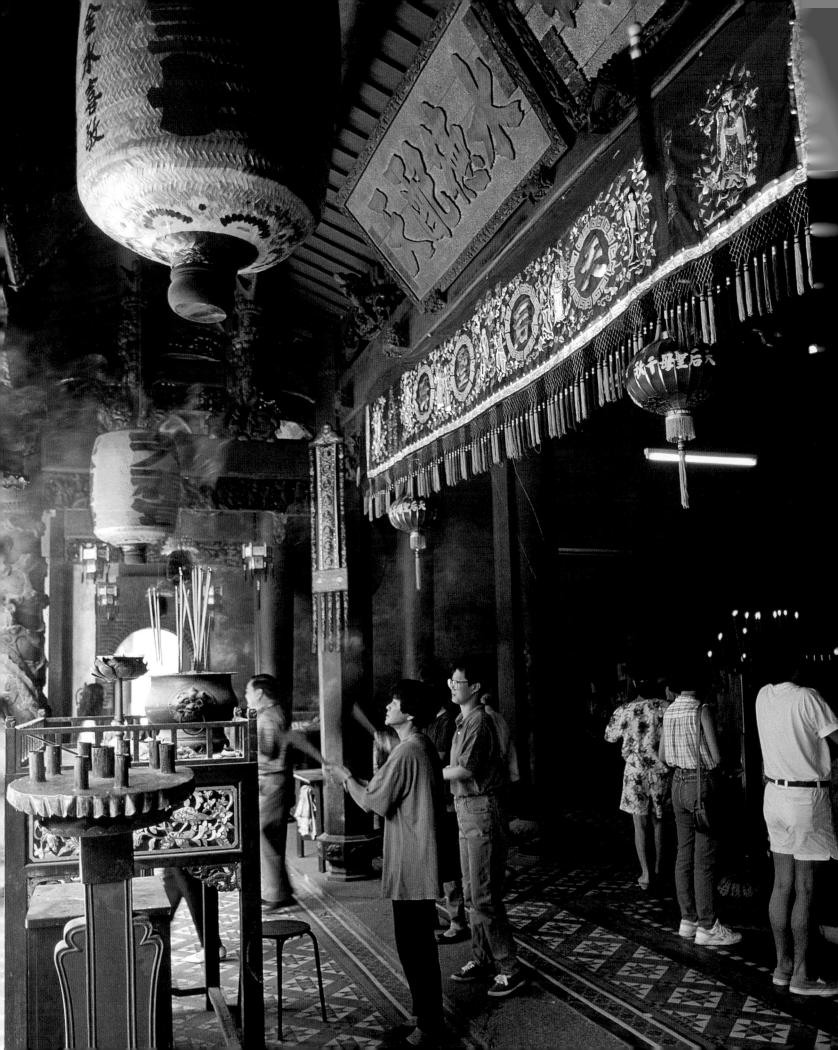

80 Built in perfect Chinese style with pavilions featuring curved roofs supported by granite columns surrounding a central courtyard, the Thian Hock Keng temple is the "Temple of Heavenly Happiness," dedicated to Ma Chu Poh, the goddess of the sea who protects sailors and fishermen. When it was built in 1841 to replace a pre-existing pagoda from 1821, it actually stood on the seashore.

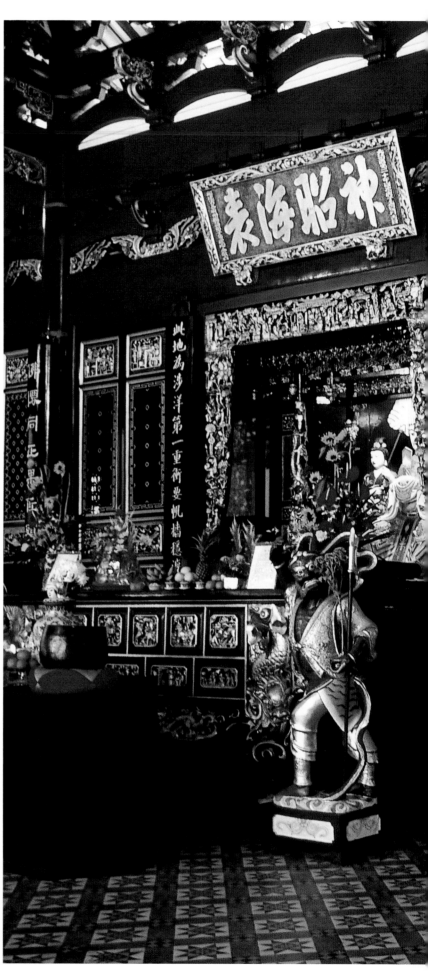

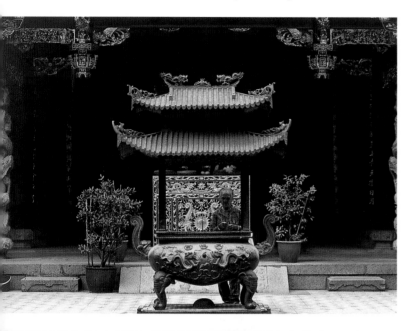

80-81 and 81 Thian Hock Keng is the most famous, spectacular, and popular Chinese temple in Chinatown. Located on Telok Ajer Street, it contains countless sculptures, lacquer pieces, and paintings portraying dragons, divinities, priests, and well-known Confucians.

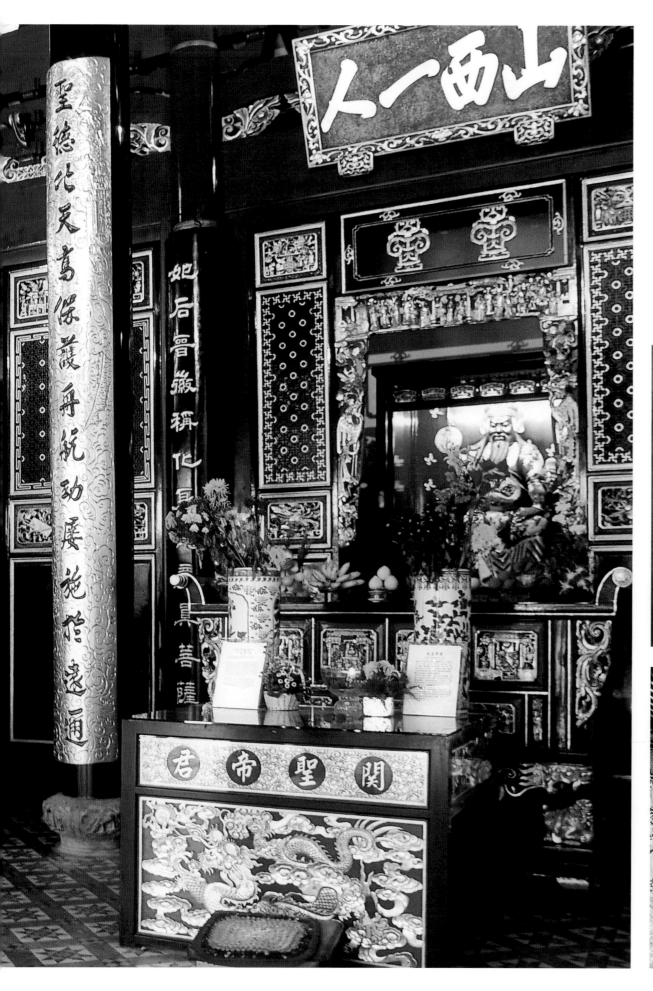

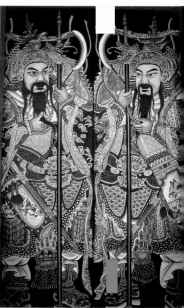

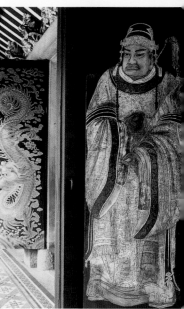

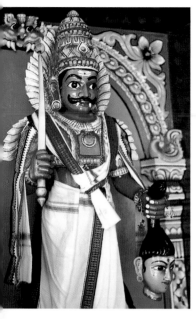

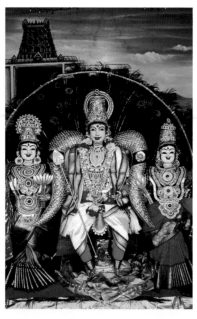

82 Hindu iconography is always surprising in the colorful and often "violent" materiality that characterizes it. Iconography of this type populates one of Chinatown's treasures, the Sri Mariamman Temple (Singapore's main Hindu sanctuary, built a century ago), with hundreds of people and creatures.

82-83 Chapels adorned with statues of divinities and colorful portrayals of the Hindu Mount Olympia crowd the gopuram of the Sri Mariamman Temple. Here the god Shiva (center) sits next to his consort Parvati and the celestial archer Arjuna (left). On the right, at his feet, the monkey-god Hanuman kneels with his hands clasped in a gesture of devotion.

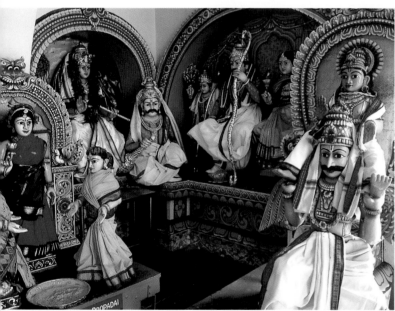

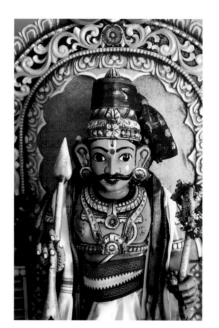

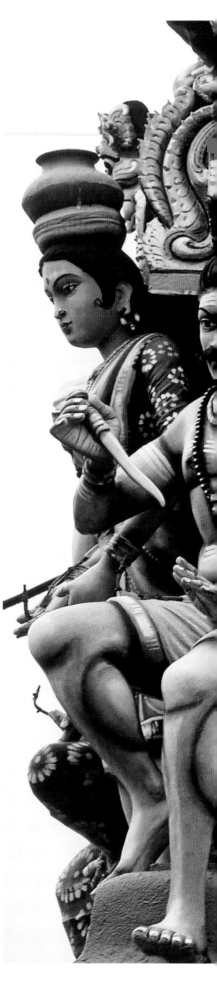

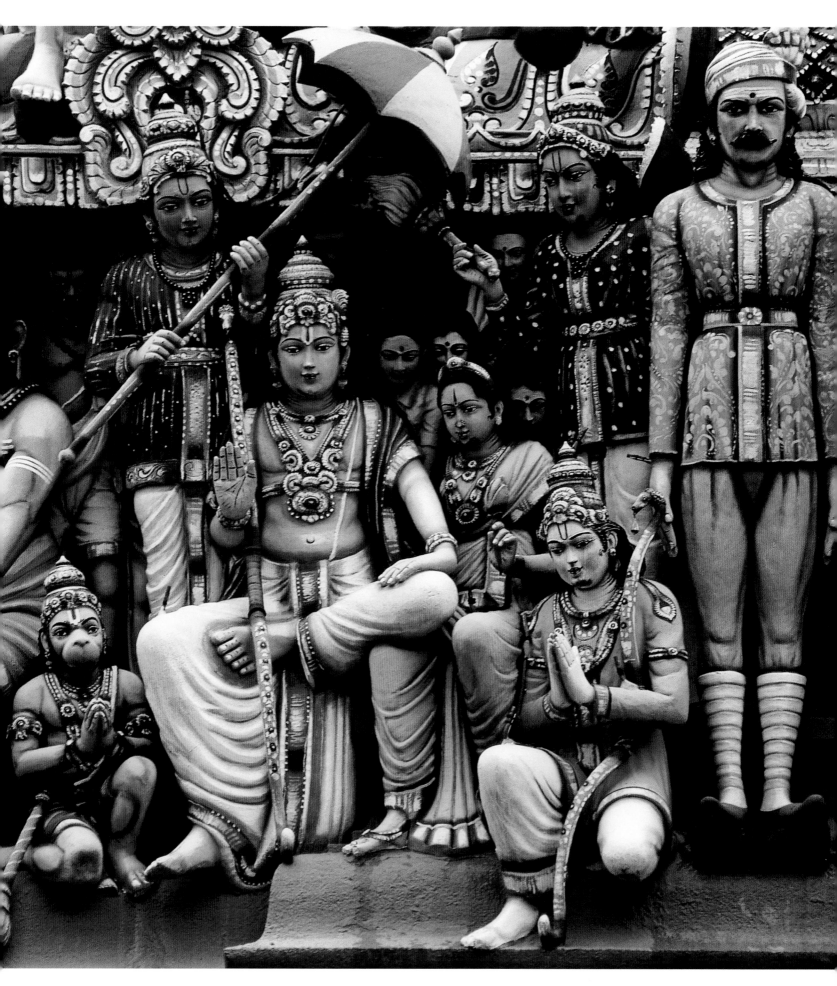

83

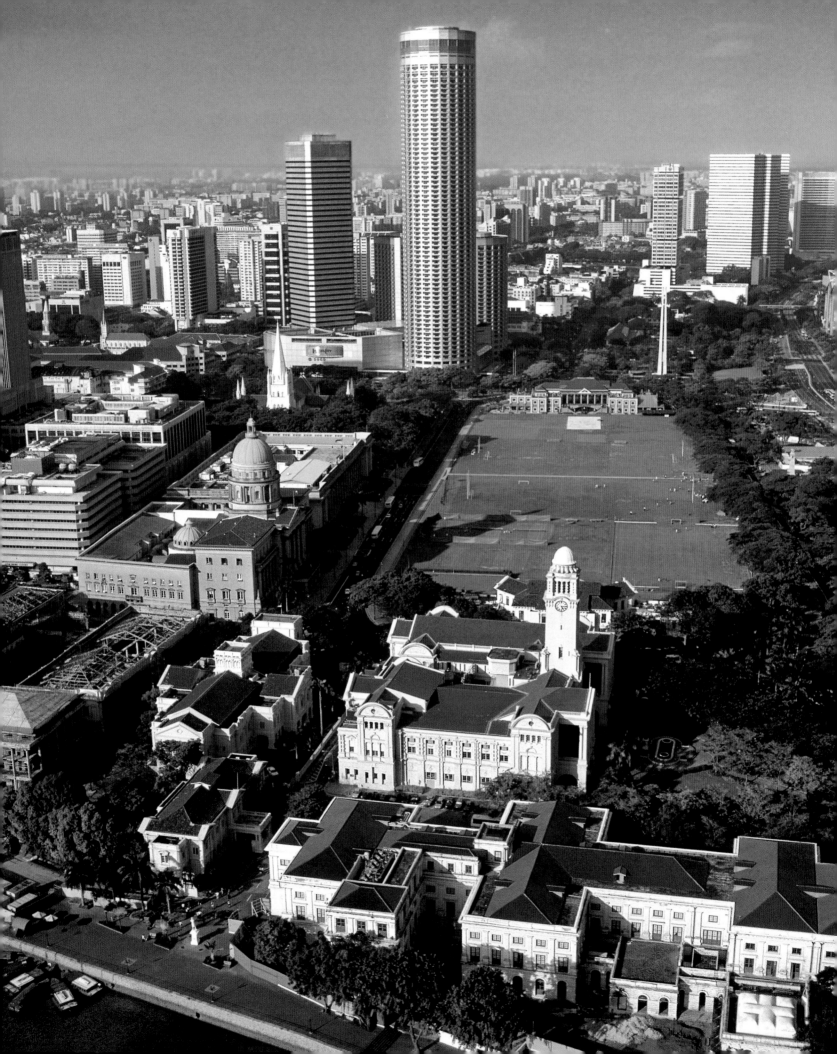

Colonial District and Clarke Quay

84 This aerial view shows the position and small size of the Colonial District, trapped between the sea and the Central Business District's forest of skyscrapers. The area is full of greenery since the Padang cricket field (center) joins with the parks surrounding the colonial buildings.

85 top left A sturdy, white clock-tower rises above the Victoria Concert Hall, the headquarters of the Singapore Symphony Orchestra, and the adjacent Victoria Theater, which serves as Singapore's city hall. The Concert hall, inaugurated in 1905, was built as a memorial to Queen Victoria. Today it is the venue for important classical-music concerts, ballets, and operas.

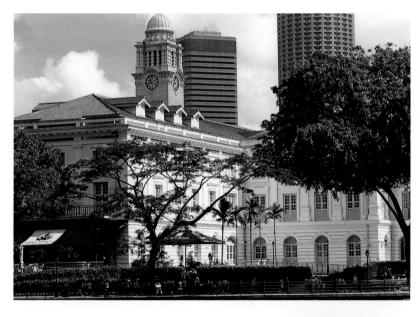

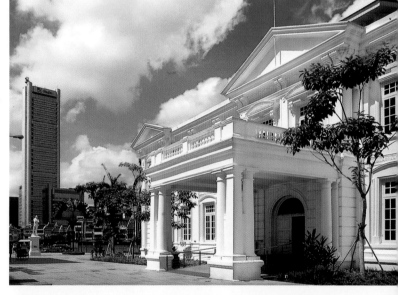

85 bottom left One of the more outstanding elements in the Colonial District panorama is the severe Neo-classical building of the Supreme Court of Justice, with a dome that reflects that of St. Paul's Cathedral, London. The building, completed in 1939, is considered one of the most beautiful of those erected during British Rule.

85 right Parliament House, the oldest government building in Singapore, is a magnificent, Neo-classical, two-floor structure inaugurated in 1827. The structure was built to be the private residence of a Scottish businessman (and judge), but was never used for this purpose: rented to the colonial government, it has always contained offices.

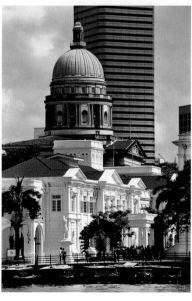

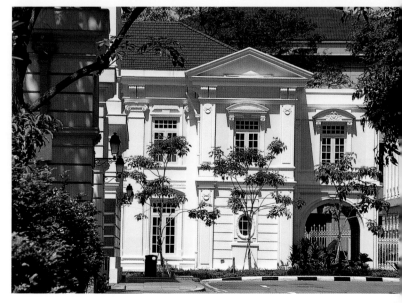

Where Singapore Was Born

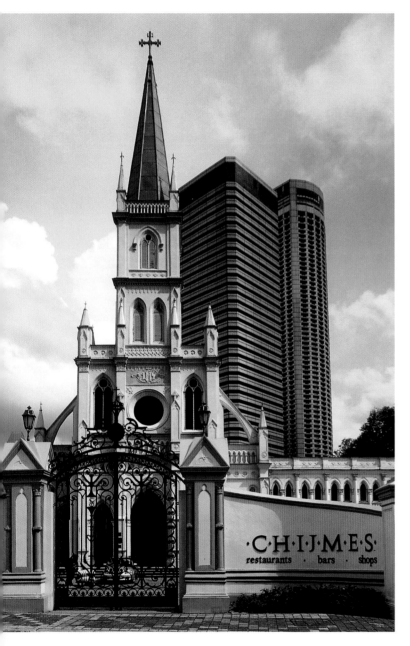

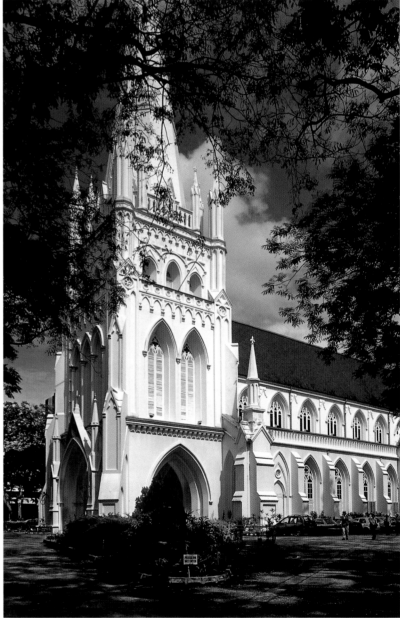

86 The Colonial District's Neo-gothic church spires are now towered over by giants of unmatchable height. On the left, the Convent of the Holy Infant Jesus (or CHIJ), dates back to 1890. In 1996, it was converted into a shopping mall, thus saving it from total abandon. On the right, the bright-white St. Andrew's Anglican Cathedral, founded in the first half of the 19th century, still draws an active congregation.

87 left St. Andrew's elegant Neo-gothic structure has wooded grounds on all sides, separating it from the city's modern buildings.

87 top right At the base of the clock-tower between Victoria Theatre and Victoria Memorial Hall, a monument honors Sir Thomas Stamford Raffles, the British official who founded Singapore in 1819.

87 bottom right The pretty Neo-classical façade of the Supreme Court Building features a plain portico with Corinthian columns and a fine gable made by the Italian artist Rodolfo Nolli.

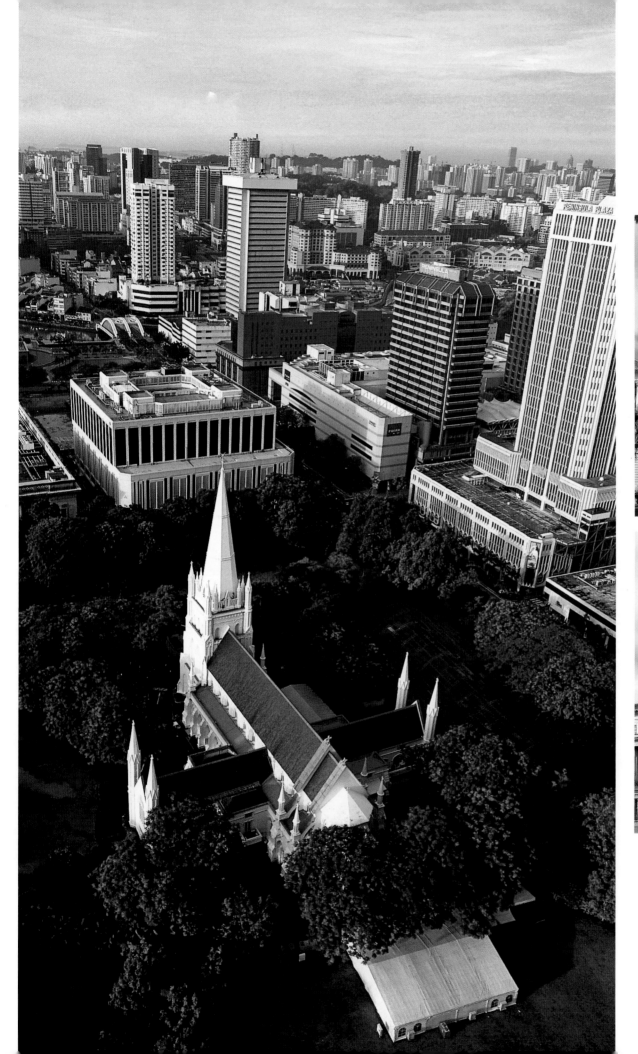
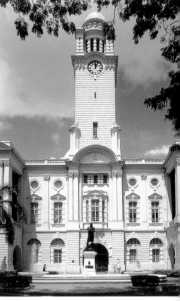
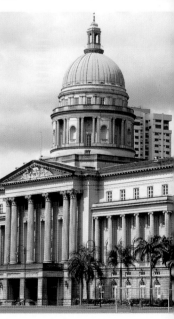

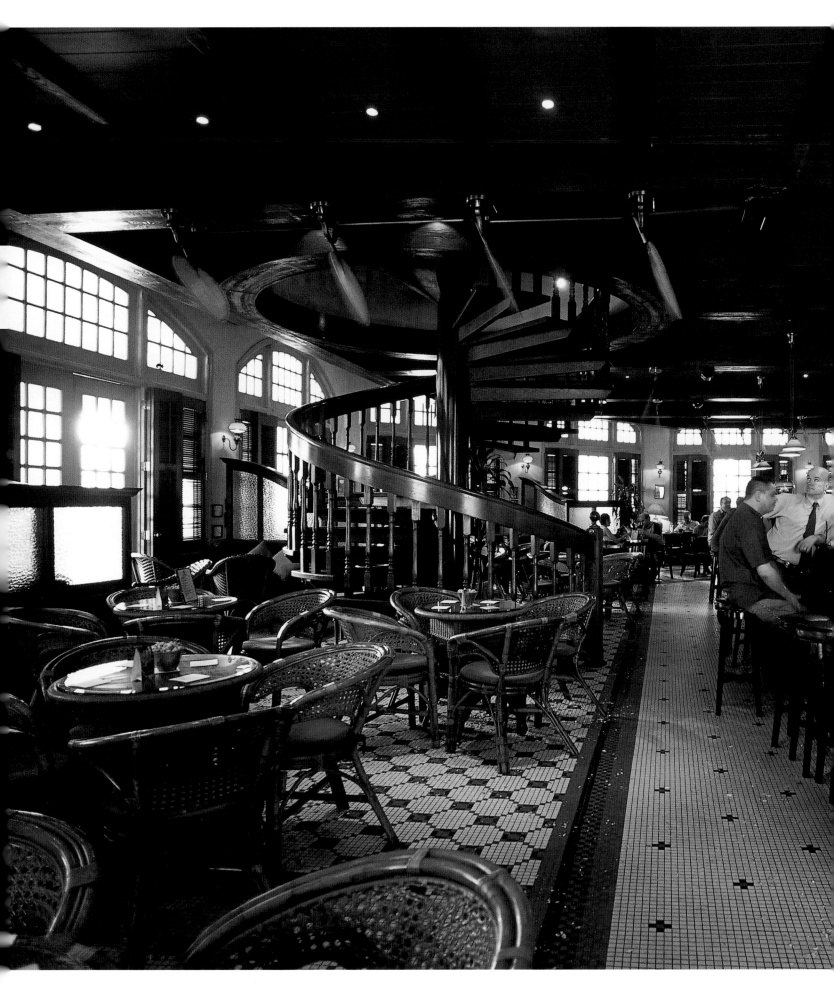

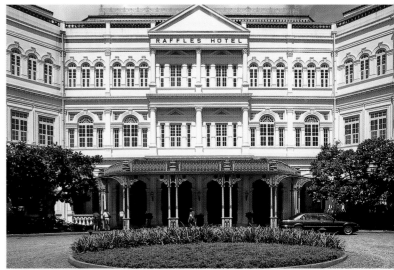

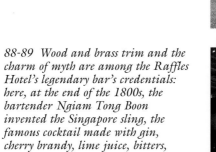

88-89 *Wood and brass trim and the charm of myth are among the Raffles Hotel's legendary bar's credentials: here, at the end of the 1800s, the bartender Ngiam Tong Boon invented the Singapore sling, the famous cocktail made with gin, cherry brandy, lime juice, bitters, and Cointreau.*

89 *The Raffles is one of the world's most famous hotels. For over a century it was a meeting place for writers and explorers in Southeast Asia. Joseph Conrad, Rudyard Kipling, Herman Hesse, Somerset Maugham, André Malraux, and Noel Coward all stayed there. Restored in 1991, its rooms are decorated with colonial furnishings.*

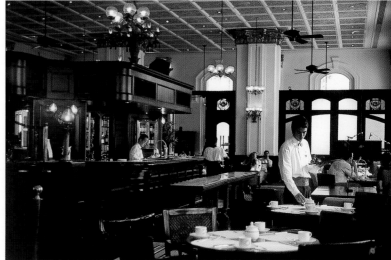

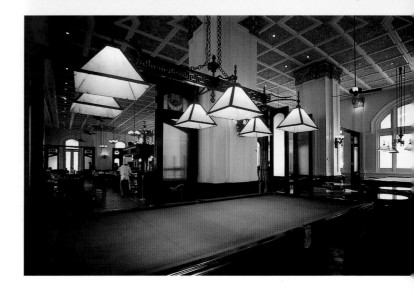

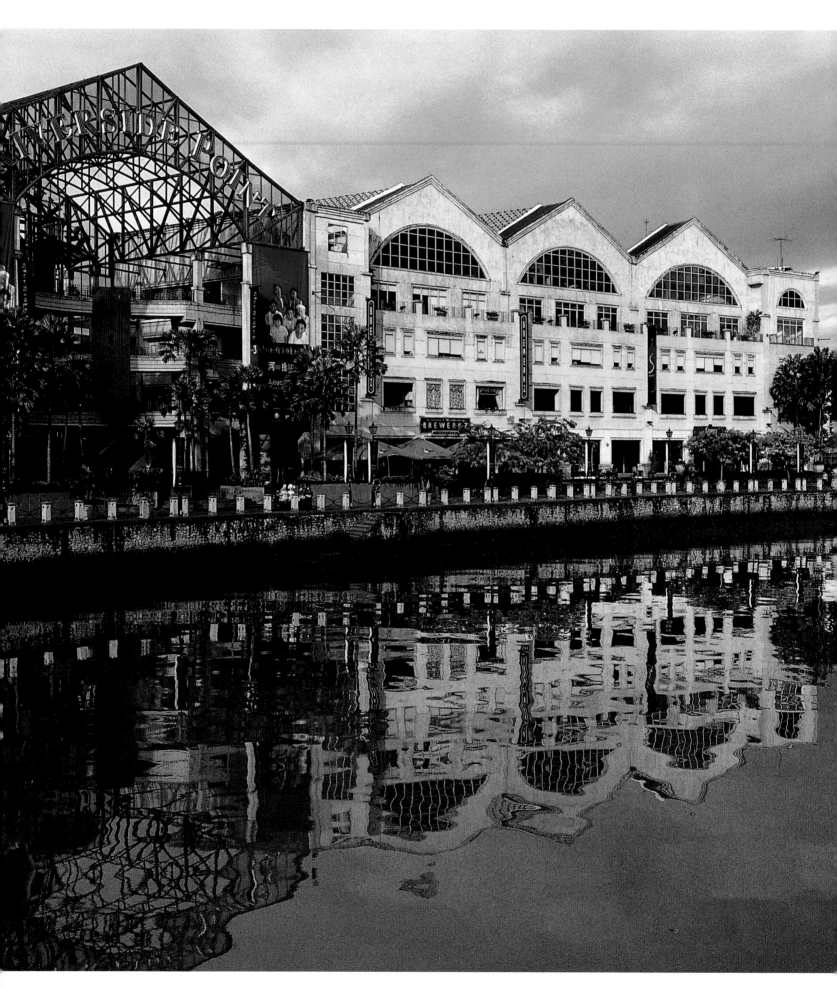

The Quays that Link Past and Present

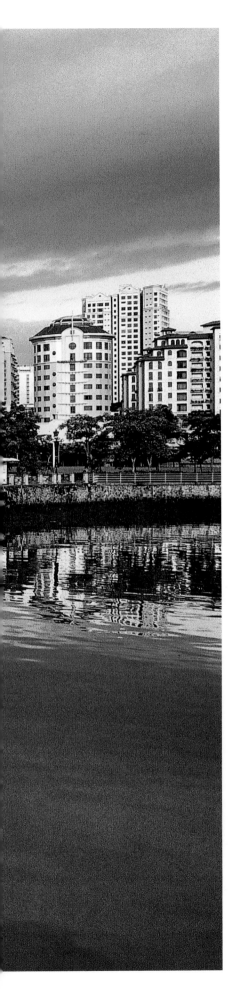

90-91 *A bit of the past has been preserved at Boat Quay, once the loading dock for cargo ships leaving for Britain – as proven by the restored warehouses seen in the photo – today converted into a recreational area. Singapore is undergoing a two-pronged urban overhaul focused on the constant development of new buildings, mostly high rises, and the salvaging of pre-existing structures.*

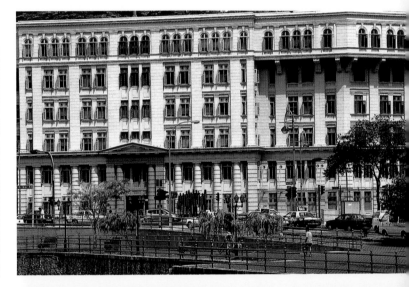

91 *The city's original nucleus arose around Singapore River, an area that, in today's Singapore, features lots of shopping and entertainment. The warehouses of Clarke Quay, on the riverbank opposite Boat Quay, have been transformed into a shopping mall with 200 stores as well as restaurants, cafés, and bars, accompanied by dozens of stands selling souvenirs.*

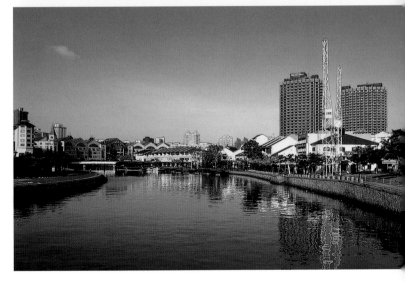

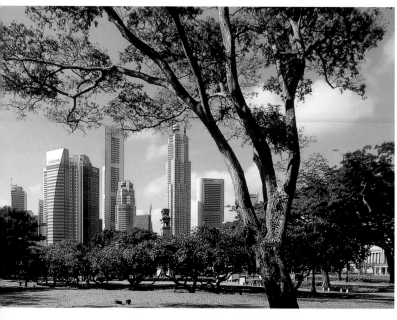

*92 top and center left and right
Singapore's vast central area boasts
an extensive series of parks and
walkways covered by a fantastic green
canopy, all surrounded by the city's
most important historic buildings,
dominated, of course, by the Business
District, to the south across the river.*

*92 bottom A few paces from
Cavenagh Bridge, which connects the
Colonial District to the Business
District, a white obelisk was erected in
1850 to commemorate the visit to the
city of Earl Dalhousie, the Governor-
General of India and a fervent
supporter of a free market.*

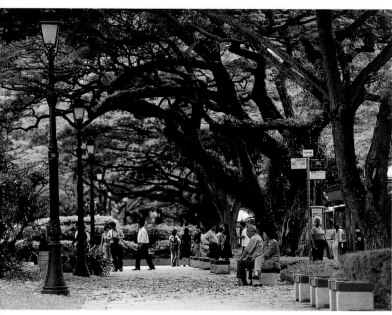

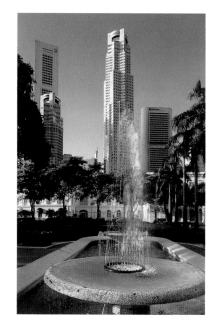

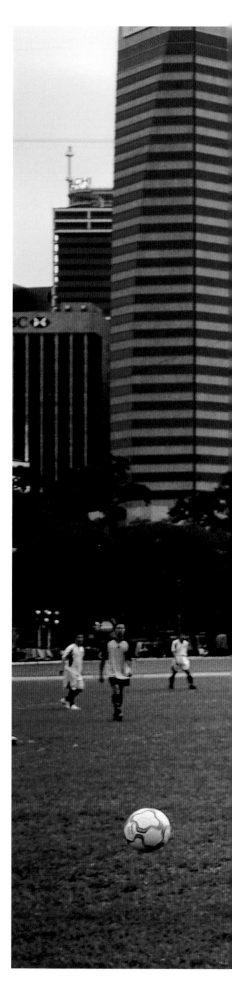

*92-93 A soccer game in Padang, in
the Colonial District, a sports field
famous above all for cricket,
Singapore's most widespread and
popular sport. The British introduced
it from India, where it was widely
played.*

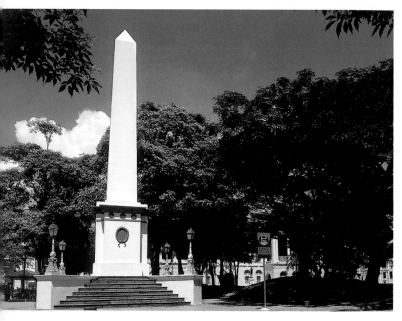

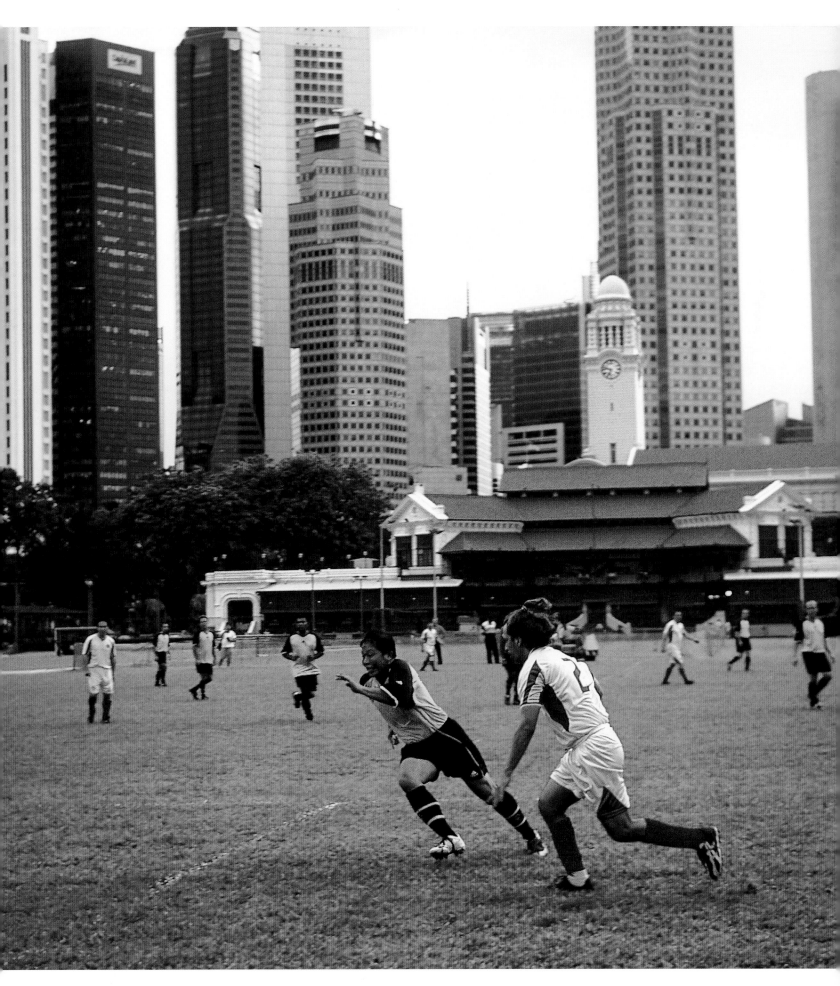

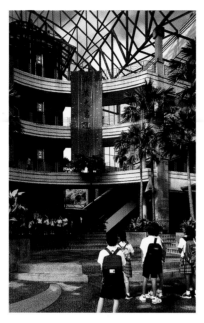

Clarke Quay

94 and 95 Clarke Quay, facing onto Singapore River, presents itself as a "festival village," a spot dedicated to shopping by day and entertainment by night, popular with Singapore's younger crowd and tourists. The rows of colonial houses, today painted in bright colors, exist in a modern environment. In the past they housed businesses.

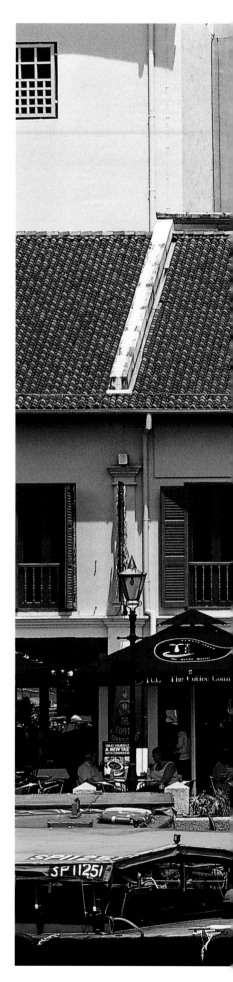

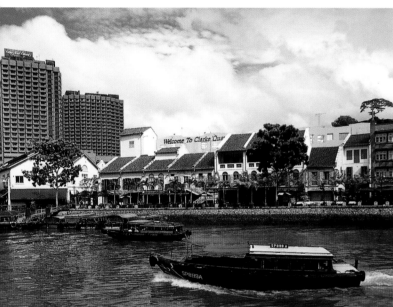

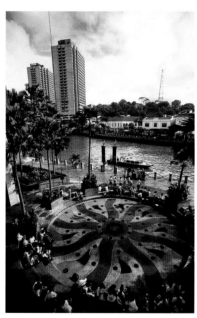

96-97 The inhabitants of Singapore, like those of all the Southeast-Asian countries, like to eat outdoors and socialize over dinner while enjoying the cool night air. Areas exist dedicated to dining al fresco like Clarke Quay and Boat Quay on Singapore River, but restaurant tables can also be found on the streets of the various neighborhoods and indoor markets.

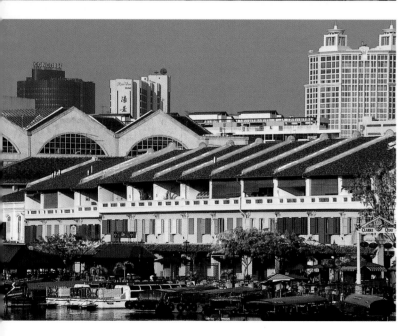

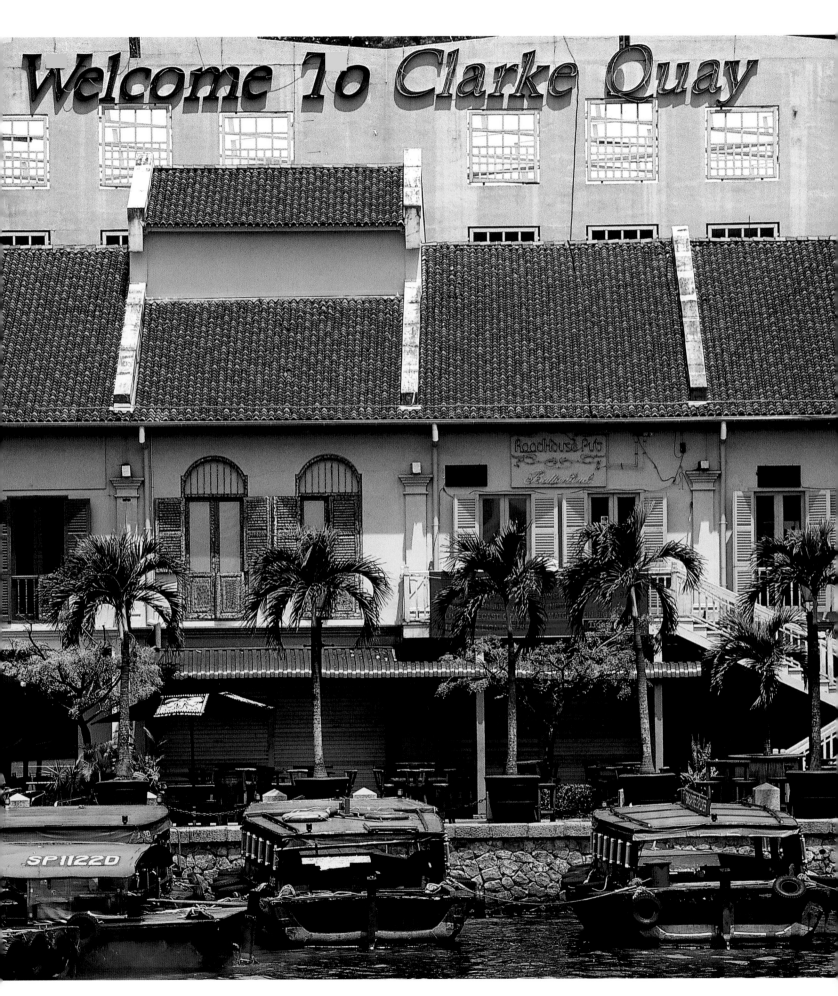

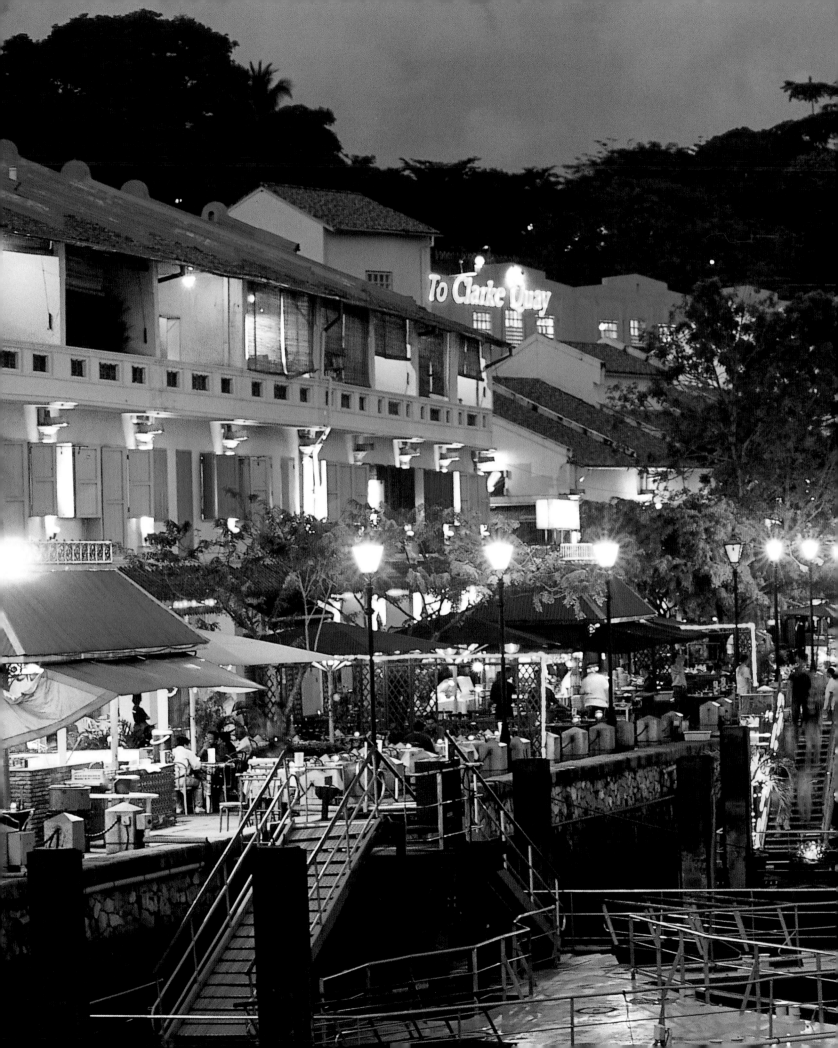

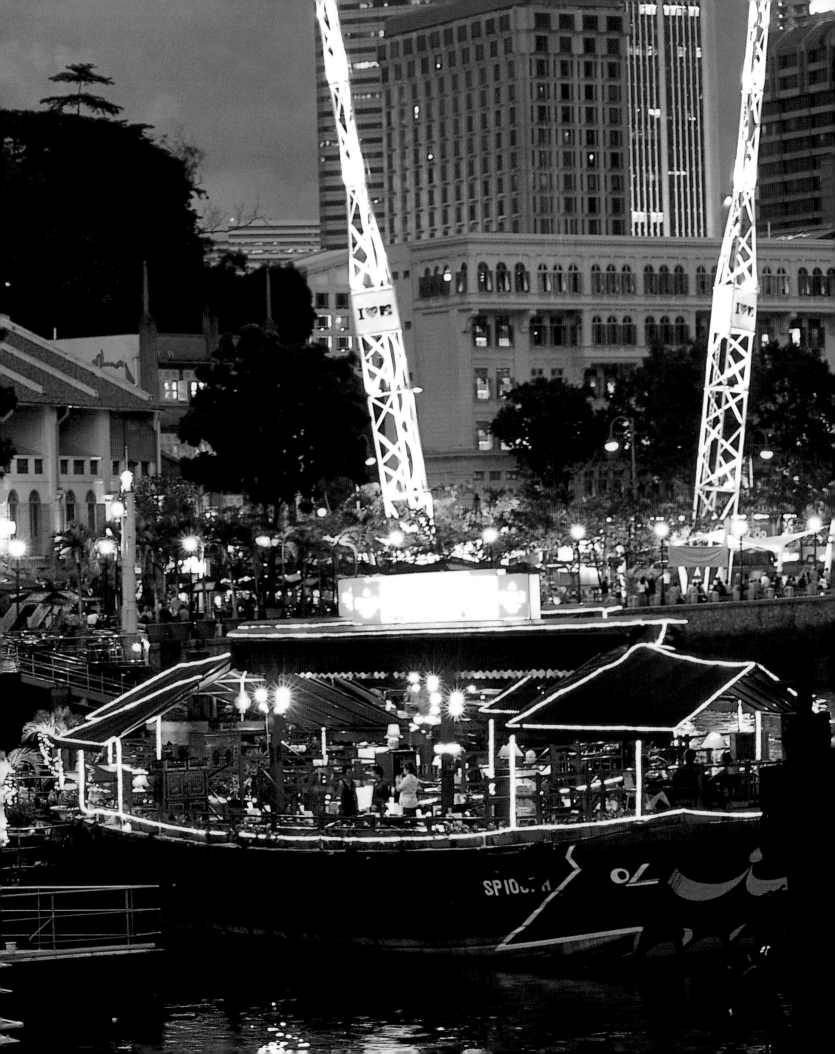

Ethnic Groups and Their Neighborhoods

98 left Serangoon Road (top) is the main road of Singapore's Little India, an Indian community with many surviving colonial-era houses. In Little India, Singapore's strict efficiency seems to give way to the more lively traditions imported from the subcontinent during the colonial era.

98 right and 99 The Hindu temple of Chettiar, which has replaced the original 19th-century complex, boasts a colorful, 75-foot-tall gopuram, a votive tower with hundreds of statues of divinities worshiped by the Tamils. The majority of Indians in Singapore belong to this ethnic group from southeast India.

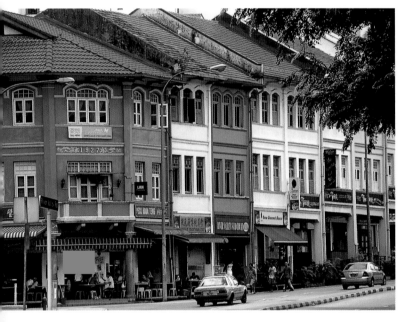

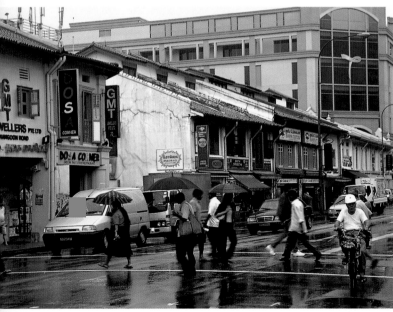

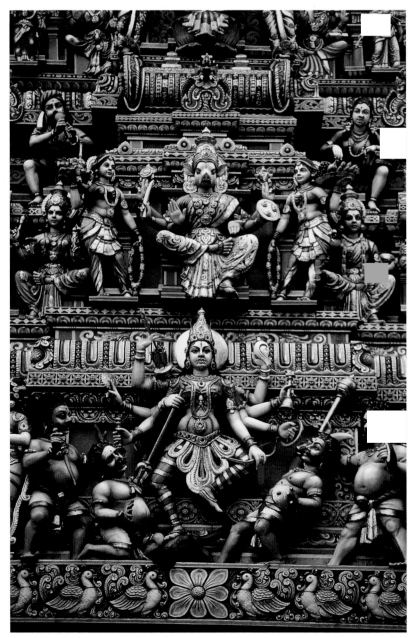

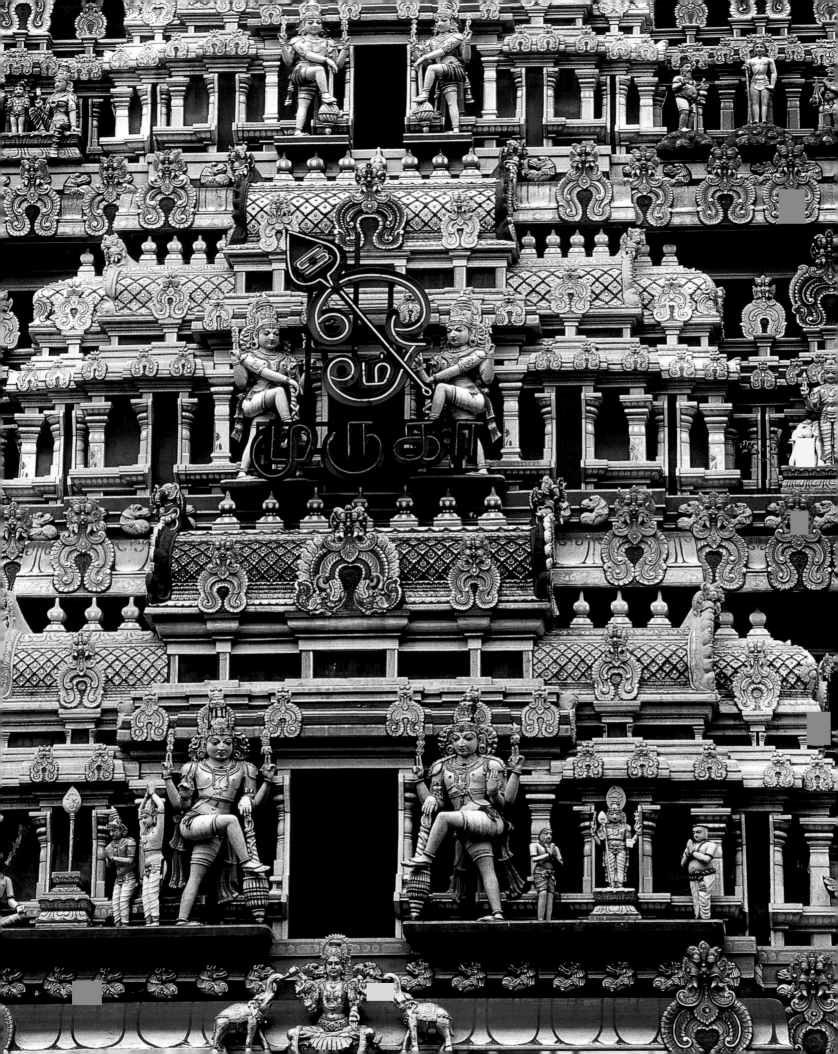

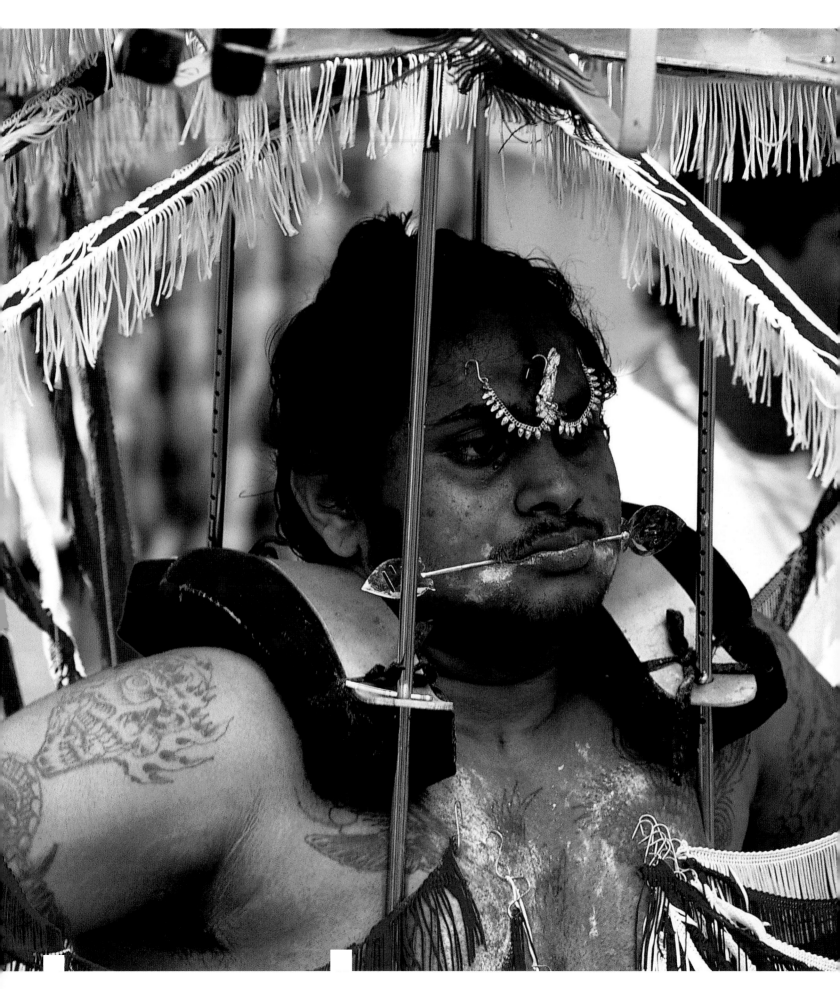

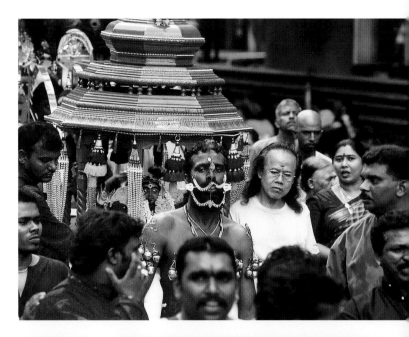

100-101 *During the procession of the Thaipusam Festival, celebrated between January and February, a fakir carries on his back the heaviest of his "cilices", the* kavadi, *a sort of wooden arch attached to the body by dozens of steel spikes or hooks. The holiday is tied to the cult venerating Subramaniam, the youngest son of Shiva, and commemorates his victory over the forces of evil.*

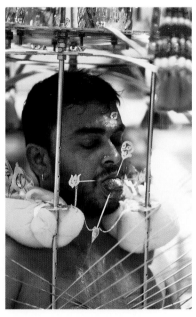

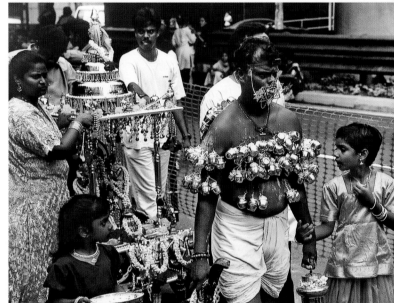

101 *The Thaipusam procession is the most impressive of the many festivals organized by the Hindu community of Singapore. Dozens of fakirs – who practice esoteric rituals that lead to a state of trance – participate in the celebration, piercing their tongues, cheeks, chins, and other parts of their bodies with long pins and sharpened daggers. In India, this type of act is usually connected with ceremonies in honor of Shiva, the god of destruction and recreation. Every year in January, the procession of fakirs departs from the Perumal Temple on Little India's Serangoon Road and winds through the Asian city as far as Chettiar Temple, on Tank Road. At the same festival, in another procession, the image of the god Subramaniam is borne amid singing and amazing acts of devotion from Tank Road to Vinavagar Temple on Keong Siak Road.*

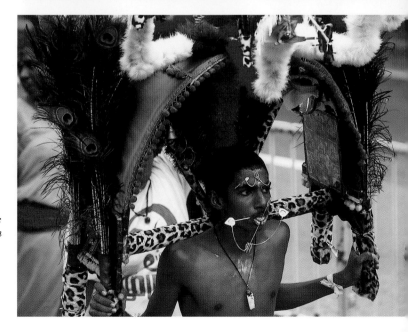

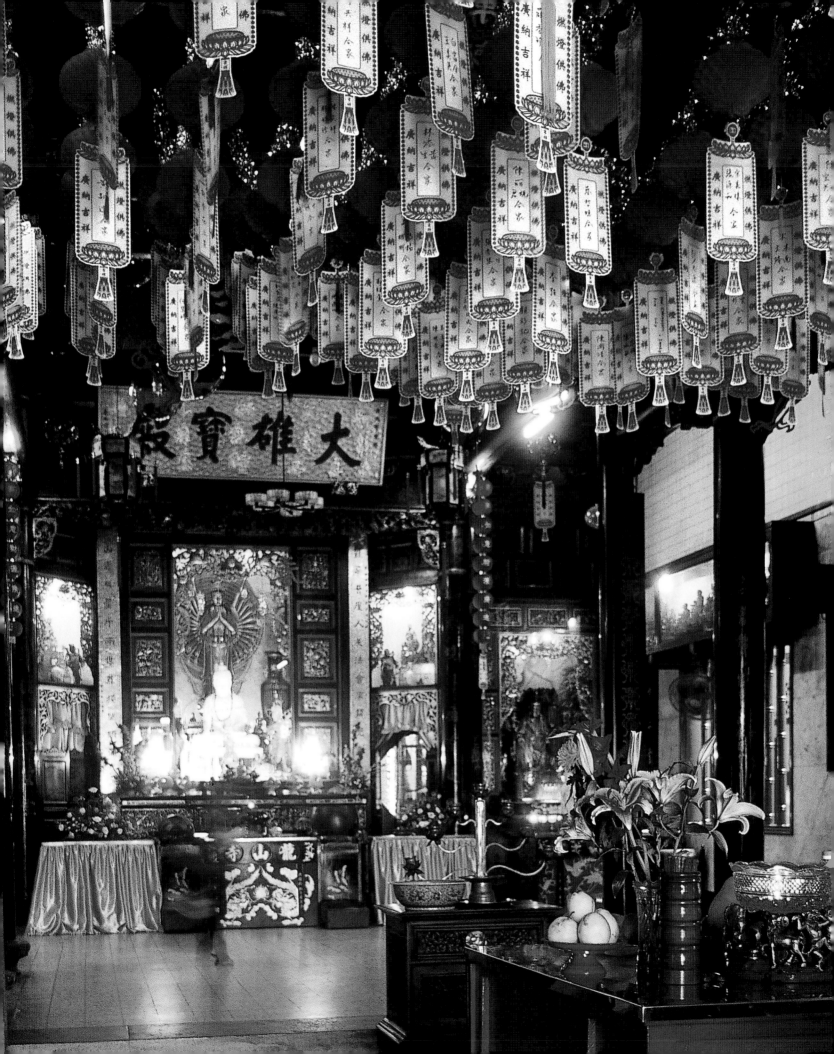

102 and 103 bottom Leong San See, or the "Temple of the Mountains of the Dragon," was built in 1917 and dedicated to the goddess Guanyin, whose cult is highly popular among the Chinese of the south. Inside the sanctuary, where worshipers – and visitors – must move in a clockwise direction to be in harmony with feng-shui, countless tablets are dedicated to the souls of the dead and, sometimes, the living.

103 top A worshiper offers incense in the Thian Hock Keng Temple. In Singapore, the majority of temples belong to the religion of the Chinese-origin population (76 percent of the population). They are spectacular sanctuaries in which the Confucian doctrine (at the base of the lifestyle and social and economic success of the city-state) is united with rituals, beliefs, and images from the Buddhist and Taoist philosophies.

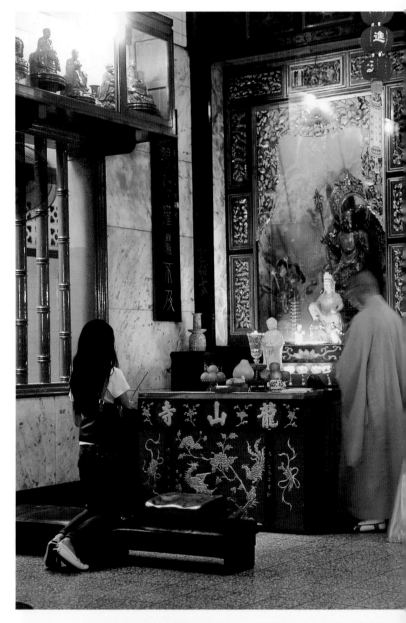

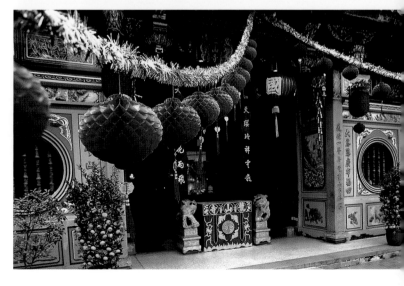

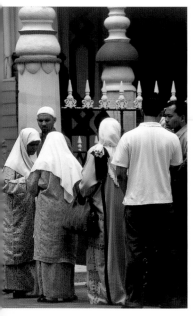

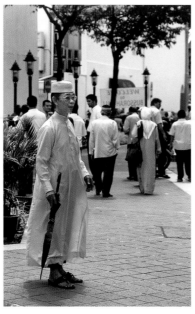

104 top, center left, and bottom The East seems to move West in the area surrounding Arab Street, in the Muslim quarter. The zone is inhabited by citizens originally from nearby Malaysia, but also by Arab merchants and immigrants from the various countries of the Middle East. Here, the efficient and modern image of Singapore is diluted in the atmosphere of a Middle-Eastern bazaar, with veiled women and shops selling carpets, textiles, baskets, silver, and spices.

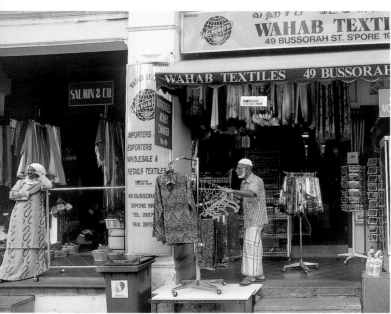

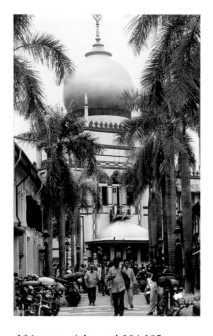

104 center right, and 104-105 Sultan Mosque, seen in these two pictures respectively from Bussorah Street and from the interior, looking toward the mihrab (the niche oriented in the direction of the Qa'aba in Mecca), is the largest Islamic sacred building in Singapore. The temple boasts a monumental dome and a large prayer hall with its floor covered by traditional carpets. Completed in 1928, it is the point of reference for the local Muslim community, which represents 16 percent of the total population.

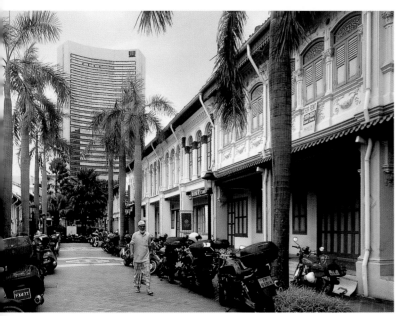

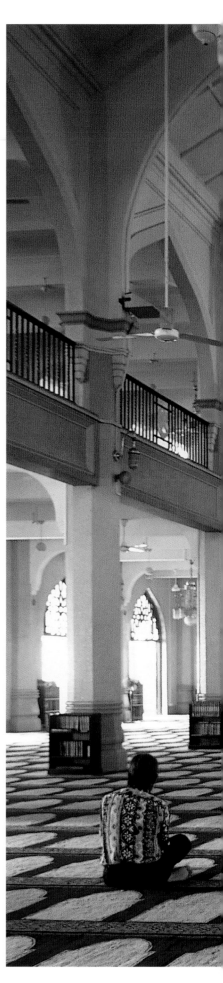

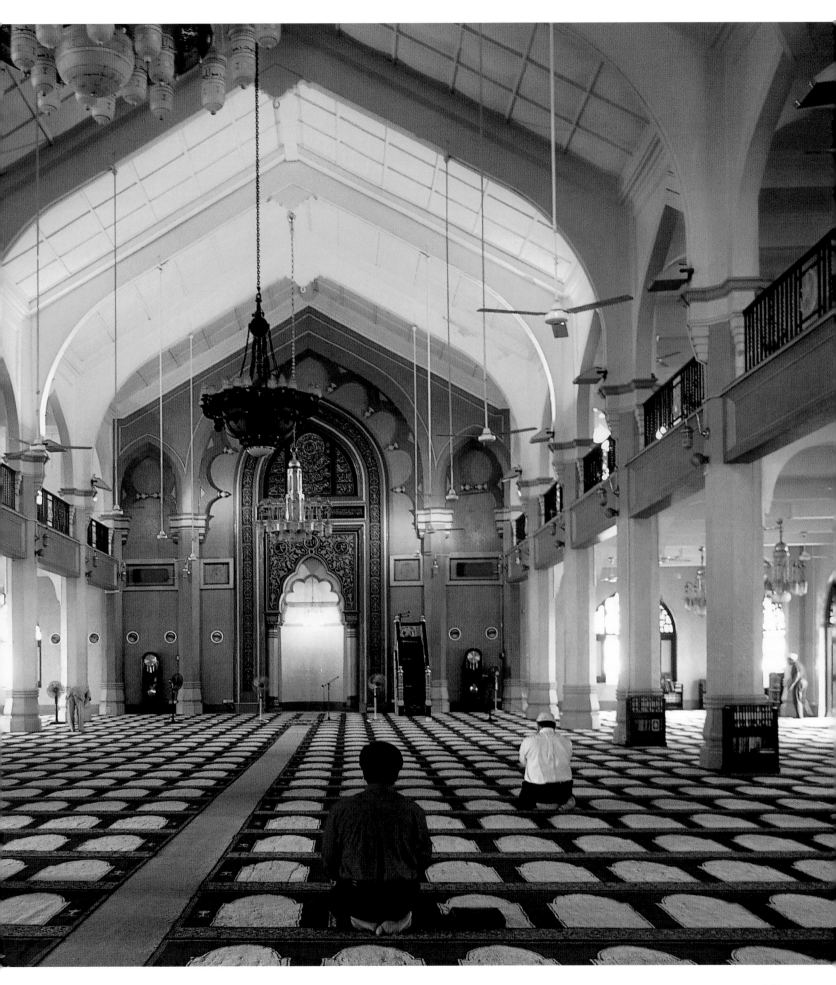

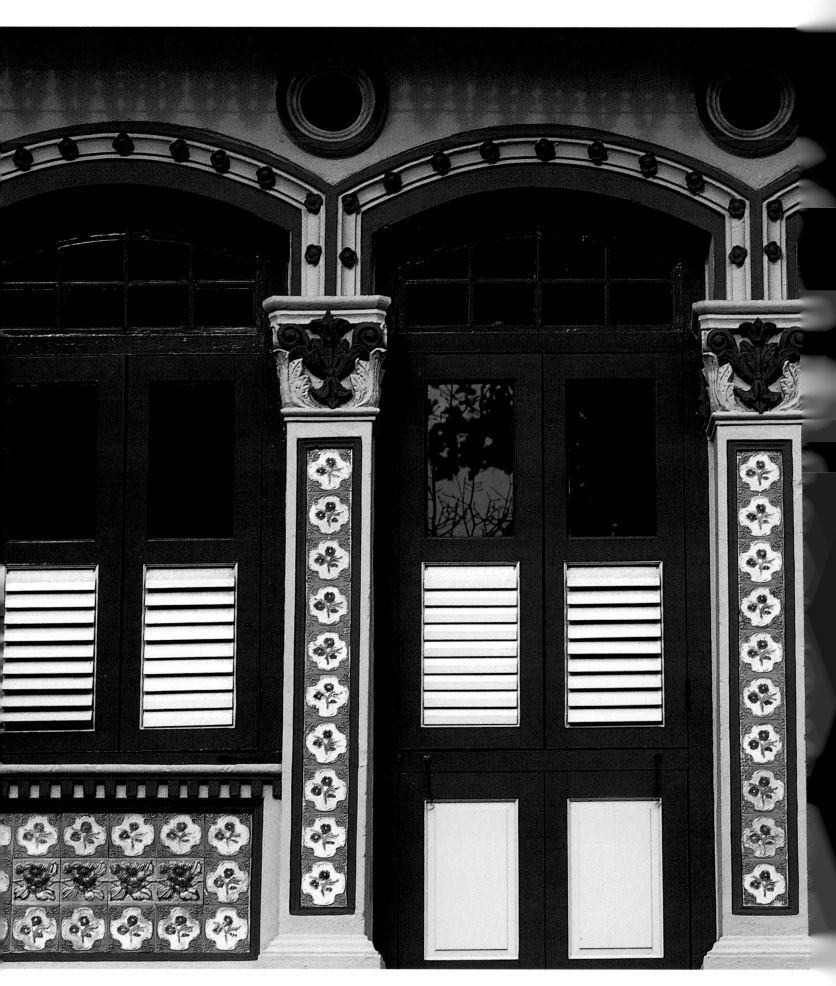

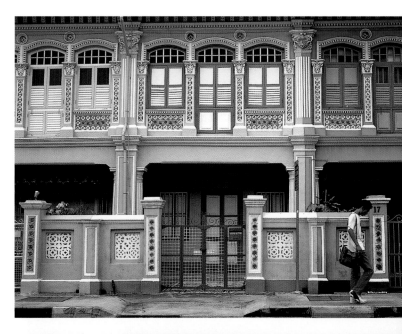

106-107, 107 top right and bottom
The Katong neighborhood has become a
sort of museum of the Peranakan
ethnic group, a minority born of the
multi-ethnic mix of colonial Singapore:
its members are the offspring of mixed
marriages between Chinese,
Malaysians, and Europeans. It is blend
of elements from the three cultures
influencing cuisine, interior
decoration, clothing, knick-knacks, and
architecture, the latter typified by little
two-story houses decorated with lovely
combinations of colors and sometimes
embellished by floral-motif majolica
panels. Here, it is possible to buy – at
prices lower than downtown but at the
same level of quality – batiks, clothes,
furniture, sculptures, and porcelain
with original designs.

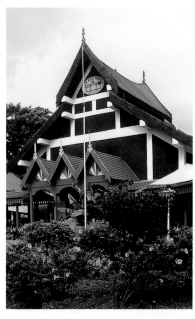

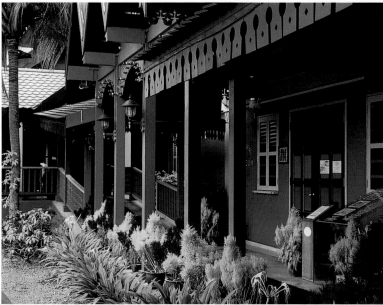

107 center The characteristic lines of
traditional Malaysian architecture
have been revived in Malay Village, a
kampong (meaning "village" in the
Malay tongue) built at the end of the
last century in order to preserve the
culture of those who were the island's
first inhabitants. The Malays were the
only people present when, in 1819,
Thomas Stamford Raffles, an official
of Britain's East India Company,
bought the island from the Sultan of
Johore. Today, the native citizens of
nearby Malaysia represent 14 percent
of the city-state's population.

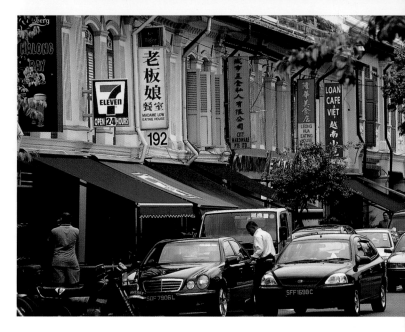

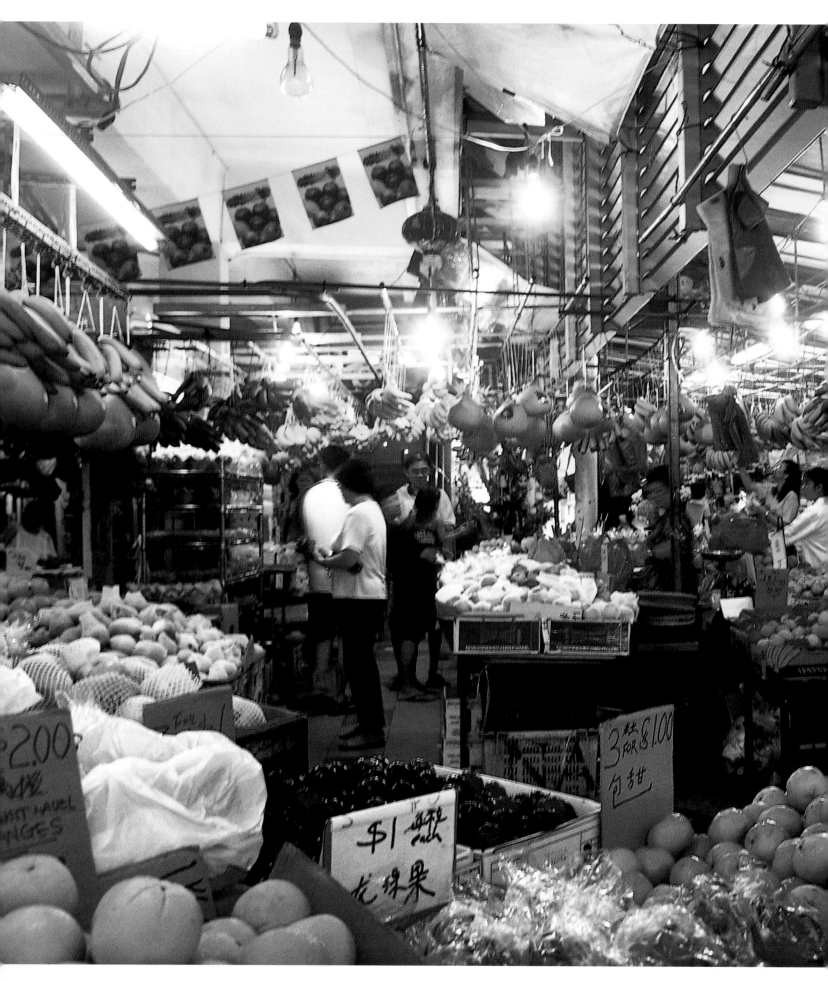

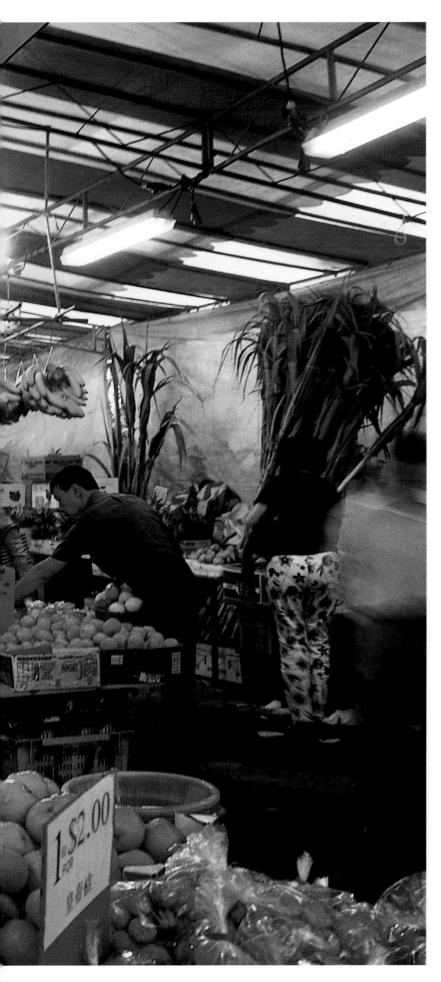

108-109 Stands of imported tropical fruit fill a section of a covered food market in Tanjong Pagar.

109 Little colonial houses painted in pastel colors line the edges of the more urban areas in Tanjong Pagar, southwest of Chinatown to which it is connected by Tanjong Pagar Road. This area of Singapore corresponds to the early nucleus of the port, which was begun in 1819 when Sir Thomas Raffles claimed the island for the British crown.

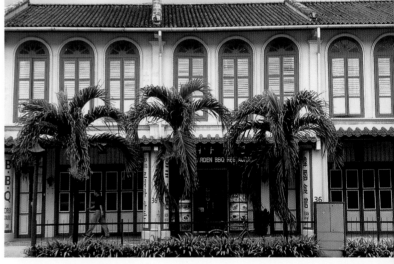

110 top and 110-111 The different natures of Tanjong Road are evident in these two perspectives. In this neighborhood, few old buildings remain since entire blocks were demolished to make way for the modern city.

110 bottom The mansion of Teo Eng Hock, a famous English rubber magnate, was transformed into Sun Yat Sen Nanyang Memorial Hall, dedicated to the politician who most contributed to the 1911 revolution, which marked the end of the Qing dynasty and the birth of the first Chinese republic.

112-113 As these paired photos demonstrate, the cold appearance of the "dormitory neighborhoods" in Singapore is often broken up by architectural solutions that favor novel lines and a landscape-style use of color.

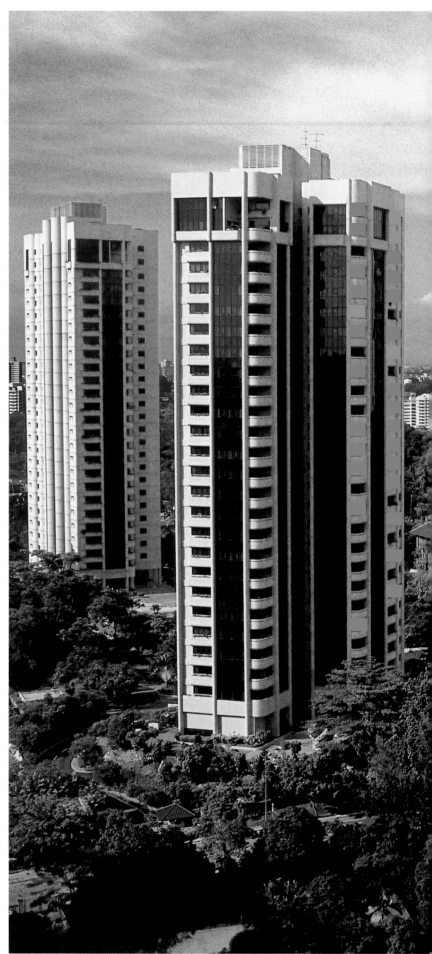

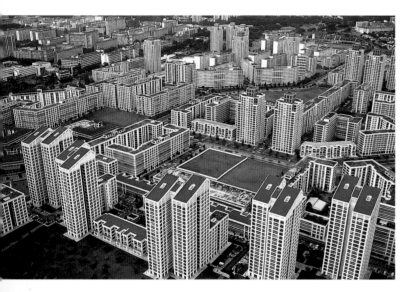

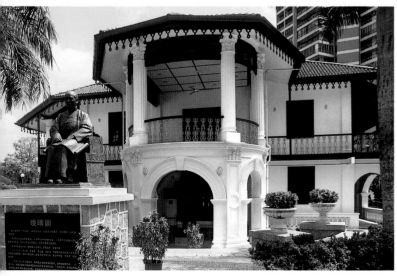

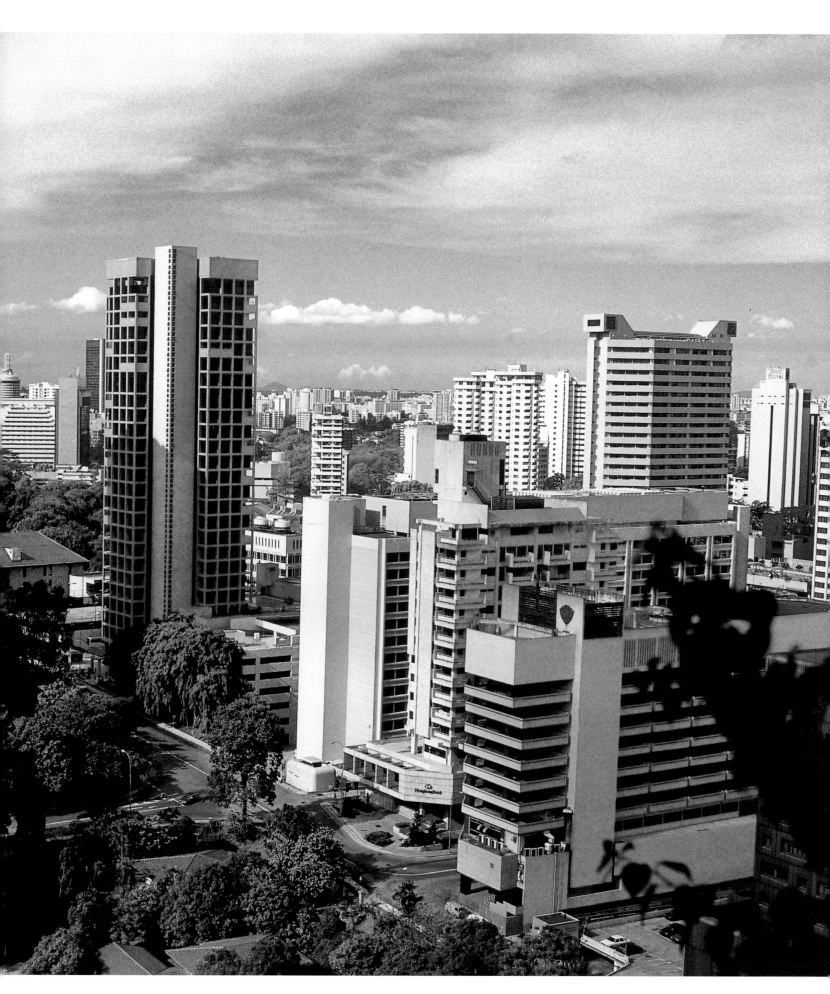

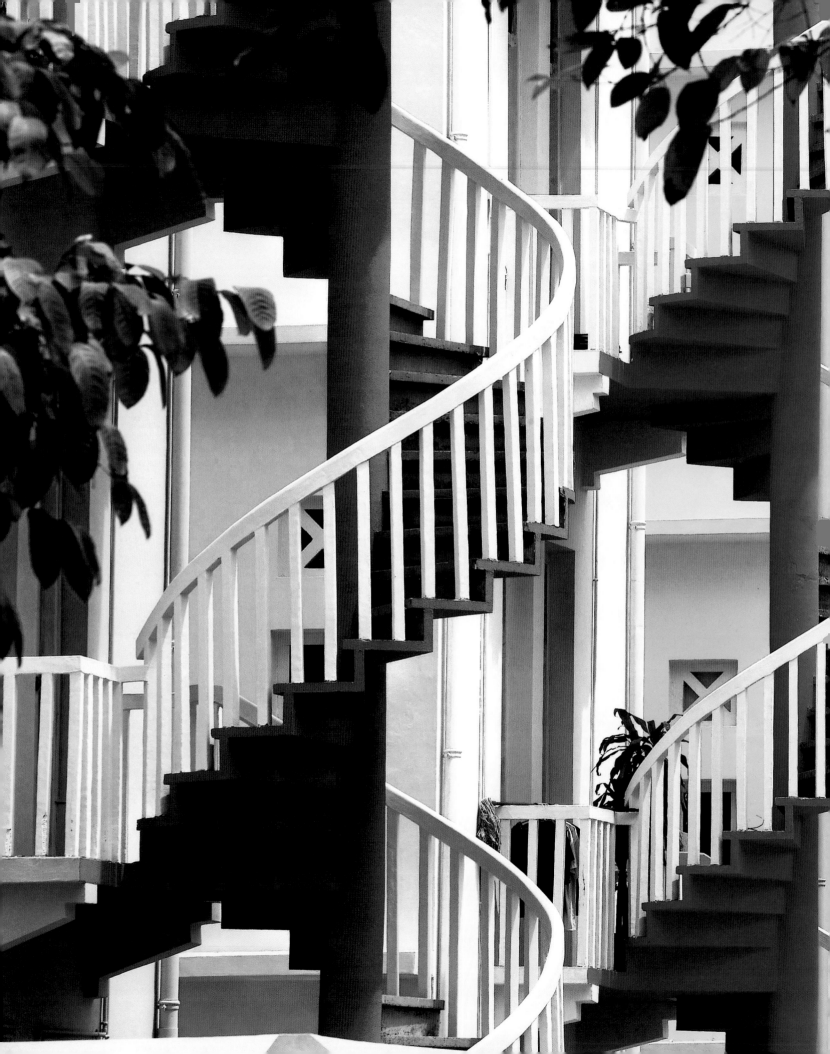

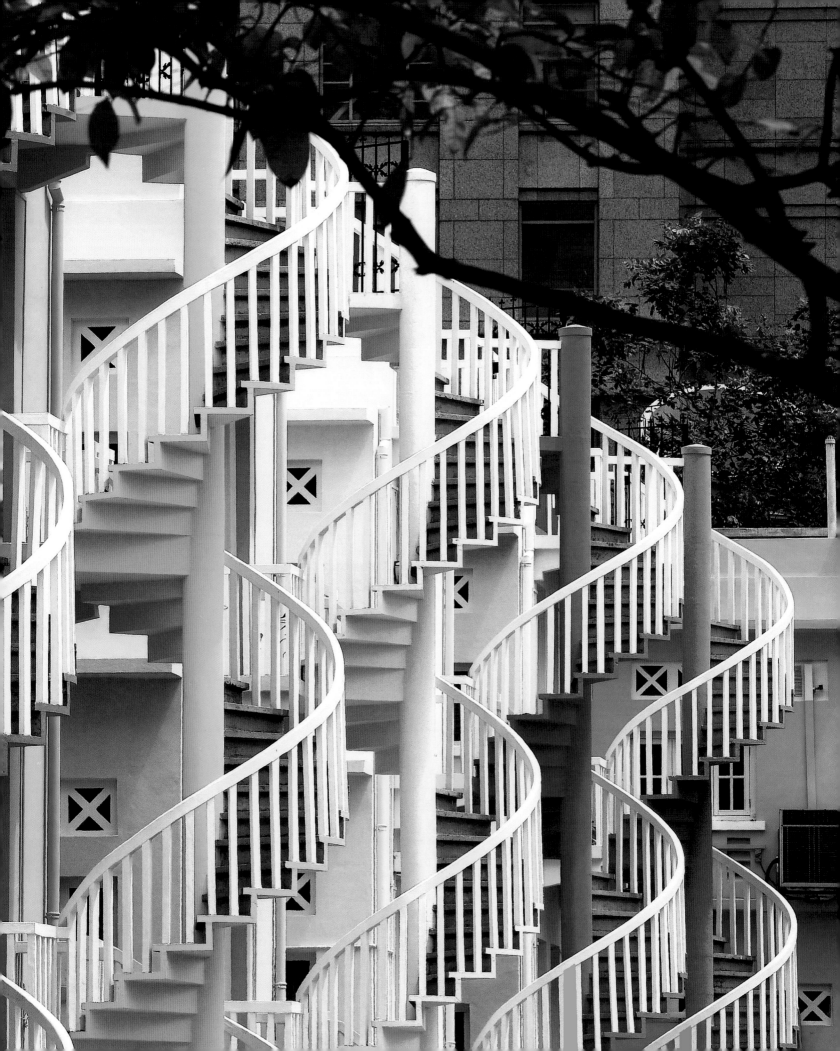

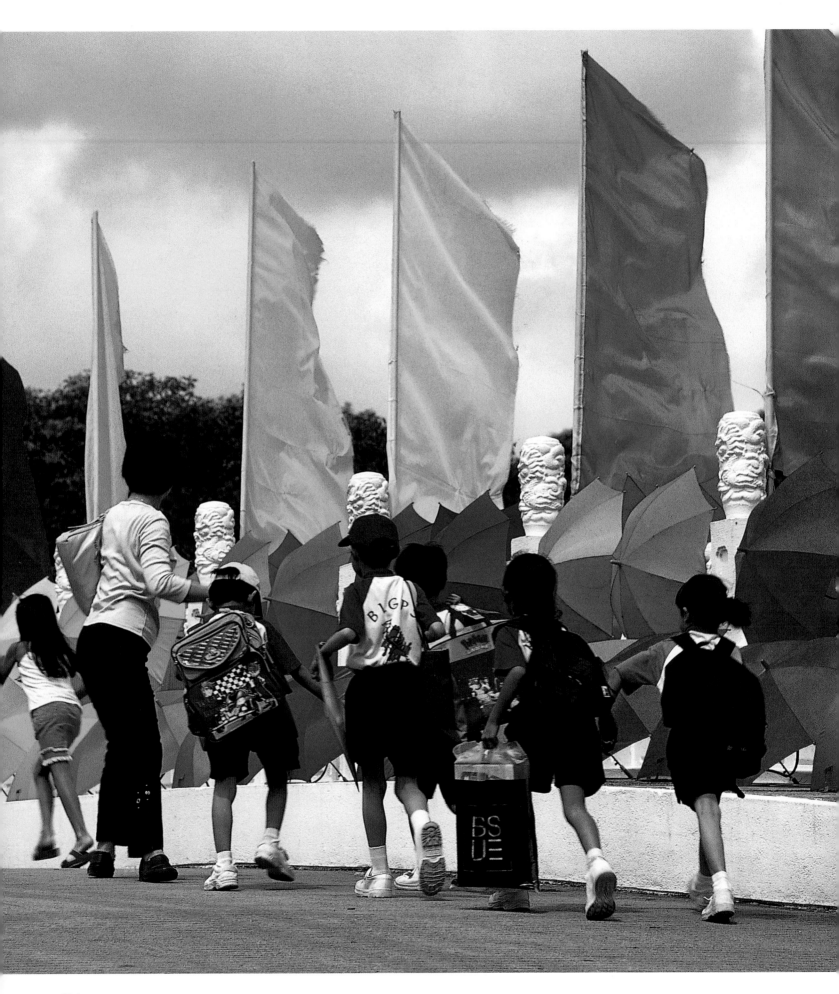

Gardens in the City

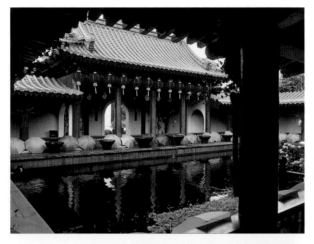

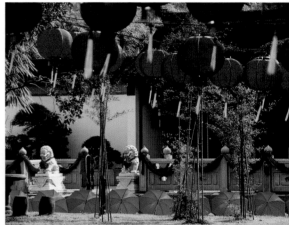

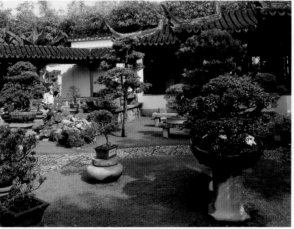

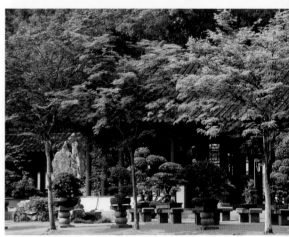

114-115 Schoolgirls on a field trip to the Chinese Gardens, where a contemporary artist exhibits his creations using umbrellas and banners.

115 top left Inside the Chinese Gardens, a traditional pavilion with curved roofs and a large central pool recall those that can still be seen today in southeastern China.

115 top right Several different exhibits by artists unexpectedly enliven the lovely Chinese Gardens. In Singapore, art is given great importance, to the point that many creative Westerners have chosen to live there.

115 bottom left and right For over a century, Singapore has been called a "garden city" because, despite its high population density, it boasts many green areas. Parks, gardens, and avenues lined by well-kept trees feature a mixture of frangipani, an infinite variety of palms, cascades of bougainvilleas, and hibiscus bushes. The most popular green area is that of the Chinese Gardens, a lovely example of the gardening tradition from the time of the Heavenly Empire, with bridges, pagodas, statues of lions, copies of warriors from the Terracotta Army of Xi'an, and a stone boat. Of course, it could not lack a bonsai garden, with stone lanterns, hills, and rock gardens.

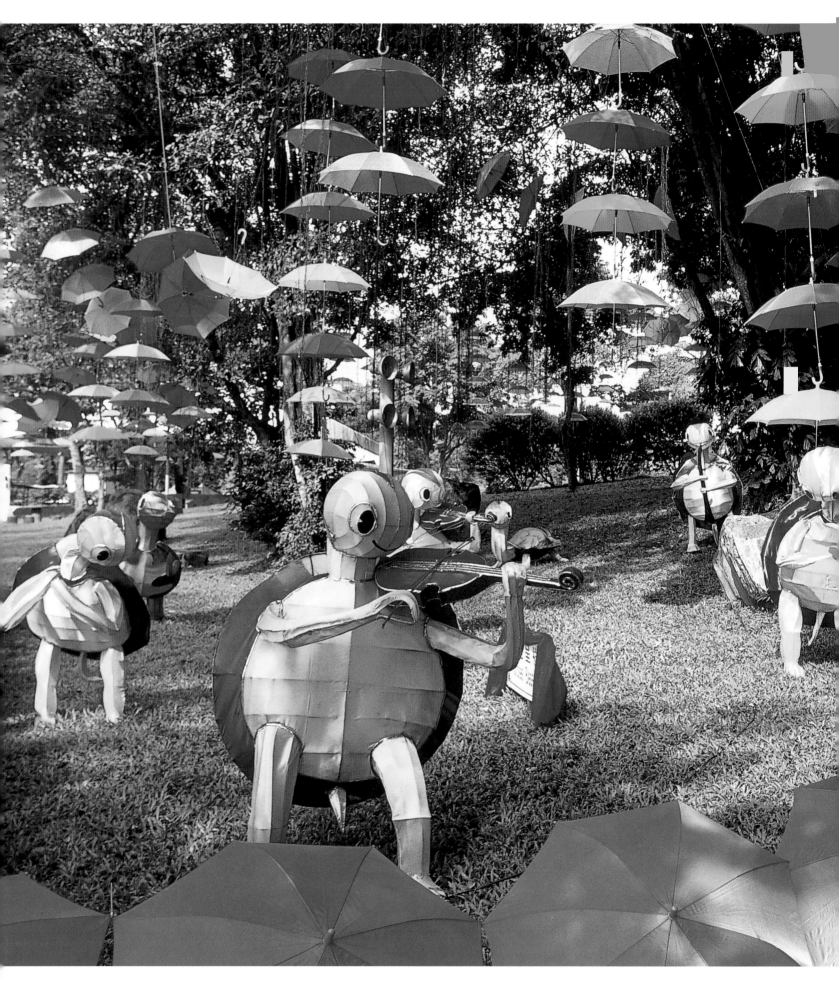

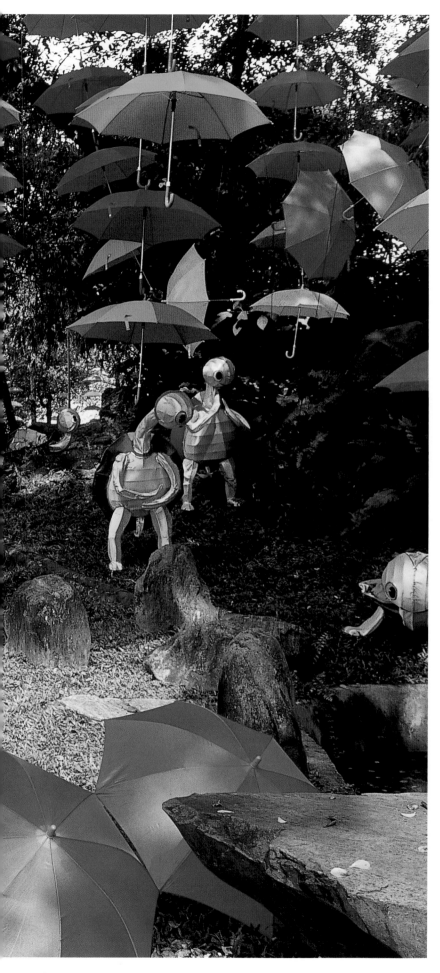

116-117 and 118-119 Lively displays of colored umbrellas and funny musicians have forcefully become part of the tranquility of the Chinese Gardens, creating an undeniably unique atmosphere. Covering 32 acres, the gorgeous park offers the public a remarkable reconstruction of the architectural style of the Sung dynasty (970-1279), inspired by the splendor of the Summer Palace in Beijing. The citizens of Singapore take refuge there to find silence and fresh air, and schoolgirls go there to partake in educational outdoor activities like studying plants and Chinese culture, or in this case, to take advantage of a fantastic opportunity to discover contemporary art.

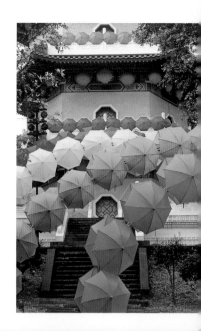

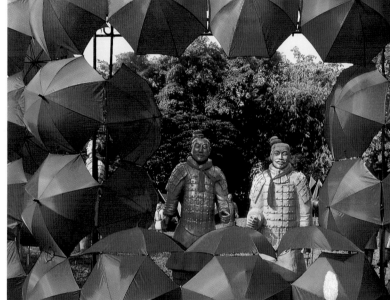

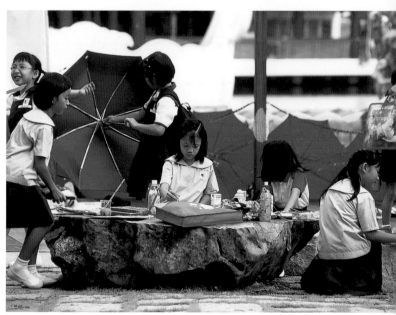

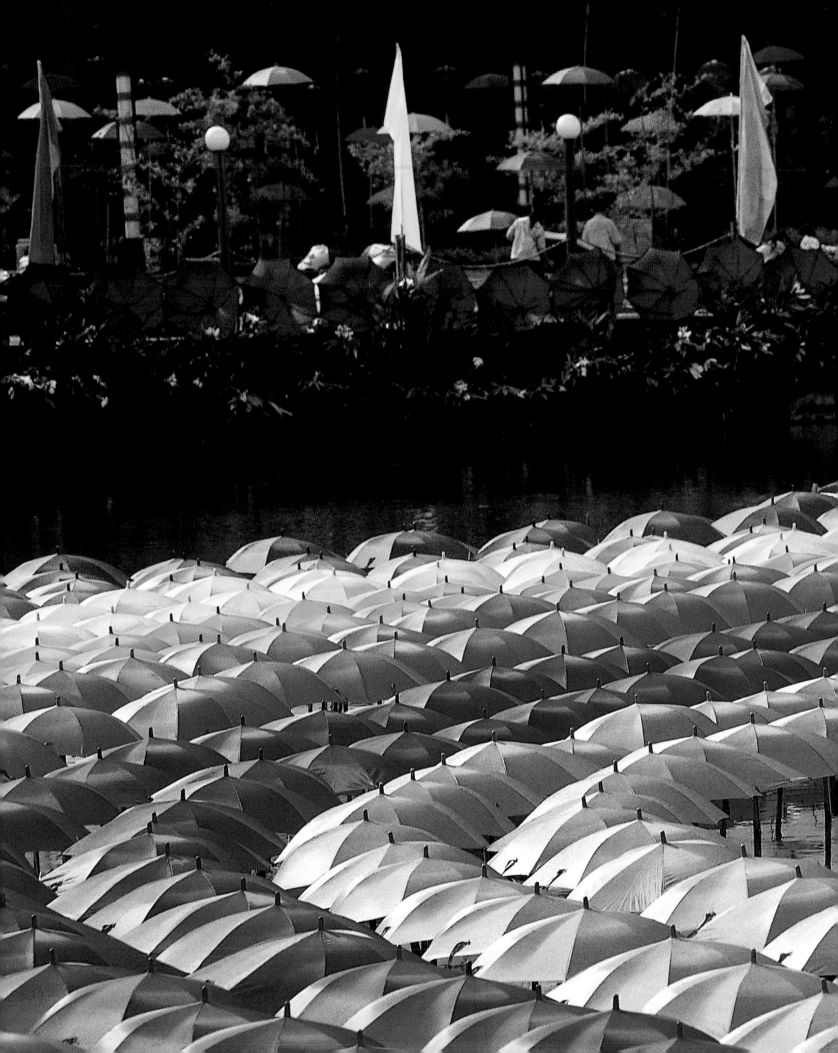

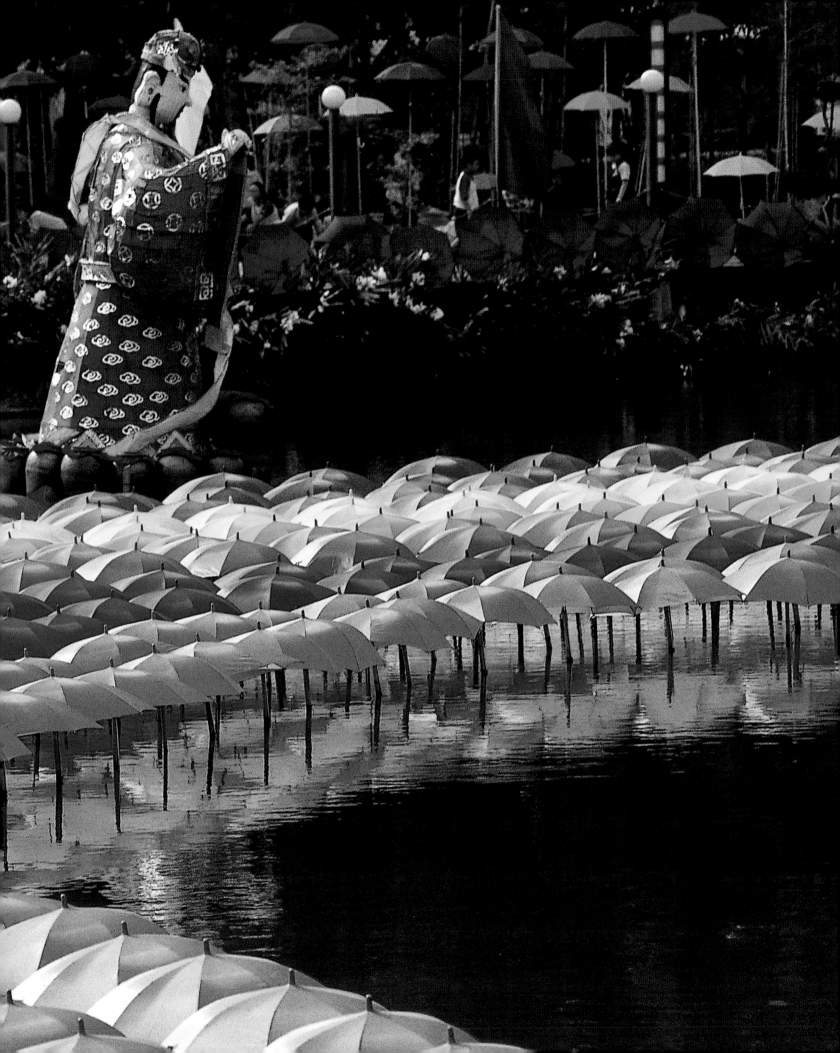

Nature Rediscovered

120 top left, right, and 120-121 In the Singapore Zoological Gardens, 1,700 animals of 172 different species are kept in 60 exhibit structures, almost always separated from the public by natural barriers like waterways, ditches, or rocks. Lions, *panthers, Sumatran tigers, spotted leopards, Malaysian tapirs, rhinoceroses, Indian elephants, baboons, orangutans, and iguanas can be observed there, all animals that thrive in the island's tropical climate.*

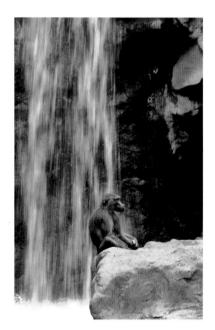

120 bottom Located on a hill, a good part of the Mandai Orchid Garden is covered by cultivations of numerous orchid varieties: almost all of those sold in the city come from here. The park also includes a Water Garden with ponds populated by exotic animals surrounded by lush tropical vegetation.

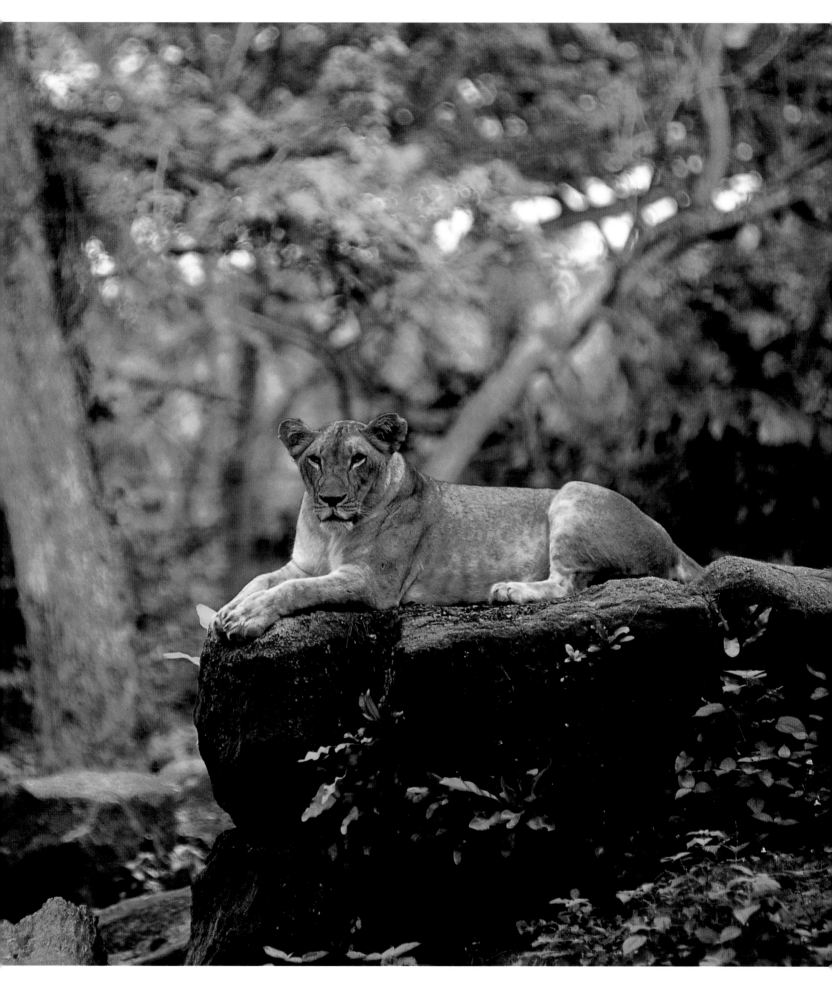

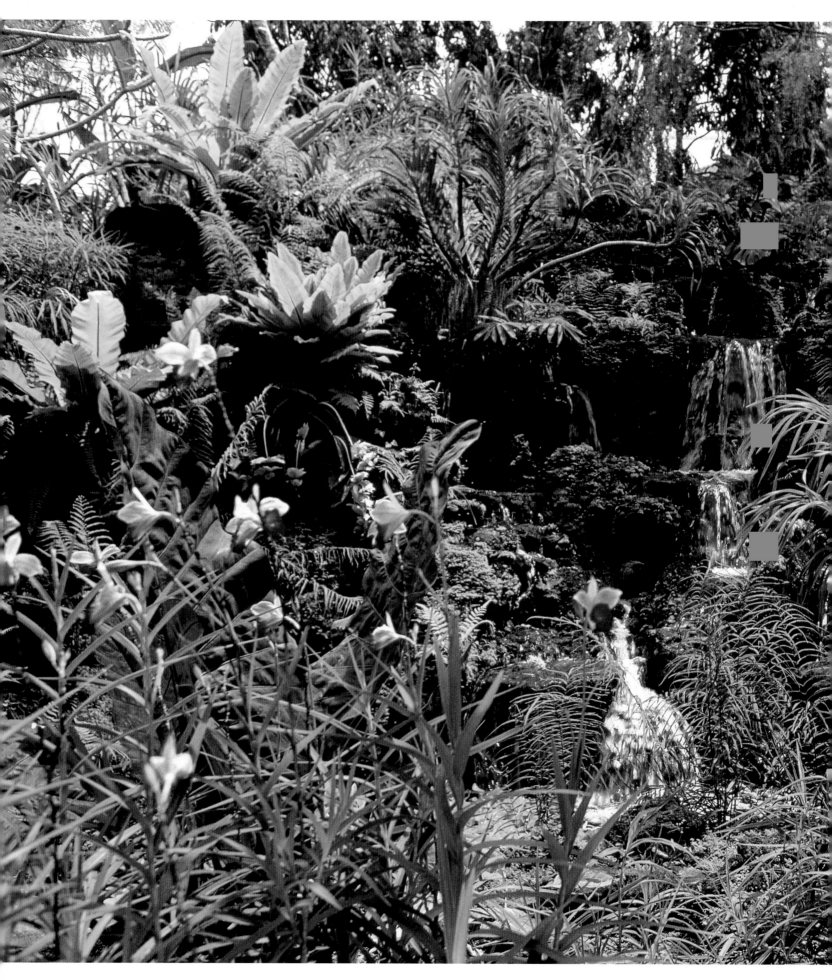

122-123 and 123 top right Artifical waterfalls gush from a magnificent forest floor of ferns, spleenwort, and orchids inside the Botanic Gardens on Cluny Road. The gardens stretch over a total area of about 150 acres, four of which are occupied by rain forest.

123 center left Jurong Bird Park in Singapore boasts one of the most important aviaries in the world, with over 3,000 birds of 300 different species.

123 center right The gorgeous orchids of Mandai Orchid Garden grow magnificently thanks to the unquestionably humid tropical climate.

123 bottom A sculpture with a nature theme has been installed above a waterfall inside a forest of tree ferns in the Botanic Gardens.

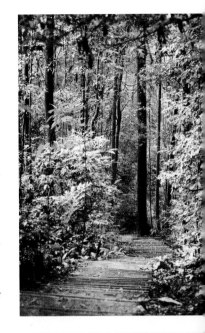

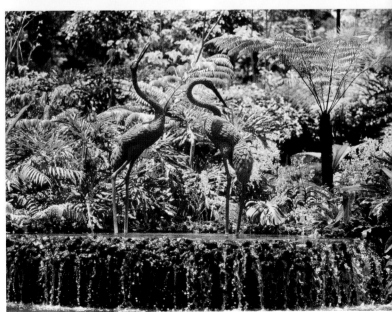

The Island of Peace

124 and 124-125 Situated off the Central Business District, Sentosa Island has been transformed into an entertainment island, a paradise for children, popular with the inhabitants of Singapore above all on the weekend. This union between tourist oasis and amusement park boasts white-sand beaches shaded by coconut palms, an aquarium featuring an underwater tunnel in which visitors can walk a few inches away from the fish, a monorail that goes around the island, a cable car, and the Maritime Museum, displaying the extraordinary commercial development of Singapore's port, the world's busiest for container traffic and brokerage companies.

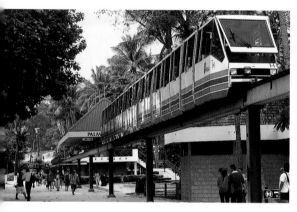

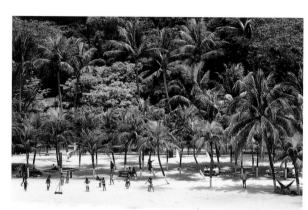

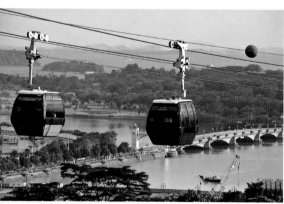

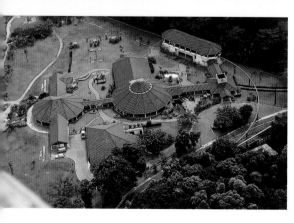

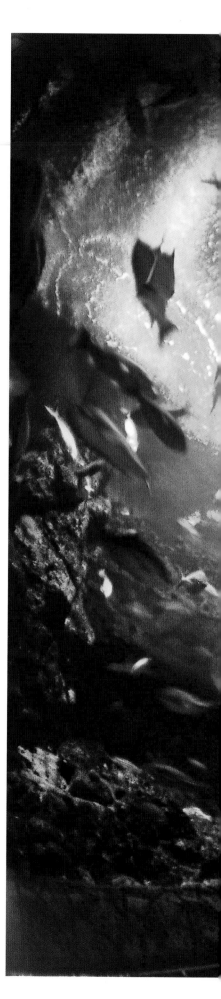

126-127 In Sentosa, the housing developments and visitor facilities share the island's 1,200 acres of surface area, occupying respectively 30 and 70 percent of the territory. The local wildlife, therefore, can live in relative tranquility (and this is precisely the meaning of "sentosa" in the Malay tongue). Among the animals found on the island are monitor lizards, monkeys, parrots, and other tropical birds.

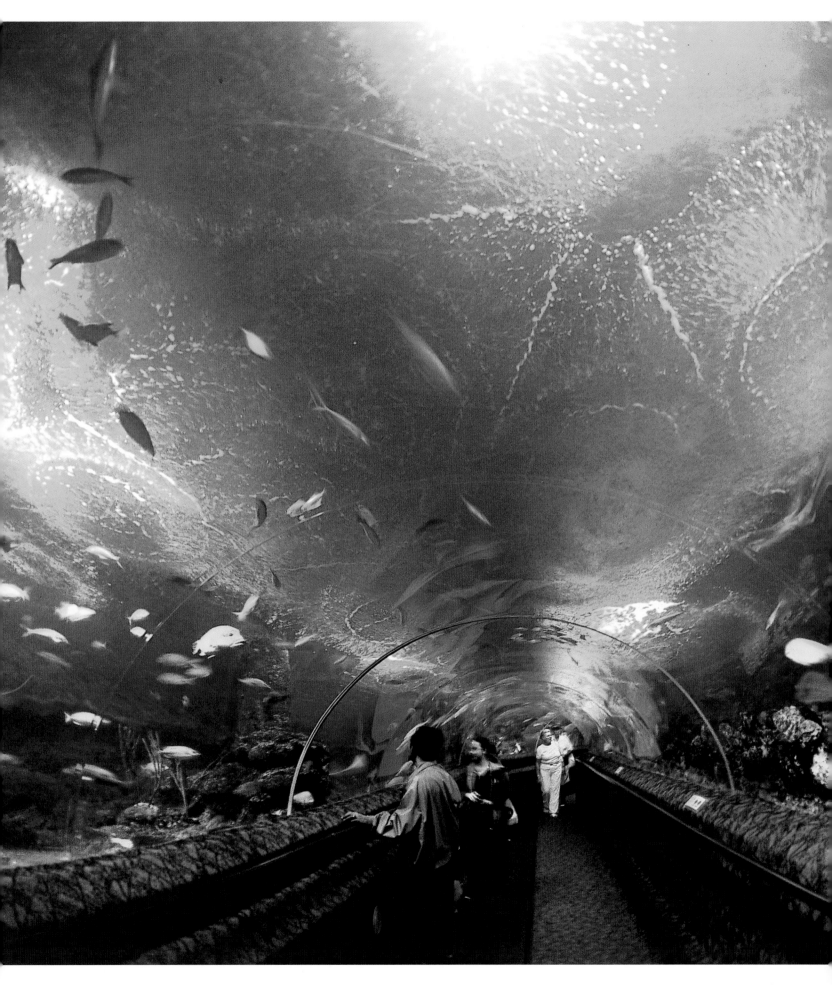

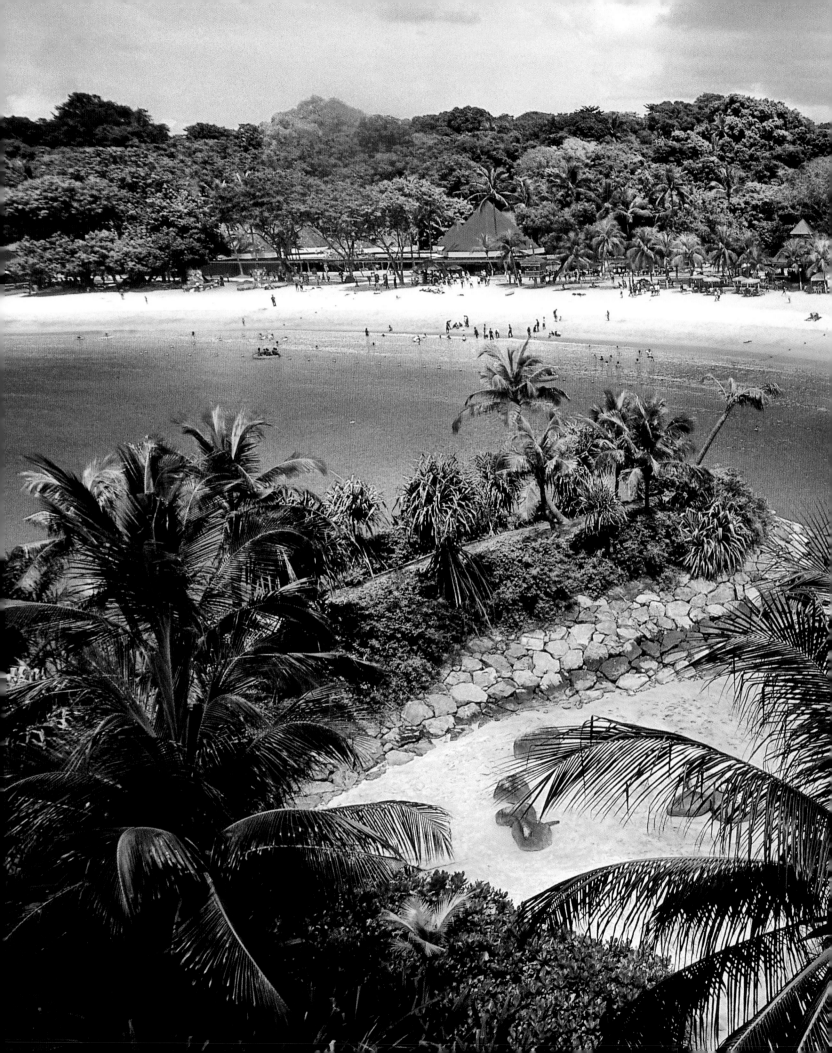

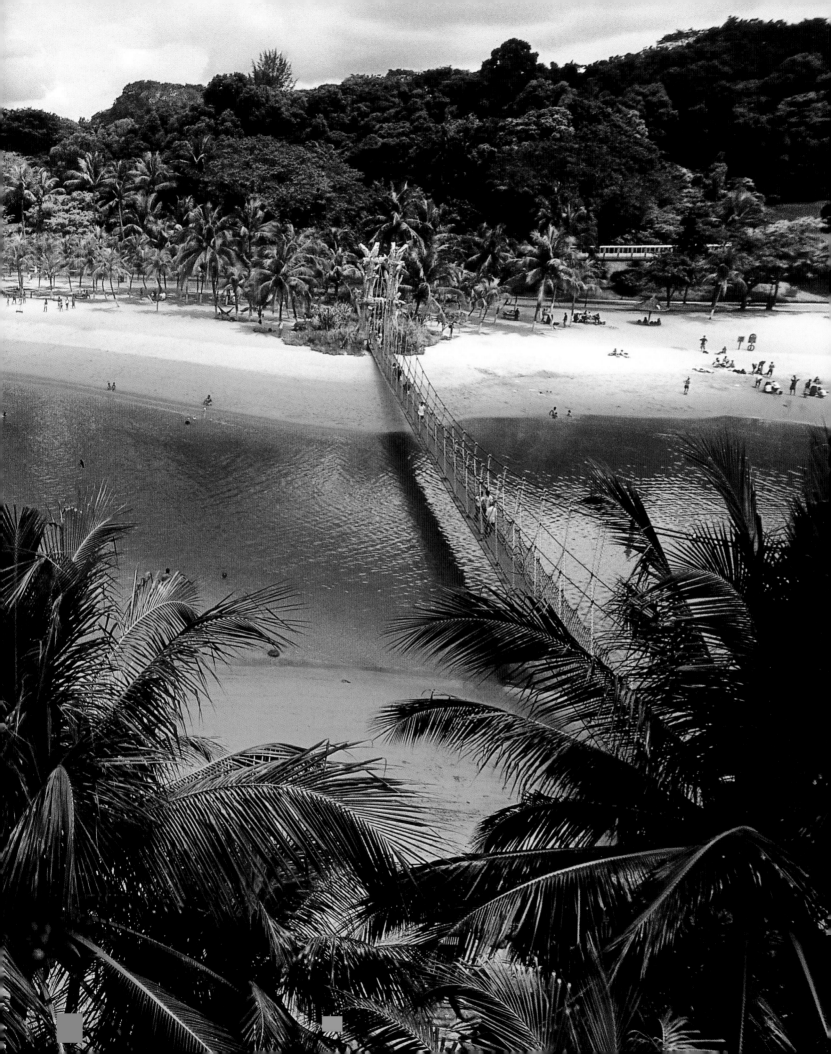

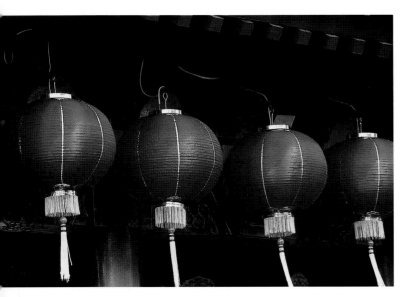

All photographs are by Giulio Veggi/Archivio White Star except the following:

pages 8-9: Alamy Images
pages 12-13: Alan Copson/Agefotostock/Contrasto
page 14 top: Bob Krist/Corbis/Contrasto
page 14 bottom: Massimo Mastrorillo/Corbis/Contrasto
pages 16-17: SuperStock/Agefotostock/Marka
pages 22-23: R. Ian Lloyd/masterlife/zefa/Sie
pages 24-25: SuperStock/Agefotostock/Marka
page 53 center: Marcello Bertinetti/Archivio White Star
pages 58-59: Marcello Bertinetti/Archivio White Star
page 74 bottom left: Marcello Bertinetti/Archivio White Star
page 75: Marcello Bertinetti/Archivio White Star
page 76 top: Kevin R. Morris/Corbis/Contrasto
page 76 bottom: Kevin R. Morris/Corbis/Contrasto
page 77: Adam Woolfitt/Corbis/Contrasto
page 79: Alamy Images
page 84: Alamy Images
page 87 left: Macduff Everton/Corbis/Contrasto
page 110 top: Marcello Bertinetti/Archivio White Star
pages 110-111: Marcello Bertinetti/Archivio White Star
pages 112-113: R. Ian Lloyd/masterlife/zefa/Sie
pages 122-123: Kevin R. Morris/Corbis/Contrasto
page 123 top: R. Ian Lloyd/masterlife/zefa/Sie
page 123 center left: Bob Krist/Corbis/Contrasto
page 123 bottom: Kevin R. Morris/Corbis/Contrasto
page 124 bottom: Marcello Bertinetti/Archivio White Star

Map by Angelo Colombo/Archivio White Star

128 Red lanterns, one of the most widespread symbols of Chinese culture, are found everywhere in Singapore: outside restaurants, inside shopping malls, in the temples, in the parks, and on the balconies of private houses from Chinatown to the residential neighborhoods.